W9-BQK-377

Kamera
BOOKS

www.kamerabooks.co.uk

Elliott H. King

DALÍ, SURREALISM AND CINEMA

Kamera
BOOKS

First published in 2007 by Kamera Books
PO Box 394, Harpenden, Herts, AL5 1XJ
www.kamerabooks.co.uk

Copyright © Elliott H. King, 2007
Series Editor: Hannah Patterson

ISBN-13: 978-1-904048-90-9

Typeset by Avocet Typeset, Chilton, Aylesbury, Bucks
Printed by SNP Lefung Printers (Shenzen) Co Ltd, China

CONTENTS

Salvador Dalí, The Youngest, Most Sacred Monster of the Cinema in His Time

Salvador Dalí (1904-1989) once remarked, 'The day that people seriously turn their attention to my work, they will see that my painting is like an iceberg where only a tenth of its volume is visible.'[1] The Catalan artist was referring to the profundity of the ideas that went into his fantastic seascapes populated by 'soft watches', though the word 'painting' might easily have been replaced with 'movies'. Dalí loved movies. He enjoyed watching the old silent comedies starring Buster Keaton and Charlie Chaplin, the great Italian and French films by Federico Fellini and Marcel Pagnol, and the animated films produced by Walt Disney – he used to project them for friends at his home in Port Lligat. His artwork also referenced cinema celebrities: Shirley Temple, Marilyn Monroe, Mae West and Sir Laurence Olivier all became 'dream subjects' in Dalí's masterfully-rendered canvases. But the films Dalí conceived *himself* have rarely been given proper consideration. They've remained beneath the surface of that Dalínian iceberg.

Some will probably know the 1929 short he made with Luis Buñuel, *Un Chien Andalou* (*The Andalusian Dog*) – its opening, in which a razor-blade slashes a young woman's eyeball, has become one of the most celebrated sequences in cinema history – and perhaps also the dream sequence from Alfred Hitchcock's *Spellbound* (1945), but these are only the most famous examples; the majority of his ideas never materialised. Though less arcane than they once were, most of Dalí's scripts are still

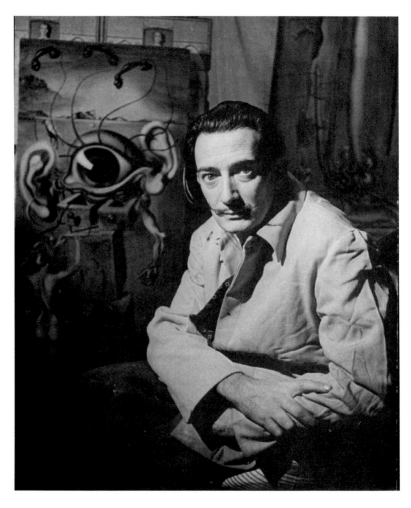

Dalí at his studio on the 8th floor of the Zeigfeld Theatre (New York) posing with his oil painting *Movies* (1944) from the Seven Lively Arts series. The painting was subsequently destroyed in a fire. Photo by George Karger/Time Life Pictures/Getty Images.

not well known, particularly to English-speaking readers – the Fundació Gala-Salvador Dalí's anthology of the artist's writings is presently published only in Catalán and Castilian. The current volume aims to introduce those lesser-known projects, or at least those for which we have known scenarios. As I will emphasise in the last section, 'Later Films', we can be sure that Dalí's experiments went well beyond those for which we have written evidence or existing footage. Little is known, for instance, about his movie adaptation of his 1942 autobiography, *The Secret Life of Salvador Dalí*, at one stage pitched to Federico Fellini; the tarot deck he designed – or that he reportedly asked Amanda Lear to design for him – for the James Bond film *Live and Let Die* (1973) that was axed from the picture when a price couldn't be negotiated with producer Albert R. 'Cubby' Broccoli;[2] or the poster for Pier Paolo Pasolini's controversial film *Salò, or the 120 Days of Sodom* (1975) that was ordered but apparently never completed.[3] He also reportedly made a brief video in 1972 in which he superimposed the facial features of American actress Denise Sandell onto the head of Marilyn Monroe, telling her he planned to put to film the Paris *Vogue* cover he had designed in December 1971 using Philippe Halsman's collage photograph, *Mao Marilyn*.[4] No remnants have surfaced for most of these projects, though hitherto unknown scripts, anecdotes and film segments are bound to emerge as more people turn their attentions towards Dalí and film.

One of the reasons Dalí's relations with the cinema have received less attention than his painting or even his sculpture, per se, is probably because his activities rarely achieved their intended ends. I have brought together about 20 films at varying degrees of completion for this book, and only 7 of them were actually realised during Dalí's lifetime: *Un Chien Andalou*, *L'Âge d'Or*, *Spellbound*, *Father of the Bride*, *Chaos and Creation*, *Soft Self-Portrait of Salvador Dalí* and *Impressions of Upper Mongolia – Homage to Raymond Roussel*. Further, perhaps only two of those – *Un Chien Andalou* (1929) and *Impressions of Upper Mongolia* (1975) – ultimately corresponded with Dalí's vision. So what happened?

Why wasn't Dalí able to realise more of his ideas for cinema? Art historian Haim Finkelstein has postulated that some of the scripts Dalí wrote were never intended to be shot – keeping in mind the popularity of certain *scenarii intournables* ('unfilmable scenarios') in the 1920s;[5] while this may have been true with some of the 1930s scripts, later it was more often the case that his designs were simply too costly and elaborate – and, indeed, esoteric – for studios to justify. As for his apparent inability to mount the films on his own, Paul Hammond describes Dalí as 'a great ideas man' but rightly observes that he consistently needed a strong director to transfer his imagination to the silver screen – a presence that was often lacking after his friendship with Luis Buñuel deteriorated.[6] Dawn Ades offers that many of the artist's cinematic projects may have been left unfinished because he came to see film as a '"secondary form", involving the intervention of too many people in its creation';[7] it is indeed curious that Dalí conceived increasingly elaborate cinematic spectacles requiring more and more professionals, but the films that materialised to his satisfaction came mostly when he was working alone with a director on a film that could be shot in less than two weeks. Amanda Lear – Dalí's model and muse, and one of his closest confidants between 1965 and 1980 – adds that the greatest obstacle the artist faced to finishing films was the unreasonable demands he deliberately put upon people of the industry. These demands, she suggests, were made chiefly to compensate for his own inability to direct and to ensure the project's failure: '[W]hen he was confronted with real filmmakers, big filmmakers like Stanley Kubrick, Fellini, he realised what an incredible job they were doing. It's very difficult to direct people. Dalí couldn't direct anybody; I mean, he couldn't even direct himself!'. In her 1984 book *Le Dalí d'Amanda*, Lear notes that Fellini was interested in working with Dalí but found him too unreasonable;[8] probably many others felt the same way.

But the story of Dalí and cinema should not be regarded only as a chronicle of failures. Though most of his scenarios weren't realised, a cursory glance at his manuscripts reveals a sophisticated understanding

of film's capabilities and, above all, the same profound imagination that permeated all his endeavours – in writing, painting, illustration, sculpture and theatre design. Even when they were not made, Dalí's cinematic visions boast sufficient intrinsic interest to justify a thorough examination – one that merits a greater depth than that which I have begun in the pages that follow, though I hope this will contribute to the discourse by introducing a wider audience to Dalí's lesser-known scenarios. One may note that I've made a special point of detailing his 'later films', when television became a more dominant medium for him than true cinema; these projects are frequently overlooked when one thinks of 'film', but judging from how Dalí used television, they certainly warrant acknowledgement.

For their help unpacking these and other Dalínian forays, I would like to extend my sincere thanks to the people who took time to speak with me about their first-hand experience with Dalí and the cinema: Leonardo Balada, Robert Descharnes and Amanda Lear. For their help in realising this book, I would like to thank my editor Hannah Patterson, as well as Dawn Ades; Montse Aguer and the Centre d'Estudis Dalínians at the Fundació Gala-Salvador Dalí; Carol Butler, William Jeffett and Joan Kropf of The Salvador Dalí Museum (St Petersburg, FL); Robert and Nicolas Descharnes; Christopher Jones and Michael Taylor. I also owe enormous gratitude to June and Dale King and Mary Alice and Garth Haigh for their unwavering support, and to Emily King, *follement aimée*, for her careful proofreading and for her love and understanding as I continue to fill our home with books and assorted 'soft watch' paraphernalia.

ART AND ANTI-ART

Salvador Dalí was born on 11 May 1904 in the Catalan town of Figueres on the Empordá plain. As a child, Dalí rarely shone as a student, though he exhibited extraordinary imagination and artistic prowess. His father, Salvador Dalí i Cusí, the town notary, hoped his son's future would also be that of a bureaucrat, but the young Salvador was far more interested in painting and making a general spectacle of himself. In September 1922, at the age of 18, Dalí began his art studies at the prestigious *Residencia des Estudiantes*[1] – the 'Resi', as it was known – and soon met two figures who would change his life: a strapping young engineering student from Aragón, Luis Buñuel (1900–1983), and a handsome and charismatic poet from Andalusia, Federico García Lorca (1898–1936).

The intellectual activity that was galvanised between Dalí and his friends profoundly affected the young painter in various areas, amongst them the realm of cinema. Dalí's friends were avid film-goers – like the Surrealists in Paris, they adored Hollywood silent comedies starring Charlie Chaplin, Buster Keaton and Harry Langdon. It was also at the 'Resi' where Dalí and his cohorts discovered the translated works of Sigmund Freud and Isidore Ducasse's sadistic novel, *The Songs of Maldoror*, both of which were to make a lasting impression on Dalí.

One of the most important attitudes to develop out of the 'Madrid period' was Dalí's position on so-called 'anti-art'. Despite its name, 'anti-art' was not against art: Rather, Dalí sought to distinguish between 'authentic art' – that which he admired that pushed the boundaries of

the avant-garde, created by the likes of Picasso, Joan Miró, Juan Gris and Jean Arp, for example – and the half-hearted modernity he castigated the establishment for promoting. Dalí's most direct statements on anti-art emerged in 1927, though one spies its roots in his earlier relations with Lorca and their development of the *'putrefacte'*, a quasi-Dadaist inside joke that attacked various esteemed Spanish personages who were respected in the fields of art and literature but whom Dalí and Lorca considered overly conventional and bourgeois. The duo ascribed to such fetid luminaries a quality of putrescent formlessness, contrasting the mathematical clarity they admired that they called 'astronomy'; they even began planning a *Book of Putrefaction*, though it never materialised: It seems Dalí finished his contributions but Lorca failed to produce a preface. Amongst the most heavily attacked *'putrefactes'* was the Spanish poet Juan Ramón Jiménez, whom Dalí declared the 'Head of the Putrescent Philistines of Spain'.[2] Dalí had previously enjoyed Jiménez's work and had even sent him two drawings in 1925, but by 1927 the Catalan painter's 'anti-art' attitude had become more militant. He took special offence to Jiménez's *Platero y Yo*, a sentimental tale recounting the idyllic travels of a poet and his faithful donkey companion, Platero. In the story, Platero eventually passes away from eating a poisoned root and is buried in a flowering orchard. As Dawn Ades observes, this scene must have inspired Dalí's recurring depiction of the rotting donkey in such works as *Honey is Sweeter Than Blood* (1927) and *The Rotting Donkey* (1928) – an image that would become famous in 1929 with *Un Chien Andalou*.[3]

The cinema was an ideal instrument for Dalí's anti-art platform: Not only did it readily lend itself to the visual effects that interested him, but, moreover, it was absolutely modern and accessible by the masses. Presaging ideas that would motivate Pop Art in the 1960s, Dalí embraced the 'vulgar' manifestations of cinema – specifically Hollywood slapstick, which he, like Buñuel, considered the cinema's greatest poetic accomplishment[4] – that stood in opposition to 'high art'. '"Artistic"', Dalí wrote to the art critic Sebastià Gasch, '– horrible word that only serves

to indicate things totally lacking in art. Artistic performance, artistic photography, artistic advertisement, artistic furniture. Horror! Horror! What we all like, on the other hand, is the *purely industrial* object, dance-halls and the quintessential poetry of Buster Keaton's hat'.[5]

Another important aspect of Dalí's work linked to the cinema that developed during this period was his enthusiasm for 'naturalism'. In October 1927, the artist exhibited two pictures, *Honey is Sweeter Than Blood* and *Apparatus and Hand* (both from 1927), in the Barcelona Saló de Tardor (autumn salon); both were hailed by critics as 'Surrealist', though at the time Dalí was unwilling to accept this label and answered that they were more accurately 'anti-artistic and direct': 'My painting is wholly and marvellously understood by children as well as by the fishermen of Cadaqués', he wrote, suggesting that his paintings were simple and straightforward as opposed to 'artistic' works that were intellectual and complex.[6] Dalí referred readers to his article, 'La fotografia, pura creació de l'esperit' ('Photography, Pure Creation of the Spirit'), published in the 30 September 1927 issue of *L'Amic de les Arts*, in which he emphasised the importance of seeing things afresh and praised the objective power of the camera: 'Let's be content with the immediate miracle of opening our eyes and being dextrous in the apprenticeship of proper looking', he wrote.[7] Dalí lauded the Dutch painter Jan Vermeer, whose eyes he declared 'the case of the highest probity', an idea that would influence him much later when, in the 1970s, he would compare Vermeer to the contemporary American Hyperrealists.

Other resonating concepts in 'Photography, Pure Creation of the Spirit' included the observation that, through a simple change in scale, photography could provoke the most unusual similarities and analogies: a cow's eye could readily become a landscape with a light overcast, Dalí observed – an example Dawn Ades has traced to publications like László Moholy-Nagy's book *Painting, Photography, Film* (1925), in which a photograph zoomed in on an eye, creating an abstract image from an otherwise identifiable subject.[8] Like the poet Louis Aragon, who in 1918

observed that in the cinematic close-up an object is given over to the world of the fantastic – 'On the screen objects that were a few moments ago sticks of furniture or books of cloakroom tickets are transformed to the point where they take on menacing or enigmatic meanings'[9] – Dalí immediately recognised the potential the close-up offered for distorting reality. Later in 1927, in the December issue of *La Gaceta Literaria*, Dalí authored another article, 'Film-arte, film-antiartístico' ('Artistic Film, Anti-Artistic Film'), in which he observed that, thanks to the faculties of close-up, a lump of sugar could loom on the screen as large as a city, while Vermeer's painting *The Lacemaker* (1669–1670) – a relatively small canvas – could become grandiose.

I introduce these ideas here because they recur over and over again in Dalí's dealings with film. His fascination with the close-up as a means of looking at objects anew was introduced in the 1920s, but it would arguably not fully come into its own until 1975, when his film *Impressions of Upper Mongolia – Homage to Raymond Roussel* launched all its action from the microscopic scratches on a ballpoint pen. His contemporaneous interest in the capabilities of photography to capture a subject 'naturally', but through simple effects transform it into something altogether unexpected, was another aspect that would take precedence in his work in forthcoming years, particularly in the development of 'critical paranoia'. Of course, influences introduced after the 1920s had their impact on Dalí's vision of the cinema too – most profoundly, Surrealism. But, through it all, he never gave up on the ideas he forged in the 1920s – that is, those views that very nearly led him to pursue film and photography instead of painting.

'C'EST UN FILM SURRÉALISTE!'

While *Un Chien Andalou* is now widely considered the quintessential Surrealist motion picture – in 1929, Buñuel even went so far as to declare in the pages of the Surrealist periodical *La Révolution surréaliste* that *'Un Chien Andalou* would not exist if Surrealism did not exist'[1] – in the years leading to its inception Dalí was, as we have seen, *resistant* to Surrealism (in 1927 the art critic Sebastià Gasch labelled Dalí 'the archetypal anti-Surrealist', adding, 'Nobody loathes Surrealism as thoroughly as Dalí'![2]). *Un Chien Andalou* is arguably Surrealist in many ways, but in exploring its irrational storyline it is good to keep in mind that it was also heavily indebted to the 'anti-art film' Dalí ideologically developed in the late 1920s, spurred by Buñuel and Lorca, Joan Miró's 'assassination of painting' and his own growing dissatisfaction with the Catalan avant-garde; much later this 'anti-art' attitude would inform *The Wheelbarrow of Flesh* (1948–1954) and *The Prodigious Story of the Lacemaker and the Rhinoceros* (1954–1962), both of which Dalí would describe as completely contrary to artistic, experimental film.

Un Chien Andalou, 1929

In the opening to his 1964 self-promotional journal, *Diary of a Genius*, Dalí expressed the benefits he perceived to wearing shoes that were too tight: 'The painful pressure they exert on my feet enhances my oratorical capacities to the utmost.'[3] One wonders, then, about the state of his feet in 1928, when – according to his account, anyway – he

penned the then-untitled script for what would become his most cele-brated contribution to the cinema, *Un Chien Andalou* (*The Andalusian Dog*) (1929); he had just purchased a new pair of shoes, he later recalled, and he wrote a very short scenario on the shoebox lid that 'went completely counter to the contemporary cinema.'[4]

Around the same time, the 28-year-old Luis Buñuel, one of Dalí's closest friends and soon to become one of the twentieth century's most celebrated directors, was preparing a film entitled *Caprichos*, based on a series of short stories by the Spanish writer Ramón Gómez de la Serna. Buñuel envisioned a man reading a newspaper from which Gómez de la Serna's short stories would appear animated in different sections. Buñuel's mother had already agreed to loan the 60,000 francs needed to finance the picture, but Gómez de la Serna had yet to come up with the promised screenplay. Dalí wasn't impressed with the idea at all, which he subsequently described as 'extremely mediocre' and avant-garde 'in an incredibly naïve sort of way';[5] he, on the other hand, had his shoebox scenario, which, he declared immodestly, 'had the touch of genius'![6]

Buñuel was impressed, recognising in Dalí's scenario some affinities with Surrealism, the intellectual movement with which Buñuel had recently made contact in Paris. The term *surréalisme* was coined by Guillaume Apollinaire in 1917 and was thence taken up in 1924 by a group of politically-minded intellectuals in Paris led by the poet André Breton (1896–1966). Surrealism sought to unleash the potential of the unbridled mind – a mission reflected in the definition of Surrealism put forth in the *Surrealist Manifesto* (1924): 'Pure psychic automatism, by which one proposes to express, either verbally, or in writing, or by any other manner, the real functioning of thought.' This endeavour initially limited the Movement to the realm of writing – unsurprising given that its founders were all chiefly poets. In these embryonic years, painting and other visual arts were not considered sufficiently 'automatic' to authentically fulfil the Surrealists' aims of tapping the subconscious. This prejudice ultimately gave way, however, as artists such as André

Masson, Joan Miró and Man Ray persuasively applied the Surrealists' ideology to their visual work.

As the Surrealists' scepticism about painting waned, they became increasingly enthusiastic over the prospects of film, which had already proven a popular vehicle for the Dadaists (of which Breton had also been a member). The reasons were clear:

The only truly modern art form, it was unhampered by tradition; its immediacy and emotive power offered fertile ground for the surrealist metaphor; its condemnation by the establishment as immoral and corrupting clearly enhanced its potential for social revolt and the expression of sexual fantasy; its perceived similarities to the state of dreaming seemed ready-made for the surrealists' own exploration of dreams and subconscious desires.'[7]

The Surrealists were zealous movie spectators: Breton and his friend Jacques Vaché would often wander from one theatre to the next, buying tickets for anything that was showing and then exiting the film halfway through, 'relishing the visual collage thus put together in their heads as if it were a single film.'[8] For the Surrealists, cinema was an intermediary state between life and dream – not a means to escape reality but to intensify it. The Surrealist Philippe Soupault recalled, 'One can think that, from the birth of Surrealism, we sought to discover, thanks to the cinema, the means for expressing the immense power of the dream.'[9]

But despite the Surrealists' enthusiasm for others' films, they were having difficulty conceiving 'automatic' films of their own; those made by Man Ray and Antonin Artaud failed to live up to the Group's aspirations. They needed a catalyst, not only to launch Surrealism into the realm of cinema but also to expand its international scope. The climate was opportune for Buñuel, who had come to Paris in 1925 with the idea of becoming a diplomat; when this fell through, he secured an apprenticeship with the renowned French director Jean Epstein, notably serving as assistant director on Epstein's acclaimed adaptation of Edgar

Allan Poe's *La Chute de la maison Usher* (1928). He began frequenting the Café Cyrano in the Place Blanche where the Surrealists routinely held meetings, and by January 1929 he was a fully-fledged member of the Group. Now Dalí's script was his opportunity to truly bring Surrealism to the silver screen.

Buñuel spoke to Dalí about his shoebox script and made plans to travel to Figueres in February 1929 to work over the scenario. 'The aim is to produce something absolutely new in the history of the cinema', Buñuel told the newspaper reporter Josep Puig Pujades, who disseminated news of the film in *La Veu de l'Empordà*. 'We hope to make visible certain subconscious states which we believe can only be expressed by the cinema.'[10] Writing took only six days and was, according to both, a quick and joyful collaboration, while their attempt to expel reason in favour of whatever wild fantasies came into their heads was readily comparable to the automatic writing the Surrealists championed. Buñuel recalled:

> We wrote with minds open to the first ideas that came into them and at the same time systematically rejecting everything that arose from our culture and education. They had to be images that would surprise us and that we would both accept without discussion. Nothing else. For example: The woman seizes a racket to defend herself from the man who is about to attack her. And then he looks for something to counterattack with and (now I'm speaking to Dalí) 'What does he see?' 'A flying toad.' 'No good.' 'A bottle of brandy.' 'No good.' 'Well, he sees two ropes.' 'Good, but what's on the end of the ropes?' 'The chap pulls on them and falls because he's dragging something very heavy.' 'Well, it's good he falls down.' 'Attached to them are two dried gourds.' 'What else?' 'Two Marist brothers.' 'That's it! Two Marists. And then?' 'A cannon.' 'No good.' 'Let's have a luxury armchair.' 'No, a grand piano.' 'Very good, and on top of the grand piano a donkey – no, two donkeys.' 'Wonderful.' Well, maybe we just drew our irrational representations with no explication...[11]

In the end, it is impossible to know just who was responsible for what images in the film, though the collaborative effort of the two suggests that this was anyway meant to be a moot point (and might have stayed so had Dalí and Buñuel not experienced a falling out after *L'Âge d'Or* [1930], leading each to claim the best parts of the film for himself and blame the rest on the other!). It is also unclear to what extent Dalí had already conceived the film's storyline on the shoebox – indeed, no trace of this first script has actually surfaced, leading some to doubt its existence and the validity of Dalí's claim to have written the first scenario at all. Buñuel later described the film's origin as the product of two dreams – his about slicing an eye with a razor, and Dalí's about a hand festering with ants.

In April 1929, Dalí convinced his father to give him the money to travel to Paris to assist Buñuel in realising their film. Buñuel hired a studio at Billancourt, a cameraman and two professional actors, Simone Mareuil, and the French silent movie star Pierre Batcheff. Shooting took two weeks, though Dalí was apparently present on the set for only one of the last days, when he spent most of his time preparing the two donkeys that would form one of the most memorable scenes.

Un Chien Andalou catapulted to become the most famous short ever made. As American film critic Roger Ebert notes, '[A]nyone halfway interested in the cinema sees it sooner or later, usually several times',[12] and in July 2006, *Radio Times* ranked it amongst the top 25 must-see movies for aspiring cinema buffs. It has become the stuff of pop culture, too: During his 1976 tour, rock star David Bowie screened *Un Chien Andalou* as his opening act (much to the audience's bafflement), and it later inspired the Pixies' 1989 song *Debaser* ('Got me a movie / I want you to know / slicing up eyeballs / I want you to know / girlie so groovy / I want you to know / don't know about you / but I am un chien andalusia').

So, after all this pomp and praise, what is *Un Chien Andalou* about? That's a difficult question, as the film eschews any lucid storyline. It opens with the idyllic fairy-tale cliché, 'Once upon a time'. Against the background staccatos of an Argentinian tango, Buñuel is seen methodi-

cally sharpening a razorblade as he puffs at his cigar. He tests the blade on his thumb, then steps onto his balcony. When a thin cloud cuts across the full moon overhead, he returns inside and slits open Simone Mareuil's left eye – in fact a calf's eye, though the effect is startlingly effective.

The attack against the eye – possibly inspired by Benjamin Péret's 1928 poem *Les arômes de l'amour* ('What greater pleasure / than to make love / the body wrapped in cries / the eyes shut by razors')[13] – never fails to solicit gasps of horror from audiences, even today. Perhaps one imagines one's own eyeball sliced open with horrific exactitude, or perhaps it is the unexpected impact the scene has without any development whatsoever. We are given no time to prepare: We don't know anything about this woman's past nor about what might have led Buñuel to dissect her eye, particularly in light of her *non sequitur* placidity.

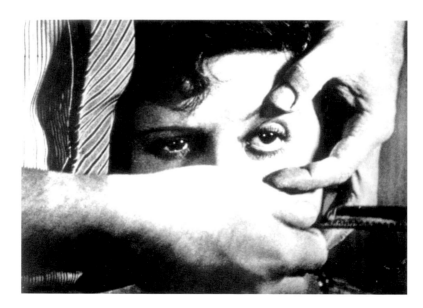

Opening scene of *Un Chien Andalou*, 1929. Directed by Luis Buñuel; Produced by Luis Buñuel. ©Video Yesteryear/Photofest.

Further, nothing develops from this grotesque mutilation. The spectator cannot help fashioning a chronological continuity between the slashed eye and what follows, but this is a fallacy – indeed, her ostensibly unprovoked attacker never appears in the film again, and the next episode – introduced, 'Eight years later' – finds the heroine's eye inexplicably intact. Almost as if it's a different film, the script turns to Batcheff riding a bicycle down a Paris street. He is dressed in a dark suit, over which he wears feminine frilly cuffs and a skirt, a collar and a hat with large white wings that blow backwards as he rides; he has a strange box tied around his neck, which reappears throughout the film. Cut to Mareuil, who is sitting in her third-floor flat reading a book. Apparently struck by a sound outside, she throws down the book – which falls open to an illustration of Jan Vermeer's painting, *The Lacemaker* – and goes to the window just in time to see Batcheff arrive and, without the least resistance, fall off his bicycle into the gutter.

Mareuil runs down to meet him. She kisses him passionately, then brings his garments upstairs (what has happened to him remains a mystery) and lays them out on her bed in the form of a body. She then sits down and concentrates on the clothes as if she expects something to manifest: The trick is effective and the man appears, though not on the bed but on the other side of the room. He is completely absorbed by a hole in the centre of his outstretched right hand that is leaking a colony of ants. From this, the scene dissolves into a hairy armpit, a spiny sea urchin, and a severed hand resting strangely on the ground amidst a bustling crowd viewed from above that gives it no notice, save a woman with a close-cropped hairstyle who pokes the hand curiously with a stick. A policeman approaches, puts the hand in the box formerly carried by Batcheff, and gives it to the woman; she clutches it closely to her breast in the middle of the road, seemingly uncertain of where to turn next, until she is struck dead by a passing automobile.

Batcheff and Mareuil have observed all this from their flat window. Strangely aroused, Batcheff begins chasing Mareuil around the room. As he caresses her, another sequence of dissolves is set in motion as her

breasts become her buttocks, both clothed and bare. Batcheff's eyes roll back into his head as if experiencing some sort of seizure or perhaps even a profound ecstasy; his mouth trickles blood and is transformed into an anus. Mareuil breaks away and attempts to fend off her assailant with a tennis racket. As Batcheff makes his way towards Mareuil, he takes up two ropes, each of which is tied to a cork followed by a melon, a Catholic priest and a grand piano containing the cadaver of a putrescent donkey, which Dalí took special care to prepare by removing the eyes and cutting back the lips so that the teeth would reflect the same whiteness as the piano keys. The woman rushes into the adjoining room but, as she closes the door, the man sticks his ant-infested hand through the frame. Suddenly the two are in the same room again: The man is lying quietly in bed.

The next caption reads 'About three o'clock in the morning', perpetu-

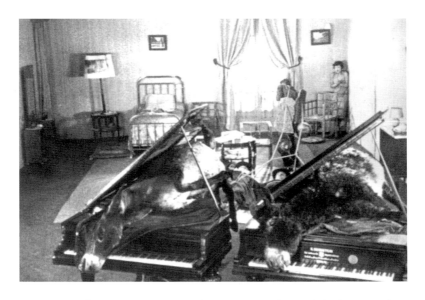

Pierre Batcheff pulls two pianos, each containing a deceased donkey. *Un Chien Andalou*, 1929. Directed by Luis Buñuel; Produced by Luis Buñuel. ©Kino/Photofest.

ating the false chronology. An impatient stranger – also played by Batcheff and thus suggesting the heroic double to the frilly-frocked cyclist, or perhaps an older version of the character raging war against a less mature self – breaks into the room and throws the cyclist's belongings out the window before ordering the cyclist to go stand in the corner. Another caption appears – 'Sixteen years earlier' – but the scene returns to the two men, unchanged. The heroic Batcheff takes a pair of books from a school desk and hands them to the cyclist to hold in his outstretched arms like a crucifix to continue the punishment, but the books suddenly turn into pistols and the heroic Batcheff is shot dead by his *doppelgänger*. As the heroic Batcheff collapses face-down, a dissolve sends him to a sunny park; his hand grazes the naked back of a young woman sitting beside him. A small crowd gathers, and a group of male park-keepers carry him off in a funerary procession.

The camera returns to Mareuil sitting alone in her flat. She stares at a death's head hawkmoth – a species of moth native to the Mediterranean and Middle East and a notorious symbol of bad luck thanks to the shape of a skull that appears on its thorax – on the opposite wall. Again, 'evil Batcheff' appears. He puts his hand to his face and, upon removing it, reveals an absent mouth, to which Mareuil responds by adorning her own mouth with lipstick. Batcheff's mouth thence sprouts hair – apparently somehow stolen from Mareuil's underarms. Exasperated, she sticks out her tongue, throws on a shawl and marches out through the door, which opens onto a windy beach. A new lover is there waiting for her. He motions at his watch, and Mareuil rushes towards him happily. It seems the new couple will live 'happily ever after', complementing the film's opening, 'Once upon a time', but the final shot turns their fate sour: Following the caption, 'In the spring', the woman is shown buried up to her chest in sand. She is blinded, her clothes are tattered, and she is burned by the sun and plagued by insects; a man is there with her too, though it is unclear whether it is Batcheff or her mysterious lover. The film ends.

Un Chien Andalou indubitably offers much for would-be interpreters,

though it is unclear whether meaning itself might be the film's greatest 'red herring'. Buñuel offered, '*Nothing* in the film *symbolises anything*', adding that '[t]he only method of investigation of the symbols would be, perhaps, psychoanalysis'[14] – recalling that Breton later considered Dalí one of the most erudite Surrealists when it came to Freud. Psychoanalysis is indeed the lens most have applied towards understanding *Un Chien Andalou*, though many others have approached it from alternative directions as well. I will not add my own interpretation to this already hefty bibliography, but to highlight Roger Ebert's observation that one struggles in vain to create a story out of *Un Chien Andalou* where one simply might not be present:

> Countless analysts have applied Freudian, Marxist, and Jungian formulas to the film. Buñuel laughed at them all. Still, to look at the film is to learn how thoroughly we have been taught by other films to find meaning even when it isn't there. Buñuel told an actress to look out the window at 'anything — a military parade, perhaps.' In fact, the next shot shows the transvestite falling dead off the bicycle. We naturally assume the actress is looking at the body on the sidewalk. It is alien to everything we know about the movies to conclude that the window shot and the sidewalk shot simply happen to follow one another without any connection. In the same way, we assume that the man pulls the pianos (with the priests, dead donkeys, etc.) across the room because his sexual advance has been rebuffed by the woman with the tennis racket. But Buñuel might argue the events have no connection — the man's advance is rejected, and then, in an absolutely unrelated action, he picks up the ropes and starts to pull the pianos.[15]

This view that the scenes may only *happen* to suggest cause and effect is very Surrealist, indeed. It's the enduring enigma of *Un Chien Andalou*: Is there meaning in the film's ostensible – and purported – meaninglessness? Even its title is an enigma: In an early letter to his friend José 'Pepín' Bello, Buñuel wrote that this 'stupendous scenario, quite without

precedent in the history of cinema' was to be titled *La Marista de la Ballesta* (*The Marist Sister with the Crossbow*) – a name that was quickly scrapped in favour of *Dangereux de se pencher en dedans* (*Dangerous to Lean Inside*), a joke based on the notices beneath windows in French train compartments ('*Dangereux de se pencher en dehors*' ['*Dangerous to lean outside*']). Dalí and Buñuel would eventually settle on *Un Chien Andalou*, a title the two invented – reportedly to much laughter – for a book of poems Buñuel was planning to publish that conspicuously contained no 'Andalusian dog'.[16] The book never made it to press, and the title was given to the film instead, which, again, had no dog.

Buñuel justified that *Un Chien Andalou* was a title without meaning for a film without meaning, but Dalí and Buñuel's former friend from the 'Resi', Federico García Lorca, thought otherwise. Lorca was indignant that the title and main character of the picture were veiled, derogatory references to him. Southerners at the *Residencia* were sometimes referred to jokingly as 'Andalusian dogs', and Lorca was the most famous Andalusian poet of the day. Ian Gibson also points out that certain scenes in *Un Chien Andalou* can be traced to Lorca's writing: The image of the protagonist falling off his bicycle, for example, Gibson identifies as a reference to Lorca's 1925 dialogue, 'Buster Keaton's Outing'.[17]

Buñuel famously reported that at the first screening of *Un Chien Andalou*, he carried stones in his pockets to hurl just in case the audience revolted; happily, this was not to be the case. Indeed, *Un Chien Andalou* was critically applauded and enjoyed a long run at Montmartre's Studio 28. But this popularity was less a gift than a challenge: Whilst the film ushered in Dalí and Buñuel's acceptance into the Surrealist group, it also meant that they would have to push the envelope further if they truly sought to shock their audience in the future. *Un Chien Andalou* had not scandalised the bourgeoisie like Dalí and Buñuel hoped it might: Next time, they would pull out all the stops.

L'Age d'Or, 1930

Following the surprising critical success of *Un Chien Andalou*, Dalí and Buñuel were encouraged to make a sequel – this time a longer picture that might capitalise on new technology and contain sound. Like its predecessor, this new film also went through some title changes: It was provisionally to be called *La Bête andalouse* (*The Andalusian Beast*), which it retained throughout shooting. Thereafter it changed to *¡abajo la Constitution!* ('*Down with the Constitution!*') and eventually to *L'Âge d'Or* (*The Golden Age*).

Un Chien Andalou was financed by Buñuel's mother; its sequel, however, would enjoy an unexpected patron: the wealthy nobleman Vicomte Charles de Noailles. Charles and his wife, Marie-Laure – a descendant of the Marquis de Sade – were interested in Surrealism and had already purchased paintings at Dalí's first solo exhibition in Paris at the Galerie Goemans. They were film enthusiasts, too, and had installed a private cinema in their mansion on the Place des Etats-Unis in Paris where they screened *Un Chien Andalou* for select audiences before its run at Studio 28, as well as Man Ray's *Les Mystères de château de dé*, which they financed. Charles was keen to endorse a full-length Surrealist movie with sound as a birthday present for Marie-Laure, and, when May Ray declined, he sought out Buñuel and Dalí.

Dalí's world had changed significantly since *Un Chien Andalou* in that he was now inseparable from one Helena Dimitrievna Diakonova – 'Gala', the wife of the poet Paul Éluard. Gala had become ensconced in the Surrealist movement through her husband and had already been the inspiration for many of its artists and writers when she met Dalí in 1929 on a visit to Catalunya; an affair quickly developed, and when Paul returned to Paris, Gala stayed behind with Dalí. When the invitation came from Charles de Noailles in November 1929 to make a full-length sequel to *Un Chien Andalou*, Dalí was simply too occupied with Gala and certain financial struggles to participate fully, so control of the project fell to Buñuel.

It is here where stories begin to differ: According to Buñuel, Dalí only sent him a few ideas for *L'Âge d'Or*, all of which were refused except for an image of a man walking in a park with a rock on his head.[18] Dalí meanwhile claimed that his participation – at least in the film's conception – was far greater (at least until 1942, when he essentially disowned the film in *The Secret Life of Salvador Dalí*, saying that all the film's sacrileges were Buñuel's ideas alone);[19] he sent Buñuel several angry letters in the early 1930s asserting that, if it weren't for him, neither *Un Chien Andalou* nor *L'Âge d'Or* would have come to fruition.

In light of Dalí's later unsavoury politics and commercial ventures, authorities were all too happy to accept Buñuel's account and give full credit for *L'Âge d'Or* to him alone – some even denied Dalí had played any pivotal role in *Un Chien Andalou*.[20] More recent scholarship, however, particularly by Spanish scholars led by the historian Agustín Sánchez Vidal, has given light to a more accurate version of the events. During the week of 29 November–6 December 1929, when Dalí and Buñuel were together in Cadaqués, many of the details for *L'Âge d'Or* were indeed worked out collaboratively, though Buñuel's mounting jealousy over Gala's distracting relationship with Dalí meant the duo were at great pains to rekindle the chemistry they had achieved writing *Un Chien Andalou*. When Dalí wrote to Buñuel with subsequent ideas between January and March 1930 from the Hôtel du Château at Carry-le-Rouet, a small spa near Marseille where he was staying with Gala, it is clear that he was completely apprised of the sequences: He suggested showing the man walking towards the camera with his fly undone, for example. Other ideas were modified by Buñuel in the finished film: Dalí had recommended that there be a love scene in a garden in which the man, kissing the woman's fingertips, bites off one of her fingernails – an effect he suggested could be achieved using a paper nail affixed to a false hand; 'this element of horror *I think terrific*, much stronger than the severed eye', he wrote.[21] Buñuel had *the woman* passionately bite *the man's* hand, and later filmed an actual mutilated hand missing all its fingers. Dalí also suggested that they recuperate donkeys and pianos

and include the cinema's first image of a vagina, which, he wrote, might be superimposed onto a woman's mouth – the next step from Pierre Batcheff's mouth transforming into underarm hair in *Un Chien Andalou*, one supposes; Buñuel wasn't interested.

One of the more innovative ideas to come from Dalí's brainstorming sessions for *L'Âge d'Or* was his description of 'tactile cinema'. In Dalí's theatre, each member of the audience would have a roller attached to the chair in front that would be synchronised with the film so that one could literally 'touch' objects presented on the screen (for example, hair implants might correspond to the vagina scene; rubber breasts might appear during a scene where a character's breasts are caressed; hot water could spray on the audience's hands during a scene when a bidet is running). The final effect might have been somewhat akin to late night screenings of *The Rocky Horror Picture Show*, when enthusiastic audience members wear newspaper hats during rain scenes – but inside Dalí's theatre, it would actually have rained!

From these examples, it can be concluded that Dalí's participation in the conception of *L'Âge d'Or* was far greater than Buñuel – or even he – later admitted. At the same time, it is sure that the final product can reasonably be credited more to Buñuel: Dalí was altogether absent during actual filming, which began on 3 March 1930 at Billancourt. On 31 March, Buñuel recorded the spoken scenes in the Tobis studios, and on 2 April used their lorry to film the spoken scenes in the street; from 5–9 April, he shot the exterior scenes at Cap de Creus, just outside Cadaqués (and in Dalí's absence, as Dalí had by this time been expelled from his family home for his painting *Sometimes I Spit with Pleasure on the Portrait of My Mother*, a blasphemous work that his father took as an insult to his deceased wife, Dalí's mother; his father had reportedly threatened to have him arrested if he ever returned to Cadaqués). On 22 April editing began, and the silent version was finished by 24 May. The soundtrack was added the following month, with the finished picture ready for screening by 1 July.

The 350,000-franc budget with which the film had begun had, in the

end, inflated to about 750,000 – about 12 times the budget of *Un Chien Andalou*. Happily, though, Charles de Noailles' generosity had allowed Buñuel to realise nearly every scene he desired. The film opens with a scientific documentary on scorpions. Then, following the caption *'Quelques heures aprés'* – 'A few hours later', recuperating the false chronology established by *Un Chien Andalou* – the scene changes to an armed bandit watching a group of archbishops nestled amongst the rocks of Cap de Creus. The bandit runs to tell his friends about the nearby 'Majorcans' – apparently the archbishops. After walking for what seems an eternity through the mineral landscape, the bandit arrives at the cabin, where – to the background music of Beethoven's Fifth Symphony – he finds his cohorts, led by a devious-looking character played by Max Ernst, in a strange state of depressive boredom and fatigue. Hearing the news that the Majorcans are near, they take up their weapons and leave, with the exception of the youngest, Peman, who says he cannot go: He's done for, he explains, adding incoherently that the others have accordions, hippopotamuses, wrenches, mountain goats and paintbrushes. The band sets off, but, one after the other, everyone collapses from exhaustion.

Meanwhile, a great seaborne concourse arrives. All make their way through the rocky alcoves to the bishops, but they are now only skeletons scattered amongst the rocks. A cornerstone founding Imperial Rome has been placed on the spot where their remains rest. As a moustachioed diplomat begins to make the announcement, the crowd is distracted by a couple – the film's protagonists, we discover – in an amorous fray amongst the rocks. They are pulled apart, and each is dragged away; the unnamed man (played by Gaston Modot) manages to kick a small white dog and crush a beetle underfoot as he is apprehended, demonstrating his cruelty.

The film turns to images of modern Rome: aerial shots of the Vatican, sequences of demolished buildings, a shot of a man kicking a violin down the street, and another of a man walking with a large stone on his head – the sole scene Buñuel had credited to Dalí. Modot is still being led by

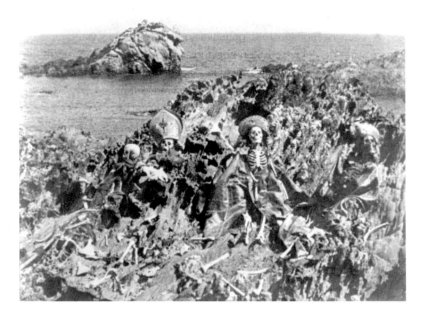

The skeletal remains of the 'Majorcans' on the rocks of Cap de Creus. *L'Âge d'Or*, 1930. Directed by Luis Buñuel; Produced by Vicomte Charles de Noailles. ©Photofest, Inc.

two men through the busy city streets. Everything he passes provides him with sexual stimulation – it would be hard to find a more morally corrupt individual. Then he produces some paperwork for his captors: It seems he is a special delegate for the International Goodwill Society! He is released, though his temperament remains the same: As he hails a taxi, he delivers a severe kick to a passing blind man. From this moment on, all his efforts are directed towards finding his lost love (Lya Lys).

Shift to a party hosted by the 'Marquis of X' – father to the female protagonist – at his Roman estate. A number of curious spectacles occur here: The Marquis is seen covered with flies, a horse-drawn carriage is rolled through the ballroom, and a fire breaks out in the kitchen causing the maid to collapse (though no one takes notice). Modot arrives and spots his love, though they are kept apart by the other guests. When the

Marchioness spills a drink on Modot's tuxedo, he attacks her and is thrown out of the party. Modot and Lys meet in the garden where Modot begins to ravage her, but they are interrupted by a porter telling Modot that the Minister of the Interior is on the phone for him. Modot goes to the telephone, where the Minister accuses him of abandoning his task: thousands of elderly people and innocent children have perished as a result of his carelessness. Modot greets this accusation with insults and, refusing to listen anymore, returns to his beloved. As they embrace, an orchestra plays the theme from Wagner's *Tristan and Isolde*. At the music's climax, the conductor stops the orchestra and, holding his head, locates the couple in the garden. Lys runs to him, kissing him passionately. Modot mournfully races to her bedroom and, in a fit of rage, defenestrates a flaming pine tree, an archbishop, a giraffe and several handfuls of feathers.

The love story between Modot and Lys ends there, but the remaining final scene is by far the most jarring: The viewer is transported to the secluded Château of Selligny, where, in the spirit of the Marquis de Sade's *120 Days of Sodom* – a nod to Marie-Laure de Noailles' lascivious relative – a group of aristocrats has gathered for a murderous orgy. The surviving men leave by the snow-covered drawbridge, led by the 'Count of Blangis', who is clearly Jesus Christ. A woman caked in blood falls from the doorway, but the Count escorts her back inside and, following a scream, emerges again, clean-shaven. The final image shows the scalps of the deceased women hanging grotesquely from the Cross.

The 63-minute picture premiered on 22 October at the Cinéma du Panthéon before an exclusive audience; the 300+ guest list included everyone who was anyone in Paris' artistic circles: Picasso, Jean Cocteau, Marcel Duchamp, Man Ray, Gertrude Stein, André Malreaux, Georges Bataille, Pierre Batcheff, Le Corbusier, etc., though the reception was 'icy'. 'Many of the guests quit the auditorium in great haste and hardly even bothered to say goodbye to their hosts.'[22]

· The first public screening was at Studio 28 – much to Buñuel's disappointment, as he had unrealistically hoped *L'Âge d'Or* might show on the

big commercial screens on the Champs Elysées. Jean Mauclair, the owner of Studio 28, invested a large sum of money equipping the theatre for a sound film and, to encourage interest, organised an exhibition of Surrealist artworks in the foyer that included Dalí, Miró, Tanguy, Ernst, May Ray and Jean Arp. Screenings began on 28 November, by which time Buñuel was in Hollywood; in his absence, Dalí wrote a programme leaflet in which he claimed sole responsibility for the screenplay, though Breton pushed him to say that it had been written with Buñuel.[23]

Six days into the run, on 3 December, the cinema was attacked by militants from two right-wing extremist groups, the *Ligue des Patriotes* (the League of Patriots) and the *Ligue Anti-Juive* (the Anti-Semitic League), who shouted, 'We'll show you that there are still Christians in France!' and 'Death to Jews!' before throwing ink on the screen, filling the space with smoke bombs and destroying most of the artworks on exhibition – in all, causing about 80,000 francs' worth of damage.[24] A week later, the censorship board banned the film for 50 years.

Charles de Noailles bore most of the responsibility for the disaster in the eyes of the press – he was expelled from the Jockey Club and even threatened with excommunication. Studio 28 was also scolded, as was Dalí for writing the programme leaflet; ironically, Buñuel's part as director went largely unmentioned. Dalí later recounted:

As we had anticipated, Buñuel had betrayed me by selecting to express himself with images that reduced the Himalaya of my ideas to little folded paper dolls. *L'Âge d'Or* had become an anticlerical, irreligious picture. Buñuel had taken over the most primitive meanings of my way-out ideas, transforming them into associations of stuttering images without any of the violent poesy that is the salt of my genius. All that came to the surface here and there out of my butchered scenario were a few sequences he had been unable not to bring off, since my staging directions had been so detailed. And they were enough to gain him a personal triumph. With admirable opportunism, Buñuel left Paris for Hollywood on the eve of the Paris premiere. Three

days later, Studio 28, in which *L'Âge d'Or* was shown, was a wrecking site.[25]

Charles de Noailles might have expected such a film from Dalí and Buñuel: After all, the Vicomte owned one of Dalí's most celebrated scatological paintings, *The Lugubrious Game* (1929). In the wake of the protests and censorship over *L'Âge d'Or*, however, he sent Buñuel a telegram asking that all circulating copies of the film be collected, adding that he would prefer that his name no longer be mentioned in connection with it; Buñuel responded with a polite note of compliance, and Charles never financed another film (as a result of the *L'Âge d'Or* scandal, the other 1930 film the Vicomte had supported, Cocteau's *Le sang d'un poète*, was suppressed for two years).

The Surrealists were meanwhile galvanised by the scandal, which they interpreted as indicative of the rise of fascism in France. *L'Âge d'Or* became emblematic of the Group's revolutionary credentials; as Robert Short writes, 'If *Un Chien Andalou* stands as the supreme record of Surrealism's adventures into the realm of the subconscious, then *L'Âge d'Or* is perhaps the most trenchant and implacable expression of its revolutionary intent.'[26] On the heels of the riot at Studio 28, the Surrealists published a four-page brochure, 'L'Affaire de "L'Âge d'Or"', signed by 16 members, in which they declared the scandal to be a demonstration that Surrealism was revolutionary and altogether incompatible with the accepted morals of bourgeois society. At a time when the Surrealists were taking a stance against Fascism in Europe by reconciling their intentions with the politics of the French Communist Party – even changing the name of their publication from *La Révolution Surréaliste* (*The Surrealist Revolution*) to *Le Surréalisme au service de la révolution* (*Surrealism in the Service of the Revolution*) – *L'Âge d'Or* was proof that the Surrealists were politically engaged and against all that was held dear by the conservative Right.

Although Dalí signed 'L'Affaire de "L'Âge d'Or"', he later criticised the film's anticlericalism as part of his campaign to present himself as

fervently anti-Communist in the wake of Franco's victory in the Spanish Civil War and his own meteoric rise to fame in America where Communist sympathies were increasingly viewed with suspicion. Whilst Dalí had his fair share of run-ins with the French Communist Party in the early 1930s, it should not be forgotten that at one time he indeed professed support for the radical Left: In his youth, he sided with the Bolsheviks in the Russian Revolution and was the only resident of Figueres who subscribed to the French Communist newspaper *L'Humanité*; in the same year he and Buñuel produced *Un Chien Andalou*, he wrote in his 28 June article 'Documental-Paris' that 'the Surrealist movement has always been, politically, an unconditional supporter and has always been for a long time incorporated in the Communist Party'[27], and in 1930, the same year *L'Âge d'Or* was made, he gave a lecture at the Anteneo in Barcelona that denounced family, religion and fatherland – that is, the platform of the conservatives. Whether he later wanted to admit it, Dalí at one time shared the Surrealists' revolutionary commitment, and the evidence of it in *Un Chien Andalou* and *L'Âge d'Or* did not emanate from Buñuel alone.

Of the three copies of *L'Âge d'Or* that were made, two were impounded by the police in Paris, while a third made its way to London where it was shown by Nancy Cunard. Charles de Noailles eventually recovered the negative and apparently kept it locked away with seven keys as a penance for financing such a blasphemous motion picture; in 1989, his heirs donated the negative to the Musée Nationale d'Art Moderne in Paris.

Five Minutes on the Subject of Surrealism, c. 1930–32

Having now become an official Surrealist – and a scandalising one at that – Dalí considered himself one of the Movement's foremost filmmakers and soon set to work planning a film documentary on Surrealism. The original shooting script (in French) is now preserved at the Scottish National Gallery of Modern Art in Edinburgh and, unlike many of his

other unrealised scripts from the period, was published prior to his centenary in 2004, by Dawn Ades in *Studio International* in 1982.[28] Ades situates the undated scenario to 1930–1932 based on Dalí's citation of his painting *Sleeping Woman, Horse, Lion* (1930) and his reference to a 'paranoiac' method as opposed to 'paranoiac-critical', as his technique would come to be known in 1933. Ian Gibson meanwhile reasons that the script might possibly predate *L'Âge d'Or*, as it quotes from the murder scene in *Un Chien Andalou* but makes no reference to Dalí's other film with Buñuel.[29]

The script's unofficial title, *Five Minutes on the Subject of Surrealism* (*Cinq minutes à propos du SURREALISME*), comes from the opening credits that present several questions the film aims to address: What is Surrealism? Who are the Surrealists? 'Surrealism can be practiced by everyone', Dalí writes. 'Pay attention to the poisonous and *deadly* images of *Surrealism*.' Although Dalí's written scenario is quite unorthodox in form – employing differently sized and styled fonts that strike a contemporary viewer as resembling a ransom note more than a film script – it is otherwise very clear in its division of narration, image and, when appropriate, sound. Dalí offers a surprisingly approachable entrance to Surrealist thought, beginning with the Movement's roots in Freudian psychoanalysis. He describes the division of the conscious and subconscious in the most basic of terms, as antagonistic forces as different as cold and hot, black and white. 'The human spirit could be compared to a tree', he writes in the film's narration, with the roots of the subconscious nourishing the leaves and fruit that emerge 'in the light of the conscious'. These roots, Dalí explains, develop according to the 'pleasure principle' – Freud's term for the Id's need for immediate gratification; when these roots emerge on the surface, however, they must follow the 'reality principle', the guiding force of the Ego that nego-tiates the Id's desires with the realities of the world. All this Dalí planned to illustrate with an animated drawing of a tree – suggesting already his predilection for cartoon animation.

Then Dalí introduces the Surrealists, whom he scripts as marching

one after another into a Métro station, each opening his umbrella as he goes underground. Dalí describes the Surrealists as rejecting all aesthetic and moral preoccupations, derived from the definition of Surrealism advanced in the Surrealist Manifesto of 1924; this is perhaps another clue that Dalí's script was written prior to 1933, as he would come into direct conflict with the Surrealists in 1934 over what he perceived as their failure to adhere to this definition when they censured as 'anti-revolutionary' his portrait of Vladimir Lenin with an elongated buttock in *The Enigma of William Tell* (1933). That year, Dalí's decision to exhibit *The Enigma of William Tell* at Paris' Salon des Indépendants – an exhibit the Surrealists had elected to boycott – forced him to endure a 'trial' by his peers, and he was only saved from formal dismissal from the Movement by his citation of the Surrealist Manifesto's definition; this, he argued, exculpated him from any images he might create, however deranged – provided they emanated from his subconscious.

A special section of Dalí's documentary is devoted to the Surrealist game, 'exquisite corpse' (*Cadavre exquis*). A sheet of paper is folded horizontally into four parts. The first 'player' takes the paper and, on the top quarter, draws an imaginary image corresponding to the head of a figure. It should be said that this did not have to be a true head: Indeed, some of the most inventive exquisite corpses have an unexpected object as part of their anatomy, such as a baby buggy or a trombone. After the first artist has finished the 'head', the paper is folded to hide what was just drawn and is passed to the second artist who draws the area of the arms and chest in similar, fantastic fashion. This is hidden from the third artist, who draws the legs, and passed to the last who draws the feet. When the last artist finishes, the paper is unfolded to reveal the resulting image, which Dalí accompanies in the soundtrack with uproarious, specifically *violent* laughter. This section not only reveals the method behind the Surrealists' game, but also implicitly illustrates their preoccupation with chance, a subject Dalí doesn't go into in any detail though he notes that the same 'exquisite corpse' method can be used to obtain poetic phrases, too. This is important, for although

Surrealism began as a strictly literary movement without any dimension in the visual arts, Dalí's documentary is almost entirely concerned with the Movement's pictorial output, which, as early as *Five Minutes on the Subject of Surrealism*, was already eclipsing its activity in the realm of poetry.

The sections devoted to the Surrealists' use of collage and to the Surrealist object are surprisingly short, particularly given their centrality to the Movement in the early 1930s. Indeed, it was primarily Dalí himself who battled for 'symbolically-functioning' Surrealist objects comprised of found materials specifically chosen for their psychological and fotishistic connotations. In his *Scatological Object Functioning Symbolically* (1931), for example, Dalí placed a glass of warm milk and a soft paste the colour of excrement inside a woman's shoe, which was set with a contraption that lowered a sugar cube printed with the image of a shoe into the milk, dissolving it. This may have been amongst the Surrealist objects Dalí planned to show in the documentary, as he mentions a hand entering the frame to initiate some sort of movement. The section on 'paranoiac activity', Dalí's great 'active' contribution to Surrealist discourse as an alternative to automatism, which he dubbed as 'passive', is also curiously thin. 'Paranoia', a term popularised in nineteenth-century psychiatry to designate all types of delusional insanity (taken from the general Greek term for madness, literally translatable as 'outside mind'), was the theoretical backing Dalí used to explain the phenomenon of the double-image, though at the time of *Five Minutes on the Subject of Surrealism* it is clear that it had not yet expanded to become the all-encompassing theory he would describe in *The Conquest of the Irrational* (1935). Still, *Five Minutes on the Subject of Surrealism* suggests these ideas were burgeoning in its description of paranoia as a means of systematising delirium – sentiment perfectly in tune with the artist's 1930 essay 'L'Âne pourri', in which he first advanced paranoia as a controllable means of systematising confusion, thereby contributing to 'a total discrediting of the world of reality'.[30]

Five Minutes on the Subject of Surrealism closes with a formal state-

ment from Breton musing inconclusively about what one might expect from the Surrealists' ongoing studies of the irrational, though it is unclear whether the words are Breton's or Dalí's. The Catalan painter had already made his own prediction on the matter in 'The Rotting Donkey':

> It would be appropriate to say, once and for all, to all art critics, artists, and so on, that they need not expect from the new Surrealist images anything other than disappointment, foul sensation and feeling of repulsion […] the new images of Surrealism will more and more take on the forms and colours of demoralisation and confusion.[31]

True to his word, Dalí's film scripts would indeed become increasingly confusing – a stark contrast to the refreshing clarity *Five Minutes on the Subject of Surrealism* would have exhibited if only it had been realised.

Against the Family, 1930–1932

If *Five Minutes on the Subject of Surrealism* was designed to offer an approachable introduction to Surrealism and psychoanalysis, Dalí's next script, the also unrealised *Against the Family*, was intended for an audience considerably more well-versed in Freud's theories and those of his contemporaries. *Against the Family* explores the psychological development of a person, beginning with the intrauterine rapture cut short by biological birth. This 'pre-Oedipal' complex had been introduced by one of Freud's most gifted disciples, the Viennese psychologist Otto Rank, who put forward his theory of 'birth trauma' in 1924, suggesting that the neuroses Freud had traced to the development of the Oedipus complex – Freud's term for the neurosis that results from the (male) child's love for his mother that competes with that of his father and leads to castration anxiety and the creation of the 'super-ego' (later dubbed the Electra complex in respect to young girls' libidinal desire for their fathers) – were in fact introduced to an individual's psychology *at birth*. Rank described the child's period in the womb as an ecstatic phase traumatically inter-

rupted by birth, resulting in Angst, repression and an unconscious desire
to return to that primordial 'paradise lost'. 'Just as the anxiety at birth
forms the basis of every anxiety or fear, so every pleasure has as its final
aim the re-establishment of the intrauterine primal pleasure', Rank
wrote.[32] 'Birth trauma' thus challenged Freud's model of psychological
development, and it caused a decisive split between the two analysts,
resulting in Rank's resignation from his positions as Vice-President of the
Vienna Psychoanalytic Society, director of Freud's publishing house, and
co-editor of *Imago* and *Zeitschrift*. This summarised history is important
to establish, for despite its rivalry to Freud's model and Dalí's utter fasci-
nation – and identification – with the Oedipus complex, the artist
embraced 'birth trauma' as the origin of psychological development.
This is most thoroughly explored in the second chapter of *The Secret
Life of Salvador Dalí*, devoted to the artist's 'intrauterine memories'. He
writes:

> [...] I must declare that my personal memories of the intra-uterine
> period, so exceptionally lucid and detailed, only corroborate on every
> point Doctor Otto Rank's thesis, and especially the most general
> aspects of this thesis, as it connects and identifies the said intra-
> uterine period with paradise, and birth – the traumatism of birth – with
> the myth, so decisive in human life, of the 'Lost Paradise.' Indeed, if
> you ask me how it was 'in there', I shall immediately answer, 'It was
> divine, it was paradise.'[33]

Following the prologue on 'birth trauma', part one of *Against the Family*
concentrates on the child's infancy and the role of the 'polymorphous
perverse', Freud's term for the phase extending from infancy to about
age five when sexual pleasure is sought in any and all forms. This leads
to the conflict between the pleasure principle and the reality principle
that Dalí had mentioned in *Five Minutes on the Subject of Surrealism*. In
Against the Family, however, Dalí explores the full range of psycholog-
ical repercussions that Freud said developed during this period: The

Oedipus complex, castration anxiety, repression, etc., resulting in the child's rebellion against paternal authority.

Though Dalí's script does not explicitly cite a personal narrative, there is surely an autobiographical dimension to *Against the Family*, as it was written in the aftermath of Dalí's own expulsion from his family by his father, Salvador Dalí i Cusi, towards the end of November 1929. *The Secret Life of Salvador Dalí* (1942) described the incident, but Dalí was uncharacteristically taciturn about its impetus, writing that it was a matter that concerned 'only my father and myself'.[34] A letter from Don Dalí i Cusi to Federico García Lorca reveals the cause: Dalí's ink drawing *The Sacred Heart* (1929), an overtly blasphemous work depicting the outline of Christ on which Dalí inscribed in French, '*Parfois je crache par plaisir sur le portrait de ma mère*' ('Sometimes I Spit with Pleasure on the Portrait of my Mother').[35] Although the inscription referred not to Dalí's own beloved mother but to the Blessed Virgin (in keeping with the Surrealists' vehement anti-clericalism), it seems his father heard second-hand about the drawing's exhibition in Paris at the Galerie Goemans and took it as an attack on his late wife. He demanded an explanation from his son, and when one was not forthcoming, he ejected him from the house with curses that he would die alone and penniless.

Dalí's banishment from his familial home had a profound impact at a time when he was ensconced in Freud and constructing his own mythology. Dalí began identifying with the son in the legend of William Tell, the story of a Swiss patriot who was ordered to shoot an apple off the head of his son. Dalí interpreted the William Tell scenario as an exemplar of Freud's Oedipal struggle, casting his father as the bearded Tell and himself as the 'castrated' son; there's a famous photograph taken by Buñuel of Dalí in December 1929 with a sea urchin balanced on his shaven head in an invocation of William Tell. All this must have heavily influenced Dalí's script, and certainly its poignant title, *Against the Family*.

As Dawn Ades observes, however, quoting Dalí's 1952 essay 'The Myth of William Tell', the artist interpreted the William Tell scenario not

only in the explicit case of his own relationship with his father but also with respect to André Breton, his 'new father on joining the Surrealist movement', and Picasso, his 'artistic father and rival'.[36] It is with this in mind that the conclusion to Dalí's script takes an unexpected turn as *Against the Family* becomes a challenge to Marxist Communism and its oppression of desire and imagination. 'The sacred communism has conquered love and, with it, all the freedom of the imagination', Dalí writes. '[...] Social diversion, the woman's condition as a useful object, opposed to the communist idea of the comrade, in which what are precisely discarded are the erotic relations.'[37]

The French Communist Party (PCF) had been gaining momentum since the 1920s, and celebrated intellectuals were increasingly joining its ranks; Surrealists Louis Aragon, Breton, Benjamin Péret and Paul Éluard all joined the Party in 1927. The Communists, however, were not generally sympathetic to the Surrealists' aims, which were seen as bourgeois in comparison with the social-realist art Communism favoured, despite the Surrealists' attempts to advance themselves as comparably 'revolutionary'. When the Communists denounced the Second Manifesto of Surrealism in 1930 (for which Dalí drew the frontispiece) as idealistic, it seemed there was little hope of reconciliation. It was not until 1931, however, that Dalí experienced the Communists' oppression of his imagination first-hand, when his article 'Rêverie' ('Daydream'), published in the December issue of *Le Surréalisme au Service de la Révolution* was denounced as indecent. This incident initiated the critical split between Breton and his long-time friend Louis Aragon, who had by that time become the sole French representative of the Commission of Control of the International Union of Revolutionary Writers; Breton criticised Aragon's short-sightedness and defended Dalí's article as 'very beautiful'.[38] It was clear to Dalí that Communism was fundamentally incompatible with his artistic aims – a position to which he would hold firmly for the rest of his life.

The political dimension to *Against the Family* makes it a compelling statement on the psychoanalytic meaning with which Dalí had imbued

his situation in the early 1930s. Having been expelled by his biological father, he seems to have regarded himself, too, as the rebellious son of Marxist Communism, enlightening his 1933 depiction of Lenin as a cannibalistic 'father' in *The Enigma of William Tell* (1933). It should be added to this that although *Against the Family* was likely written between 1930 and 1932, Dalí may have sensed another rebellion manifesting against another 'father-figure', Breton. Though Breton defended 'Rêverie' in 1931, it would not have escaped Dalí that the poet's dogmatic tastes were just as likely as the Communists' party line to infringe on Dalí's imagination; indeed, Breton had already expressed his disgust with the scatological element of Dalí's painting *The Lugubrious Game* (1929). Dalí's fears would indeed come to fruition in 1934, when Breton would finally charge him with allegations of counter-revolutionary activity. Thus Dalí would ultimately find himself rebelling against Breton, too, finally being ejected from his Surrealist 'family' in 1939. In 1952, he would open his *Myth of William Tell* with a telling quotation from Freud on the Oedipus complex: 'He is a hero who rebels against paternal authority and conquers it.'[39] Dalí often cast himself as the victim-son of paternal authority, but he equally projected a myth of heroism: The son who is subjugated by the father but ultimately overcomes him.

The Sanitary Goat, 1930–1932

As noted earlier, one of Dalí's most important contributions to Surrealist discourse was his development of the 'paranoiac-critical method', a deliberate misreading of the world in order to provoke images from the subconscious. The fundamentals of his burgeoning method – indeed, it had not yet even been baptised a 'method' – were published as three essays in his 1930 book *La Femme Visible*: 'L'âne pourri', 'Le grand masturbateur' and 'La chèvre sanitaire' ('The Rotting Donkey', 'The Great Masturbator' and 'The Sanitary Goat'). 'The Rotting Donkey', which attempted to bestow psychoanalytic credence upon his double-

images, has since become one of the most widely-cited sources on Dalí's art and writing, whilst the poem 'The Great Masturbator' has enjoyed recognition largely afforded by the eponymous 1929 oil painting. 'The Sanitary Goat', meanwhile, which considers critical paranoia in terms of contemporary science and the relationship between psychology and poetry, has received only cursory attention from most scholars, though it, too, offers valuable insights into Dalí's developing methodology.

Building from Dalí's battle with the chimera of reality, as advanced in 'The Rotting Donkey', 'The Sanitary Goat' pronounces that the greatest clarity might be derived from the most confusing things. Rather than interpreting these phenomena through psychological-sensory connections and influences, Dalí wrote that it would be equally valid to interpret them through *gratuitous* evidence – that is, independent from what the things seem to be. 'The gratuitous would constitute something like a geometric point perfectly sheltered from any contamination and from any psycho-sensory influence', Dalí wrote; '[...]n other words, [...] it lies outside physiology'.[40] This 'point' distanced from the physical world Dalí baptised 'the sanitary goat', specifically because this title was itself 'gratuitous' – wholly separated from that which it served to designate. These ideas may seem abstruse, and indeed 'The Sanitary Goat' proves to be one of Dalí's most challenging essays of the period. It is no wonder, then, that it would also lead to one of his most opaque unrealised film scenarios, also titled *The Sanitary Goat*.

The Sanitary Goat (film) revolves around a *very* loose story involving two protagonists: a woman described as a *femme fatale* – cold but good – and a man. These two characters appear in three situations of love: 1) prohibited love (brother and sister), 2) reciprocal love (Romeo and Juliet) and 3) love by the lover (Don Juan). In the first act, 'the encounter', the enamoured brother meets his sister in his room, whilst in the other two scenarios the lover meets his beloved. The scenarios are presented in such a way that the audience could be sure that it is watching distinct stories, which might otherwise be confusing given

that the same characters are used in all three circumstances.

The most detail is provided for the first scenario, the brother and sister, who are set as children in a garden in the presence of their family: a bearded father, his older wife who catches butterflies to show the children, an aunt and a third child. Dalí describes various events surrounding these characters interspersed with illustrations of his contemporary frame of mind – he cites the intervention of dreams and hypnogogic images, specifically in an episode in which a character closes his eyes and instantaneously sees a multitude of crucified women. In another sequence, he describes focusing on a humidity spot in order to transform it into something else and thereby discredit reality in favour of a so-called 'surreality', implicitly invoking Leonardo's advice to his pupils in *Trattato della pittura* that they should locate images within humidity stains on walls,[41] an acknowledged precursor to critical paranoia and an example that will be recurring in Dalí's theorising. Aside from these elements in their context, however, the confusion of *The Sanitary Goat* is such that there is scarcely anything else worth recounting, at least for the sake of clarity. That was the very nature of the script: *gratuitous imagery*, stemming from the Surrealists' interest in *l'acte gratuite* ('the gratuitous act'), the wholly random and unmotivated act exemplified by the character Lafcadio in André Gide's novel *Les Caves du Vatican* (1916), who kills a man 'for no reason', thus committing a purely gratuitous murder. André Breton later endorsed such random acts of violence in 1930, when he penned in the Second Surrealist Manifesto that the most Surrealist act would be firing a revolver into a crowd at random – a passage inspired by Breton's eccentric friend Jacques Vaché, who interrupted the premiere of Apollinaire's *Mamelles de Tiresias* by threatening to open gunfire on the audience. Just as Dalí's essay makes clear that the very title 'The Sanitary Goat' is wholly gratuitous, so then the events of the film script reflect the *acte gratuit* by being in and of themselves unprovoked and random (e.g., a spoken poem illustrated by images completely independent from the text; a beheaded hen – a macabre subject that would reappear in *Babaouo* – that runs across the

screen; an oversized bus – also recuperated for *Babaouo* – containing a single woman with her head wrapped like Elizabeth Arden; the systematic use of elements that clash with the scenery [e.g., a man seated in a chair in an empty space]; frequent, *non sequitur* images of Cap de Creus; a series of events that seem to be leading to a climax but never reach it, thus becoming 'gratuitous').

As one can imagine, this all would have made for an awfully peculiar film, though one imagines the Surrealists might have appreciated *The Sanitary Goat* immensely had it been realised. Lacking any cinematic instructions as far as camera angles and the like, however – Dalí only specifies that things must be contradictory – it is unclear whether the Catalan artist ever truly intended *The Sanitary Goat* to become a motion picture, or if he was only experimenting with the *acte gratuite* as it might apply to film.

Babaouo, 1932

The unrealised scripts I have identified thus far are all relatively embryonic – normally a manuscript exists with perhaps some marginal drawings, but nothing more. In contrast, *Babaouo* was so developed – not only in its writing but in the drawings and paintings Dalí created around it – that it merited its own publication, a 1932 book in French produced by Éditions des Cahiers Libres in Paris.[42]

Babaouo is set in 1934 'in any European country during a civil war'. The tango *Renacimiento* was to serve as the film's soundtrack, and Dalí suggested that it be repeated constantly as a leitmotif throughout the film. The opening scene is the hallway of a large hotel: A bellhop hurriedly looks for a room to deliver an urgent message. Just as he is about to knock on one of the doors, he hears the sound of a dozen or so people laughing hysterically emanating from inside, mingled with the violent crashes of heavy objects being thrown against the walls. After hesitating, the bellhop timidly knocks, though the laughter only increases. Growing frustrated, the bellhop knocks loudly on the door; a

feminine voice from inside calls out, 'Just a moment! You can't come in now!' Then the door slowly opens, revealing a woman in a transparent negligee. 'Urgent letter for Mr Babaouo', the bellhop tells her, 'to be delivered to him in person.' The woman says she will fetch him and closes the door, to which the laughter and noise returns; at one point, the door is knocked ajar and a headless chicken stumbles out, collapsing in a pool of blood. Finally a man appears at the door: Mr Babaouo, whom Dalí describes as utterly unremarkable. Babaouo takes the letter and reads it aloud: 'All alone for three days at the Château de Portugal, I can't take it anymore. Help. Your beloved, Mathilde Ibañez.' He checks the time and hastily leaves the hotel. As he traverses the lobby, a piano is thrown from the third floor down the stairwell.

Upon leaving the hotel, Babaouo meets a friend with whom he starts a long conversation. As they walk, the camera reveals that the men are marching in water up to their ankles; the torrent sweeps along various debris and dead animals that they frequently have to step aside to avoid. When the two have parted, Babaouo arrives at a large square full of blindfolded bicyclists, each carrying a large stone on his head and sporting a small white cape. He crosses the square and enters the Métro station, passing a woman sawing wood at the entrance and some tango dancers on the staircase. When he arrives at the crowded platform, there is an orchestra set up attempting to play the overture from Wagner's *Tannhäuser*. Each time the musicians begin playing, however, a train arrives, flooding the platform with people who knock over their stands and kick their instruments. But as soon as the train leaves, the musicians take their places again to perform.

Sitting in the Métro car, Babaouo frequently checks his watch (which is, of course, soft!). Amongst the other passengers in the car are a naked woman and a postman. Two fried eggs sit on the postman's shoe, falling to the ground when the Métro stops. Babaouo changes lines. As he is awaiting his next train, a legless beggar approaches him asking for money; the beggar holds out his hand, revealing two fried eggs. Babaouo gives him a coin that punctures one of the eggs and boards the

train. When he reaches his stop, he exits the Métro and hails a cab to the Château de Portugal; as he settles into the cab, he pulls out a revolver and checks that it is loaded. Suddenly the cab stops and, without saying a word, the driver gets out, wearing a Native American feathered headdress. The film turns from black and white to colour. The driver approaches a fir tree and sits down against its trunk with an expression of profound boredom. Babaouo gets out and tries to convince the driver to continue on to the Château, but the driver only gives an apathetic gesture. Furious, Babaouo gets into the car and continues on himself, there ending the colour section of the film.

Babaouo arrives in the town, which seems to be completely deserted. He gets out and walks through the empty avenues, observing bed sheets that are extended over the facades of some of the houses. He walks for what seems an infinitely long time and, as the sun sets, he hops on a tram. The tram traverses a street covered in flowers. Babaouo gets out at a street of roses and enters a large theatre through an open door. He ascends to the fourth story and observes the panorama of the deserted town; the only movement comes from the bed sheets blown by the wind. He leans back against the door of a room, but the door opens under his weight and he falls inside. When he gets up, there is a virtuoso violinist passionately playing in the theatre. A cupboard with open drawers spilling linens is balanced on his head, and his naked foot rests in a plate of milk.

Babaouo checks his (soft) watch, races down the stairs and leaves the centre of town. In the suburbs, he can make out the form of the Château de Portugal. As he approaches the Château, he hears monstrous, fatigued breathing. He grows frightened as the sound draws nearer, though he eventually realises it is only the sound of the waves. He continues on to the Château, the door of which is decorated on each side with a sculpture of a beheaded chicken. Through the garden gate is a 15-metre-long bed set out on the lawn with a cypress tree lying on it. In the distance, a coffin passes slowly through the main door of the Château. Babaouo crosses the garden, and Mathilde – a beautiful and

distinguished woman – runs to him, grateful she is no longer alone. They go inside to her bedroom where there is a dead body lying on the bed, covered with a white drape. Babaouo starts to pull back the drape but is stopped by Mathilde, who tells him it is too horrible: The body has been there for six days. Suddenly an elderly woman with white hair enters and throws herself into Babaouo's arms: It's Mathilde's mother, just arrived. At the same time, a group of men and women in evening wear hasten in, switch on a phonograph and begin dancing. Mathilde's mother says she wants to see the body one more time. Babaouo tries to dissuade her, but Mathilde tells him to let her go, as they will have a good joke on her. Mathilde and a young boy run into the bedroom and take up the body – one by the feet and the other by the head; Babaouo opens the door to let the mother in, at which point Mathilde and the young boy throw the corpse onto her. In the chaos that ensues, Mathilde and Babaouo make their exit. They get into the taxi and drive off, regularly passing patrol squads of Communist soldiers. As the car passes one of the streets, Babaouo and Mathilde spot a bus five times larger than natural size, the interior of which is filled with water; on the water is a small boat with three legless, singing Japanese men. Babaouo stops to contemplate them for a moment, then drives on. They enter a forest, but, without any warning, Mathilde ferociously attacks Babaouo, sinking her teeth into the nape of his neck. Babaouo releases the steering wheel and the car crashes into a tree.

Mathilde is thrown three metres in the crash, where she stays motionless and presumably dead. Babaouo manages to crawl from the debris, but he is blinded when some twisted metal scratches against his eyes. Unable to see, Babaouo cries out for Mathilde. He finds a shoe, which he interprets as a foot. Believing he has found Mathilde, he gropes further and finds a tyre cut in two, which he takes to be her legs. Too afraid to touch the lifeless head, he stops at a burning cushion that he thinks is her body; he whispers some loving words, embraces the cushion with all his force and is thus horribly burned.

Mathilde's death concludes *Babaouo*, though the script goes on to

include an epilogue followed by a Portuguese ballet about William Tell (again featuring legless characters, now 35 in number). The epilogue explains that Babaouo later has an operation that restores his eyesight, after which he becomes a painter. As the film comes to a close, Babaouo, with eyes bandaged and a loaf of bread on his head, sets off on a bicycle. Like the bicyclist in *Un Chien Andalou* and the previous bicyclists in the *Babaouo* script, he wears a cape. He pulls the bandages from his eyes, but just as he begins to enjoy his restored eyesight in the light of day, a gunman in a passing car opens fire and Babaouo falls dead.

In 1978, a Spanish and French edition of *Babaouo* was published by Las Ediciones liberales (Barcelona), along with a deluxe edition printed with an original engraving and seven woodcut illustrations. In the prologue, Dalí insisted that, despite everyone's suspicions, he was not the model for Babaouo, though scholars have pointed out several auto-biographical references in his script: Matilde Ibáñez was the name of a girl he had known in Barcelona,[43] and while the epilogue's setting is said to be Bretagne, it was undeniably inspired more by Dalí's own environment amongst the rocks at Cap de Creus; even the epilogue's reference to Babaouo's neighbour, an old woman and her two fishermen sons, must be a thinly-veiled casting of Dalí's long-time friend in Cadaqués, Lídia Noguer Sabà, whose two real-life fishermen sons figured in some of Dalí's paintings. As for the name 'Babaouo', Pilar Parcerisas explains:

Etymologically, it [the name Babaouo] derives from the root 'bab', which means to babble or stutter. At the same time, the word babau in Catalan has the sense of a weak, soft character, lacking in initiative, an indecisive individual who is astounded at things of no great signifi-cance. Babau or cugula is also the name of the seed of the darnel or wild oats, a graminaceous plant that grows among the good cereals and is prejudicial to the crops, and refers in a figurative sense to a person or thing considered detrimental to society and the moral order.[44]

Any of these justifications might have been used by Dalí to name his character, though he was reticent to say anything more about the name's origin. In an amusing resurfacing, however, in the 1960s Dalí was often photographed with two ocelots, Babou and Bouba, the pets of his business manager Captain Peter Moore.

Haim Finkelstein suggests that Dalí never actually intended *Babaouo* to be shot, observing that many of the film's episodes are long and 'from the point of view of film – useless and insignificant scenes' (e.g., Babaouo's lengthy conversation with his friend as they hurdle over dead animals in the flooded street). '*Babaouo*, in spite of its quite effective images, sequences, or metaphoric constructions, remains a loose collection of visual gags. Dalí, clearly, is often thinking in this screenplay in terms of static visualisations – in fact, he is thinking as a painter or, rather, as an illustrator.'[45] Finkelstein's criticisms are well-pointed: As would be the case in many of Dalí's scenarios, *Babaouo* is indeed largely comprised of incomprehensible single spectacles without a cohesive narrative to support or justify them. At the same time, this is not so far from the 'automatic' images compiled for *Un Chien Andalou*, and it is telling that when Dalí interviewed Buñuel in 1929 for *L'Amic de les Arts*, he asked the director whether he believed in the possibility of 'pure Surrealist film', which he defined as '*a succession of Surrealist images, oneiric screenplays, etc.*'[46] *Babaouo* seems precisely the sort of film Dalí was pushing Buñuel to support, and by its explicit subtitle, '*C'est un film surréaliste!*' ('It's a Surrealist film!'), Dalí cannot have been clearer that he considered this succession of nonplussing images in line with what a Surrealist film ought to be – regardless of whether or not it was actually feasible for him to make at the time. Certainly *Babaouo* would have required a budget far exceeding that of *Un Chien Andalou* or even *L'Âge d'Or* to materialise its bevy of cast extras and proposed special effects, though perhaps it was less a case of Dalí's imagination run amok than a deliberate move to position Surrealist film on a par with the oversized Hollywood pictures of celebrity directors like Cecil B DeMille. Already with *Babaouo*, Dalí was dreaming of Surrealism's entry into mainstream

cinema, with all the professional actors and big-budget sets such a move would bring; undoubtedly *Babaouo* was many times more ambitious than any Surrealist film before it.

A final nod should be given to the role of humour in *Babaouo*, though one must be wary of relying too heavily on comedy to explicate Dalí's motives; as the artist often said, those things he considered jokes often turned out to be serious and those things he considered serious later turned out to be only jokes. Comedy can be an invitation to not taking Dalí seriously, which is often an easy way of dismissing his activities without considering his underlying motivations. At the same time, it seems likely that Dalí was indeed trying to inject *Babaouo* with comic elements, albeit rather macabre ones – the headless chicken, the violent laughter, the singing Japanese men, etc. This is supported by the fact that in the *Babaouo* publication the scenario was preceded by a 'Short Critical History of Cinema' in which Dalí lauded 'irrationally inclined film comedics' as 'the only ones to show the true path to poetry', singling out for distinction Harry Langdon, William Powell and the Marx Brothers' *Animal Crackers* (1930).[47] According to 'Short Critical History of Cinema', Dalí's comedic exemplar was the eccentric French writer Raymond Roussel (1877–1933), whose writing shall be more deeply considered later in light of *Impressions of Upper Mongolia – Homage to Raymond Roussel*, though he deserves mention here as some images in *Babaouo* seem to have been inspired in no small part by Roussel's writing: In *Impressions of Africa* (1910), for example, a group of Europeans stranded in Africa hold a sharp-shooting contest using a boiled egg. The first shot grazes the top of the egg white exposing the yolk, and each subsequent shot trims a bit more off the white until only the yolk is left. When all the shots are fired, one of the characters takes the yolk in his hand and squeezes; the liquid yolk trickles out from between his fingers, just as it does in the hands of the beggar in *Babaouo*.[48] Confirming a link between Roussel and *Babaouo*, Dalí sent Roussel a complimentary copy of *Babaouo* in 1932, shortly before the author's suicide in 1933.

The subject of humour in Dalí's work arose during a fascinating round-

table discussion at the Philadelphia Museum of Art in 2005 amongst Dawn Ades and Dalí's former confidants, the model and actress Amanda Lear and the Pop artist Ultra Violet. Although their comments primarily concerned the panel's first-hand knowledge of Dalí in the 1960s and 1970s, they enlightened the role of humour in his earlier work, too. Describing Dalí as 'the funniest man that ever lived', Ultra Violet recalled his wish to make a funny painting: 'He said, "I want to do a painting that is so funny that when people look at it they will laugh and laugh and laugh." And he tried, but he could not do it.' Lear agreed: 'He was really fascinated by laughter.'[49] Recalling that 'dark humour' was a cornerstone of Surrealist activity (Breton would compile the *Anthologie de l'humour noir* [*Anthology of Black Humour*] in 1940), it is easy to imagine Dalí finding the decapitated chicken that runs from the hotel room in *Babaouo*'s opening scene a burst of comic genius, though today it would generally register as grotesque rather than funny. This same predilection for dark humour would undermine Dalí's other comedic ventures, too, notably his 1937 proposal for a film with the Marx Brothers, which the artist suggested might also include a 'gag' – Dalí's term – in which 'cries of terror and mad laughter' could be heard through the closed door of a hotel room.[50] It wasn't that Dalí wasn't funny: Everyone who knew him agrees that he could be extremely witty and quite often utterly hilarious. Amanda Lear got to the crux of the problem: 'His sense of humour was completely different [...] Something made him laugh that did not make us laugh, it was completely different.'

Though it was never realised during his lifetime, *Babaouo* was finally picked up in 1997, when it was made into a motion picture directed by Manuel Cussó-Ferrer based on an adaptation of Dalí's script by Pilar Parcerisas and starring Hugo de Campos and Cristina Piaget.

The Surrealist Mysteries of New York, 1935

Sifting through all the writing Dalí did in the early 1930s, it is easy to forget that his primary occupation was that of a painter. While he

contributed many essays on all manner of subjects to the Surrealists' periodicals, he was also enjoying successful exhibitions in Paris at the Galerie Pierre Colle. The first exhibition at Galerie Pierre Colle in June 1931 saw the premiere of his 'soft watches' in *The Persistence of Memory* (1931), which was purchased for $250 by the New York gallerist Julien Levy. It was the most Levy had ever paid for a painting, though his investment would prove sage as *The Persistence of Memory* became one of the most celebrated artworks in America: 'Journalists from coast to coast wrote stories about "Limp Watches"', Dalí later recalled.[51] Levy became Dalí's gallerist in America and hosted the first US solo exhibition of his work in November/December 1933, followed by a second exhibition of etchings and drawings to illustrate *Les Chants de Maldoror* in April 1934. Dalí's fame grew: It was time for him to visit New York.

Just before his second solo exhibition at the Julien Levy Gallery opened in November 1934, Dalí arrived in New York aboard the ocean liner *Champlain*. At a press conference Levy organised, the artist announced in a phonetic declaration that Surrealism had officially arrived in America:

aye av ei horror uv joks
Surrealism is not ei jok
Surrealism is ei strangue poizun
Surrealism is zi most vaiolent and daingeros
toxin for dsi imaigineichon zad has so far
bin invented in dsi domein ouve art
Surrealism is irrezisteible and terifai-ingh conteichos
Biuer! Ai bring ou Surrealism
Aulredi meni pipoul in Nui York have bin infectid
bai zi laifquiving and marvelos sors of Surrealism[52]

Dalí explained that one of his objectives was to uncover the 'truth' about New York: 'I have never been to America', he wrote aboard the

Champlain, in his text *New York Salutes Me*, 'but by this simple process I have learned already what great lies are all the photographs, descriptions, films, and other miserable stories which are repeatedly and monotonously retold to me from over there.'[53] America was curious to see what he thought too: Not long after his arrival, Dalí was commissioned by the magazine *American Weekly* to illustrate his eccentric impressions of the City, leading to a series of articles published between February and July of 1935 in which Dalí expounded on his impressions of Central Park (where he saw an anamorphic skull hidden in the shape of one of the rocks), Fifth Avenue fashion and, of course, the 'Big Apple's' iconic skyline.[54]

Although Dalí wrote that he wanted to diverge from the conception of America that had been disseminated to him through the media – specifically film – it's clear from his drawings that his view of New York was heavily influenced by the cinema. The second *American Weekly* instalment, 'New York as seen by the Super-Realist Artist M. Dalí' (24 February 1935), included a drawing specifically titled 'dream after seeing a movie tragedy', which depicted a piano with a wounded man lying across it and blood gushing from his head. The fourth instalment, 'Gangsterism and Goofy Visions of New York by M. Dalí, Super-Realist' (19 May 1935), read almost like a three-part film storyboard: An armed 'gangster', embodying the cinema's conception of the prohibition-era mobster as disseminated in *Little Caesar* (1930), *The Public Enemy* (1931) and *Scarface* (1932),[55] is pictured dramatically breaking through a window with a moll perched neatly on his arm.

These impressions of New York and its seedy, crime-ridden underground clearly influenced Dalí's next proposal for a Surrealist motion picture, the ultimately unrealised *Surrealist Mysteries of New York*, loosely based on the 1914 silent film *The Exploits of Elaine* (1914). *The Exploits of Elaine* had been a hugely popular film in Europe, where it was screened with the title *The Mysteries of New York*.[56] It tells the story of Elaine Dodge (Pearl White), whose father (William Riley Hatch) is murdered by a secret society headed by a ruthless criminal known only

as 'The Clutching Hand' (played by Sheldon Lewis). Dodge enlists the help of a 'scientific detective', Craig Kennedy (Arnold Daly), to solve the case, leading to a number of perilous situations extending over the film's subsequent 13 episodes, which find Kennedy and Dodge confronting all of The Clutching Hand's colourful henchmen.

While Dalí's version seems to have taken on the original film's violent genre – suggested by his 1935 poster depicting a 'soft', presumably murdered character with a severe head wound bound by safety pins and blood dripping onto his white shirt – its story, laid out in his prologue to the script, is quite altered:

The head of a secret organisation set up to sow surrealist mystery in New York is sitting thinking in his office. Outside his window, an anthropomorphic skyscraper is used for breeding hysterical mediums. One of these mediums escapes from the cataleptic glacier and enters the head's room and rushes towards him threateningly. He prudently flees, but in her fury, the medium rips off his hand as he shuts the door. She is terrified to discover the horrible hole at the centre of the hand through which thousands of ants begin to emerge. The hand writhes in agony and falls onto a bedside table that is now a horrible ball crawling with ants and a swarm of bees that have also come out of the hole. In distress, the medium reacts and kicks away the bedside table and the hand. She opens the door and finds herself in a deserted landscape in the middle of which is a large item of clothing hanging between two buoys. She settles down to sleep in a bed as long as a skyscraper.[57]

Elsewhere in the script Dalí presents the Catalan composer Enrique Granados as a severely handicapped drifter – perhaps an ambiguous reference to Spain, as suggested by the script's final, rhetorical flourish:

First of all, why do so many cypresses stick out of the walls of empty skyscrapers? And, above all, where are the rotten tangos from my

adolescence? The authentically syphilitic tangos, the narcissistically disheartened tangos, the suicidal tangos, sung by singers in ruins, colossal rubbish, Argentine and criminal, where I listened, more scoundrel-like than anywhere else, at the Eden Concert in Barcelona?[58] Likewise, where is the minuscule and fragile aerodynamic skull (sparkling in the sun) twinkling with sand, which Gala found that first winter of our love amongst the wild fossils of Cap de Creus? But Gala is in New York, and that means that New York is a mysterious and surrealist city because Gala is the muse of my imagination; no-one except for Gala and Salvador Dalí knows the Surrealist mysteries of New York.[59]

Though perhaps not the best example of Dalí's screenwriting abilities, *Surrealist Mysteries of New York* is amongst the first examples of his penchant for recycling images from earlier projects: His take on the 'clutching hand', now severed by a door and swarming with bees and ants, is clearly more closely linked to the festering appendage in *Un Chien Andalou* than to the 1914 arch-villain. *Surrealist Mysteries of New York* also introduces some subjects that Dalí would later pick up in future projects: The bees as an unusual symbol of decay would reappear in his unrealised nightmare sequence for *Moontide* (1941), while the elongated bed that had already appeared in *Babaouo* (and in Dalí's 1930 frontispiece for *La Femme Visible*) would feature yet again in *Giraffes on Horseback Salad* (1937). Dalí even gave Harpo Marx a part in *The Surrealist Mysteries of New York*, as a beggar with severed arms and legs[60] – not a role the silent comedian would have likely welcomed. *Surrealist Mysteries of New York* might be acknowledged as an unrefined bridge between the successful Surrealist films Dalí executed with Buñuel and the more complex scripts he would pen later as he became more familiar with the devices that would make for a successful motion picture.

HOLLYWOOD

As Dalí's fame grew in America – his face appeared on the cover of *Time* magazine in December 1936 – increasing numbers became aware of this strange art movement called Surrealism. Dalí continued to enjoy successful exhibitions in London, Barcelona and New York, but still he dreamt of heading west to Hollywood. 'Nothing seems to me more suited to be devoured by the surrealist fire than those mysterious strips of "hallu-cinatory celluloid" turned out so unconsciously in Hollywood, and in which we have already seen appear, stupefied, so many images of authentic delirium, chance and dream', he wrote in his 1937 essay 'Surrealism in Hollywood', by which time, as he observed himself, the word 'Surrealism' was on everyone's lips.[1] Dalí sent an enthusiastic letter to André Breton back in Paris: He had contacted 'the three great American Surrealists' – Walt Disney, Cecil B DeMille and the Marx Brothers.

Breton cannot have been altogether pleased: Though the Surrealists also admired Hollywood comedies, Dalí's high society hobnobbing could hardly be seen as revolutionary activity supporting the Surrealists' cause. They were undoubtedly bristled by his image in America as Surrealism incarnate, which conflicted with the Group's collective mentality. It would not be long before Breton would definitively expel Dalí from Surrealism, coining the anagram 'Avida Dollars' as a castigating denouncement of his commercial exploits. But for most people it didn't matter whether Dalí was a 'Surrealist' stamped with Breton's approval; in 1942 the artist would quip to *Esquire* magazine, 'I am Surrealism!', which in America was indeed the perception.[2]

It should be said, though, that the relationship with Hollywood that was to ensue wasn't altogether harmonious. Dalí's 1955 portrait of Sir Laurence Olivier in the role of Richard III, in which the actor's face is doubled to create a disquieting sense of the King's insanity, has become emblematic of the artist's amicable connection with the film industry, but little is said of all those projects he proposed that fizzled – his c.1948 proposal to Jack Warner to make a documentary about his book *Fifty Secrets of Magic Craftsmanship*; his desire to make a film about the life of Goya; the *Seven Wonders of the World* series he was commissioned to paint for a movie launch in 1954[3] that was executed but unused; or the Pop Art poster for the film *Fantastic Voyage* (1966), starring Stephen Boyd and Raquel Welch, that he made in 1965 but, again, wasn't used. Hollywood was often more interested in Dalí's publicity potential than in faithfully realising his designs. In the end, most of the evidence we have of his Hollywood 'successes' is only a pale reflection of what he actually hoped to achieve.

The Surrealist Woman / Giraffes on Horseback Salad,[4] 1937

Dalí was an ardent admirer of the Marx Brothers: Chico, Harpo, Groucho, Gummo and Zeppo – the stage names for Leonard, Adolph, Julius Henry, Milton and Herbert Marx. In 1932 he declared their 1930 motion picture *Animal Crackers*, based on a 1928 stage musical with the same title, 'the summit of the evolution of comic cinema', adding another invocation of Raymond Roussel's 'comedy':

> All the desires of the latent systematic and concrete irrationality throughout film comedies reach their peak in this admirable film – desires that progressively cast off any justification, pretext, subjective humour, etc., these being mitigating circumstances that have prevented a realisation of these films' violent moral quality through which they become films à thése. *Animal Crackers* achieves these kinds of solemn, persistent and exhausting, cold and diaphanous,

predispositions and contagions so rarely reached, and this only after having gone past the all too physiological stage of humour, the stage of frivolous solutions, not to say entertaining schizophrenias; once the terrain of concessions to instantaneous mental hypotheses is crossed, attaining at last the true and palpable lyrical amazement, that, for myself, is effectively provoked by certain passages by Raymond Roussel.[5]

Dalí's zeal for *Animal Crackers*' comedy was specifically centred on Harpo, 'the one of the Marx Brothers having curled hair, this face which is that of persuasive and triumphant madness'.[6] A balance for Groucho's quick wit and double-talk, Harpo never spoke, generating his comedy through visual gags performed with an ever-smiling expression of child-like naiveté.

In 1936, Dalí finally had the opportunity to meet his comic idol at a party in Paris, which he followed that Christmas with an inventive present – a harp covered in teaspoons with barbed wire for strings. A competent harpist – it was based on his ability with the instrument that Adolph acquired his stage name, courtesy of Art Fisher – Harpo loved it and responded to Dalí with a photograph of himself with bandaged fingers, wild eyes and a manic grin, jokingly implying that he had injured himself trying to pluck the harp's vicious strings.[7] The photograph was followed by a telegram in English, sent on 31 December 1936:

DEAR SALVADORE [sic] DALI RECEIVED WIRE FROM JO FORRE-STAL SAYING YOU INTERESTED IN ME AS VICTIM THRILLED WITH IDEA SHOOTING NOW FINISHED ABOUT SIX WEEKS IF YOU ARE COMING WEST WOULD BE HAPPY TO BE SMEARED BY YOU HAVE COUNTER PROPOSITION WILL YOU SIT FOR ME WHILE I SIT FOR YOU HAPPY NEW YEAR FROM GREAT ADMIRER OF PERSISTENCE OF MEMORY[8]

Dalí was surely thrilled with Harpo's compliance as a 'victim', and when

he arrived in Hollywood the following January, he announced he would be making a portrait of the silent comic.

Their first meeting took place in January 1937 at Harpo's Los Angeles home, where Dalí and Gala stayed a few days with the comedian and his newly-wed wife, Susan Fleming.[9] Dalí described their introduction:

> [Harpo] was naked, crowned with roses, and in the centre of a veritable forest of harps (he was surrounded by at least five hundred harps). He was caressing, like a new Leda, a dazzling white swan, and feeding it a statue of the Venus of Milo made of cheese, which he grated against the strings of the nearest harp.[10]

As Michael Taylor notes, Dalí's description may be exaggerated but should not be fully dismissed: Harpo 'was known for sometimes playing his harp in the nude, with guests occasionally being introduced into the most revealing of first impressions'![11] Dalí set to work drawing Harpo and his 'instrument of torture', the barbed-wire harp. Happily posing for press photographers during the sitting, Dalí executed at least two drawings of Harpo and possibly a painting as well that depicted Harpo in the manner of an eighteenth-century nobleman, acknowledging Harpo's taste for painters of that period.[12]

As Harpo began shooting the Marx Brothers' next film, *A Day at the Races* (1937), Dalí worked over his own script – a comedy he had begun around December 1936 about an extremely wealthy woman living according to dreams and fantasy:

> Daily she reconstructs with minute exactitude the images of her dreams and of her imagination, helped by a band of fanatic and loyal friends who surround her with an atmosphere only comparable to those of the most dazzling, decadent periods of history. (The film is preceded [sic] by a historical preface on Caligula.)[13]

In what seems to be the earliest version of the script – preserved at the

Dalí sketches Harpo Marx playing a harp with barbed-wire strings – a Christmas present from the artist. Image published in *The Los Angeles Examiner*, 17 February 1937. *Photo* ©ARCHIVES DESCHARNES/daliphoto.com

Bibliothèque Kandinsky in Paris – Dalí established his plot: Although this woman's strange behaviour turns much of society against her, she becomes the love object for the film's hero despite the fact that he belongs to the same conventional society that persecutes her.

> At the beginning he accepts the atmosphere of madness and her phantasies [sic] solely on account of his love for her, but soon the world that he has discovered intoxicates and takes possession of him without his even noticing. All the sentimental and dramatic development of the plot is based on the continuous struggle between the imaginative life as depicted in the old myths and the practical and rational life of contemporary society. These struggles are so violent that they comprise the dramatic substance for the 2 characters for he always hopes for a normal life with her outside of this continuous hallucination in which they live. The heroine is terribly disappointed not to be understood in the very essence of her self and in a blind fury there succeed one another a rupture and diplomatic intrigues on account of the personal influence he exerts over other powerful people. This ends by a declaration of war on his own country in order to avenge himself on the society of his former fiancée. After a short but disappointing attempt to readapt himself to his former life he suddenly realises that he can no longer support the conventional normality of before which now appears to him monstrously absurd without any justification. After a decisive scene with his fiancée he forsakes everything, his duty, and his post at the war and rushes to rejoin the heroine. But he is too late. The invasion of the enemy mixed with a general revolution ransacks the large palace where she had built the strange world of her imagination.[14]

There is conspicuously no mention of the Marx Brothers, possibly suggesting that Dalí had not yet conceived that his script might feature the famous comedy troupe. The synopsis, however, would provide the basis for a revised script titled *La Femme surréaliste* (*The Surrealist*

Woman), with Harpo and his madcap brothers starring as the heroine's 'band of fanatic and loyal friends'. One can easily spot the parallels in a summary of *The Surrealist Woman* kept in the archives of the Fundació Gala-Salvador Dalí:

> A hugely rich woman known as the Surrealist Woman, personifies the world of fantasy, dreams and the imagination. Her friends are the Marx Brothers, the real protagonists of everything that happens in the film. At the opposite extreme of the Surrealist Woman is Linda, who is also very rich. She is a snob, ambitious and unimaginative, and is engaged to be married to Jimmy, who falls in love with the Surrealist Woman as soon as he meets her. The entire film takes place amidst the struggle between these two women, who personify the world of convention and the world of the imagination. Their struggle culminates in a process in which it becomes impossible to judge which of the two worlds is more absurd than the other.[15]

Dalí wrote several versions of the subsequent script, each of which elaborates in its own way on this story. From the unpublished, 93-page script in the Bibliothèque Kandinsky (consisting of several versions of the text written in different languages), as well as the 65-page manuscript at the Fundació Gala-Salvador Dalí,[16] one learns that much of the motion picture's action was to take place in a Surrealist cabaret, which was to include such Dalínian touches as a lip sofa and mirrors from which women's arms protrude to ensnare passers-by. The 'Surrealist Woman', accompanied by Harpo and Groucho, would enter the cabaret via an enormous white satin tube 'so as to permit the party to proceed to their table without being seen by the public in the room'.[17] From there, she would charm Jimmy, a young Spanish businessman living in exile in America during the Spanish Civil War (blatantly modelled on Dalí's own circumstances during the War), who would follow her throughout the rest of the film. Other elements would include a car with 'indoor rain' (anticipating the artist's *Rainy Taxi*, exhibited in 1938 at the International

Surrealism Exhibition in Paris), and a 60-foot bed on which the 'Surrealist Woman' would recline, surrounded by dwarves captured by Harpo using a butterfly net who serve as living candelabras. Dalí continues:

> While love tears at Jimmy's heart, Groucho tries to crack a nut on the bald head of the dwarf in front of him. The dwarf, far from looking surprised, smiles at Groucho in the most amiable way possible. Suddenly in the middle of dinner, thunder and lightning begin inside the room. A squall of wind blows the things over on the table and brings in a whirl of dry leaves, which stick to everything. As Groucho opens his umbrella, it begins to rain slowly.[18]

Yet another scene finds Harpo 'playing his harp ecstatically, like a modern Nero' while Chico accompanies him on the piano wearing a diving suit; 'Scattered across the gangway leading to the tower, an orchestra plays the theme song with Wagnerian intensity as the sun sinks under the horizon.'[19]

As such scenes suggest, Dalí had written an extraordinary Surrealist script, though not one that really befitted the Marx Brothers' comedic style. Groucho later recalled, 'Salvador Dalí wrote a surrealist movie for us. He approached me one day at the studio. "Hello Dalí," I said. "Groucho," he went on, "have I got a script for you." No, he didn't – it wouldn't play'.[20] Once again Dalí was confronted by the fact that his idea of what was funny simply wasn't shared by those around him. Harpo was nonetheless enthusiastic and encouraged the artist to continue writing. In February 1937, Dalí wrote a letter to Harpo from the Arlberg-Wintersporthotel in Zürs, Austria:

> I'm spending a week in the snow and I'm going to take this advantage to write the scenario in which you are the only protagonist, after I've got to know you. I'm absolutely decided that we will do something together because we really do both think the same sort of things and we like exactly the same 'type of imagination'; I'm sure that a short

film, with the sensational scenario made expressly for your genius, with extraordinary decorations and a very lyrical music, like Cole Porter's, would be something hallucinatory which in addition to amusing us could make a successful revolution in the cinema.[21]

Unfortunately, this revolution was never to manifest. Like so many of Dalí's scripts, *The Surrealist Woman* – retitled *Giraffes on Horseback Salad* sometime in 1937 – was never made, purportedly because it was 'too surrealist'. When Joe Adamson asked Dalí in around 1973 what had happened to the script, Dalí became furious and began beating pigeons with his cane. '"No one would *dare* to do Dalí's script!" he expostulated, exasperated [...] When asked if there wasn't someone who could find affection for the script, his countenance softened. "Harpo liked it," he said.'[22]

Moontide, 1941

After *Giraffes on Horseback Salad* failed to get off the ground, a second Hollywood opportunity came in 1941, when Dalí was approached to design a three-minute nightmare sequence for Fritz Lang's *Moontide*, the story of a longshoreman named Bobo (Jean Gabin) who fears he may have committed a murder during a drunken binge on the San Pablo waterfront, one of the inlets of the San Francisco Bay.

On 4 November 1941, Dalí sent a description of his scenario to Twentieth Century Fox Film Corporation from the St Regis Hotel where he was staying: The nightmare – conceived, he wrote, from scientific symbols that were at once Freudian, Surrealist and Dalínian[23] – would begin at the beach during high tide; the rhythmical sound of the tide's ebb and flow would be the constant throughout the episode, beginning softly and with a very gradual crescendo that, by the end of the sequence, would be almost deafening. Dalí's script opens with Bobo visibly burdened with some emotional oppression. As he slowly crosses the port, the sun sets behind a monumental sewing machine on the

horizon, at which point he collapses. After a brief moment of immobility, he laboriously pulls himself up, initiating the 'delirious phase' of the nightmare: He is in the tavern, but amongst its tables he spies some naked women with shark heads – echoing Dalí's 1939 *Dream of Venus* pavilion and the controversy that ultimately led him to storm off the project when the organisers refused his request to have mermaids with female bodies and fish heads (an idea taken from René Magritte) rather than *vice versa*.[24] On one of the tables is a gutted shark, the entrails of which a Japanese man is extracting with a pocket-knife. Bobo is astonished by this transformation of his local pub and hurriedly leaves the strange 'brothel-slaughterhouse'. He goes to the post where he tied up his dog and discovers a very heavy cord tied to the same post. The cord winds through the tavern and disappears into a room at the bottom of the stairs. Strangely enraged, Bobo pulls the cord with all his strength, but it is tied to a large iron bed inside the room; the bed is in terrible disarray, sprinkled with wine and various snack foods. Bobo leaves the tavern, dragging the cord and the heavy iron bed behind him.

As he crosses the port, Bobo encounters female strangers who strike provocative poses for him, only to transform horribly when approached; each of them gestures towards the giant sewing machine in the distance, crowned by three giant umbrellas that open and close with the rhythm of the waves. Bobo passes a window that suddenly shatters, revealing the face of the Japanese man, which then transforms into that of a camel. The camel throws itself through the window and falls dead on the iron bed. Though the way is treacherous, Bobo manages to get to the base of the sewing machine, which the ascending tide has already begun to flood. A beautiful woman is tied up under the sewing machine's needle, her eye opened widely in terror as the approaching needle threatens enucleation. Bobo puts his hand between the needle and the woman's eye to protect her but withdraws it at the last moment. Just when the needle is about to touch the eye, its pupil suddenly becomes luminous, transforming into the sun rising over the horizon of the sea. Bobo violently closes his eyes so as not to witness the perfo-

ration of the eye, at which point he becomes aware of reality: the rising sun, the radiating clouds and the shouts of seagulls that free him from his nightmare.

Certain elements from Dalí's script will strike a familiar chord: The Japanese man may be a remnant from *Babaouo*, while the needle threatening the eye clearly invokes *Un Chien Andalou*, as does Bobo's struggle to drag a heavy iron bed, recalling the heavy pianos filled with donkeys that Pierre Batcheff laboriously pulled across the room in 1929. The greatest source for *Moontide's* imagery, however, is surely *Les Chants de Maldoror* (*The Songs of Maldoror*), an 1868 prose work by the French author Isidore Ducasse written under the ornamented pseudonym Le Comte de Lautréamont.

Born in April 1846, Ducasse finished *The Songs of Maldoror* at the age of 23. He arranged to have the first canto privately printed, but it wasn't distributed 'due to a sometimes violent style that made the publication perilous',[25] referring to the text's sadistic and blasphemous overtones. Ducasse died only a year later, and the work wouldn't be published for still another nine years, when it seems to have gone relatively unnoticed until it was republished in 1920, the year after André Breton printed Ducasse's only other known work, *Poésies*, in the journal *Littérature*. Almost immediately Lautréamont became an avant-garde cult figure in Paris, with Breton referring to him in his 1922 lecture in Barcelona as perhaps the most liberating force on the contemporary poetic imagination.

The Songs of Maldoror opens with the warning that readers should beware of its 'gloomy and poisonous pages. For unless he is able to bring to his reading a rigorous logic and a spiritual tension equal at least to his distrust, the deadly emanations of this book will imbibe his soul as sugar absorbs water.' The pages are macabre indeed, and include all manner of vice and violence – from rape and blasphemy to bestiality. Lautréamont recounts a series of ghastly encounters surrounding the enigmatic and misanthropic title character Maldoror, a figure opposed to God and who is absolutely evil. The book is written in a highly poetic

fashion and is best-known for its description of the beautiful young boy Mervyn, who is said to be 'fair [...] as the chance meeting on a dissecting-table of a sewing-machine and an umbrella'.[26] For the Surrealists, Lautréamont's description was the epitome of the unanticipated combinations of disparate elements that gave birth to the 'marvellous', inspiring, amongst other works, Man Ray's *The Enigma of Isidore Ducasse* (1920), a sewing machine wrapped in an army blanket and tied with string.

In 1933, Dalí signed a contract with the Parisian publisher Albert Skira to illustrate Lautréamont's text, telling Charles de Noailles in January of that year, 'It has always seemed to me the most gripping thing to do.' Dalí had long been an enthusiast for Lautréamont, having been introduced to *The Songs of Maldoror* as a student at *Residencia des Estudiantes*; though the book would not be published in Spanish until 1924, extracts had been printed in 1909 by Ramón Gomez de la Serna, and Lorca had drawn from *Los raros*, an 1896 Ruben Dario book that included a 'pen-portrait' of Lautréamont, for his own *Impressions and Landscapes* (1918). As one of the pinnacle texts of Surrealism, Dalí's illustrations must have been a very high-profile commission within his artistic circle.

Dalí was explicit that his illustrations were to be 'paranoiac', which is to say that they were only *inspired* by Lautréamont's verses and did not illustrate the text directly. David Lomas has done an interesting exploration of the sexual dynamics Dalí's illustrations suggest through their references to Jean-François Millet's painting, *The Angelus* (1859), which Dalí described as the most capable means of illustrating *Maldoror*, pairing Lautréamont's umbrella and sewing machine with the masculine and feminine figures of *The Angelus* respectively;[27] 'The umbrella', Dalí wrote, '[...] besides its flagrant and well-known symbol of erection, can be none other than the masculine figure in the Angelus [...] Facing him, the sewing machine, a feminine symbol known to all...'[28] It seems doubtful that Dalí had this symbolism in mind when he penned his scenario for *Moontide*, though the pairing of the sewing machine and

umbrella was clearly a deliberate reference. Amongst Dalí's 1934 illustrations of *Maldoror* is a grotesque, moustachioed figure with an elongated skull eating a baby that is pierced by the needle of a sewing machine – a far more grotesque predecessor to the *Moontide* sequence.

Another *Moontide* allusion to Maldoror comes in the woman-sharks at the tavern: In Lautréamont's text, Maldoror peripatetically wanders the Earth in search of a mate 'who resembles' him. Lomas appropriately observes the homoerotic overtones in this, and indeed Maldoror states explicitly, 'I do not like women! Nor even hermaphrodites! I must have beings who resemble me.' This search does not take him to another man, however – at least successfully, as he does attempt a correspondence with Mervyn – but rather to a female shark. In the shark, Maldoror sees a creature whose vicious nature equals his own, and they copulate in the sea.[29]

After submitting his first script to Twentieth Century Fox, Dalí wrote a second *Moontide* scenario for Fritz Lang. Some elements are shared by both scripts, though there are notable differences. Dalí's second script opens with Bobo travelling from tavern to tavern, presumably to reinforce that his nightmare is caused by a drunken stupor. At one of the stops, Bobo experiences an hallucination (the first of three): Inside his liquor glass he sees a bouillabaisse of painfully contorting anatomical parts united beneath a thin membrane. He touches an eye at the centre of the amalgam with a spoon, causing the arms and legs to contract as if everything in the glass were a single organism. He removes the spoon and looks towards the horizon, where he sees volcanic lava descending down the mountainside and a sky radiating with galloping giraffes in flames – recalling perhaps the flaming giraffes he had intended for *Giraffes on Horseback Salad*, but more directly those he had painted in *The Invention of Monsters* (1937), for which he described the flaming giraffe as a 'cosmic masculine apocalyptic monster'.[30] Bobo's vision finishes abruptly and he leaves the tavern.

As he stumbles to the next bar, it begins to rain; he tries several times to open his umbrella but it doesn't work. He grows frustrated but is

distracted by an antique shop window and the fortuitous meeting of heterogeneous objects that are displayed there: a sailor's cap, a sewing machine, an optician's anatomical eye, an umbrella, a suspended skeletal fragment and a Japanese mask – all presented for proper Maldororean effect atop a dissection-table! Bobo is completely taken with the sinister effect of the elements and is so distracted that he is almost run over by a passing automobile. After the drama has passed, he returns to the showcase and enters the store where, in the back room, a small bar is installed. Two seated sailors drinking at the bar signal to him to come over. Then he experiences the second hallucination: a skull that changes its expression according to the movement of the sailors. This immediately leads into the third hallucination, which Dalí warns will be the most complex and require the most preparation. The skull, he writes, is to be composed of different elements to create a terrifying effect: One of the eyes will be occupied by a honeycomb covered with bees, and the other will show a bowl of milk into which a white ball will be thrown in slow motion, the splash from which will create the form of a crown; in the nose will be a vipers' nest, and the mouth will be filled by another skull that will extend into infinity, as in each of its eyes and mouth there will be yet another skull with the same attributes. Incapable of continuing this horrible vision, Dalí writes, Bobo will throw himself against the skull that is in reality the bar-mirror, shattering it.

Bobo leaves the bar and re-enters the rain, every drop of which takes on the semblance of a sewing-machine needle. As he makes his way through the fog, gigantic umbrellas beat against the sky, while the sound of the tide continues to mount towards the climax. As the fog dissipates, Bobo finds himself confronted with the same giant sewing machine with three umbrellas as was in the first scenario, though now to get to it he must cross a long landscape populated by Surrealist women – some with heads of flowers, others with heads of sharks and one wearing the Japanese mask. Again, when he arrives at the sewing machine, Bobo finds someone tied up under the needle, though in the

second version Dalí writes that instead of a woman he might find the character Pop Kelly (played in the film by Arthur Aylesworth). As the needle advances towards Kelly's eye, the pupil again becomes luminous and is replaced by the rising sun that ends Bobo's nightmare; the three umbrellas on the sewing machine become three seagulls, and the frame pans out to reveal a sky full of birds.

One of the more significant changes in Dalí's second script is his detailed description of the skull, based on his 1940–41 painting *The Face of War* – a work that premiered in his 1941 exhibition at the Julien Levy Gallery a few months before he sent his first *Moontide* script to Twentieth Century Fox. Dalí's terrifying description of the skull besieged by vermin also recalls some of the more visceral passages in *The Songs of Maldoror*:

I am filthy. Lice gnaw me. Swine, when they gaze upon me, vomit. Scabs and scars of leprosy have scaled off my skin, which exudes a yellowish pus [...] My toes have taken root in the soil and have grown up around my belly in a kind of lush growth, neither plant nor flesh, where dwell vile parasites [...] In my left armpit a family of toads has taken up residence [...] An evil viper has devoured my penis and taken its place. The villain has made a eunuch out of me. Ah! If only I had been able to defend myself with my paralysed arms, but I fear they have been transformed into logs of wood [...] Two little hedgehogs of mature development flung to a dog, which did not refuse it, the contents of my testicles; and having carefully washed out the epidermis they have set up housekeeping within. My anus has been taken over by a crab. Encouraged by my inertia he guards the entrance with his pincers and causes me much pain.[31]

Following *The Face of War*, now at the Museum Boijmans Van Beuningen in Rotterdam, Dalí executed a pencil and wash on paper drawing of the *Moontide* skull, now in the collection of the Fundació Gala-Salvador Dalí. The Foundation also owns drawings of the sewing

machine and a sketch of Bobo looking into the antique shop window, all of which are reproduced in the 2004 catalogue *Dalí, Mass Culture*[32], as well as a striking pencil sketch of the hallucinatory bar glass pulsing with arms, eyes, legs and even a rotting donkey – a final nod to *Un Chien Andalou*. Dalí also executed at least two small oil paintings for *Moontide* that each depict the sewing machine and are reproduced by Enrique Sabater in *Las arquitecturas de Dalí*.[33]

It's unknown why Dalí's scenario wasn't used in the finished picture, though it's in any case a pity as it was amongst his most striking cinematic efforts and might easily have been more successful than his dream sequence for *Spellbound* had it been realised. One imagines Dalí's vision of terrifying skulls and bloody shark entrails was probably a bit over the top in gore for 1940s Hollywood, particularly after the film was taken over from Fritz Lang by the more conventional Archie Mayo. Still, Dalí's unique style of capturing dreams' reality was coaxing Hollywood away from its tradition of Vaseline-smeared lenses. Three years later he would have the opportunity to finally realise one of his cinematic visions with *Spellbound*, though this, too, would fall short of his expectations.

Spellbound, 1945

Peck: 'Lunch, lunch – What'll you have? Ham or liverwurst?'
Bergman *(breathless)*: 'Liverwurst.'
(scene fades)

Alfred Hitchcock's *Spellbound*, a pseudo-psychoanalytic 'who-dunnit' very loosely based on the novel *The House of Dr Edwardes* (1927) by Hilary St George Saunders and John Palmer (writing under the pseudonym, Francis Beeding) has long been bemoaned by Hitchcock aficionados who chortle at its silly dialogue and contrived circumstances. The film has nonetheless become known as one of the milestones in Dalí's cinematic career and 'one of the few real and tangible examples

of Dalí's collaboration with Hollywood'.[34] In 1944, Hitchcock personally enlisted Dalí to design the now-famous two-minute and forty-second dream sequence in which everything about the plot's murder and its perpetrator is laid out in thinly-veiled code to be facilely deciphered by the heroine (Ingrid Bergman) using only the most ridiculously simplistic of 'psychoanalytic' means.

Extensive research has been done on Dalí's participation on *Spellbound* by James Bigwood, who conducted interviews with many of the personages involved with the film; he has personally sought to dispel rumours propagated by Bergman that Dalí's dream was originally 20 minutes long.[35] As Bigwood has convincingly argued, the dream sequence was indeed cut, though not by more than a minute or so; more importantly, it seems that it was less the fruit of Dalí and Hitchcock's collaboration than the work of the director/designer William Cameron Menzies, whom producer David O Selznick called upon to rescue what he saw as a disappointing film that had gone well beyond its budget.

Very little of *The House of Dr Edwardes* survives in *Spellbound*, having been copiously reworked by Hitchcock and screenwriter Ben Hecht. The story opens when the head of Vermont's Green Manors mental asylum, Dr Murchison (Leo G Carroll), is forced into retirement after a breakdown. He is succeeded by the eminent psychiatrist Dr Anthony Edwardes, played by Gregory Peck, who arrives and immediately falls for one of the other staff psychiatrists, the beautiful and reserved Dr Constance Petersen (Bergman). But Edwardes exhibits strange behaviour: He can't stand the sight of parallel lines against a white background and he passes out whilst conducting a surgery. Soon it comes to pass that this man is an impostor. The real Dr Edwardes has been murdered, and this man, an amnesiac who knows himself only as JB (initials he retrieved from a cigarette case), is the prime suspect; even JB himself presumes he is guilty, as he is unable to fathom why else he would have put himself in the Doctor's place. Though logic would see Constance alerting the police, she has become enamoured with this

mysterious, potentially psychopathic character and instead follows him to New York, where she begins treating him in an effort to retrieve his past, prove his innocence and reveal the mysterious fate of Dr Edwardes. Travelling to Rochester, they enlist the aid of Constance's former instructor, Dr Alex Brulov (Michael Chekhov), who personifies every Freudian cliché, from his goatee, glasses and Germanic accent to his subtlely misogynistic remarks ('We both know that the mind of a woman in love is operating on the lowest level of intellect'). Brulov reluctantly helps Constance analyse a dream JB recalls, around which most of the story will unfold:

> I can't make out just what sort of a place it was. It seemed to be a gambling house, but there weren't any walls, just a lot of curtains with eyes painted on them. A man was walking around with a large pair of scissors cutting all the drapes in half. And then a girl came in with hardly anything on and started walking around the gambling room kissing everybody. She came to my table first. [...] I was sitting there playing cards with a man who had a beard. I was dealing to him and turned up the seven of clubs. He said, 'That makes 21. I win!'. When he turned up his cards they were blank. Just then the proprietor came in and accused him of cheating. The proprietor yelled, 'This is my place and if I catch you cheating again I'll fix you!' [...] He was leaning over the sloping roof of a high building, the man with the beard. I yelled for him to watch out. Then he went over, slowly with his feet in the air. Then I saw the proprietor again, the man in the mask. He was hiding behind a tall chimney and he had a small wheel in his hand. I saw him drop the wheel on the roof. Suddenly I was running. Then I heard something beating over my head; it was a great pair of wings. The wings chased me and almost caught up with me when I came to the bottom of the hill.

The aspects of JB's dream are allowed only one signification, and it's that meaning on which everything hangs to prove his innocence. From

JB's extraordinary fear of dark lines on white and his description of running down a hill, Constance deduces that Dr Edwardes and JB were skiing together at the time of the accident. The wings, we learn, allude to Constance's role as his 'angel' and signify the name of the resort, Gabriel Valley. Eventually Constance realises that the 7 of clubs making 21 is a reference to a certain '21 Club', where JB overheard the real murderer ('the proprietor') threaten the bearded man (Dr Edwardes), and that the 'wheel' the proprietor drops in the dream is the revolver that was used to shoot Edwardes during the skiing outing.

Of course, this sort of direct interpretation is absurdly simplistic, despite that Selznick agreed to have a professional psychoanalyst on the set for consultation. It must be remembered when viewing *Spellbound*, however, that Freud's theories were still fresh; following Charles Vidor's *Blind Alley* (1939), *Spellbound* was only the second movie to introduce psychoanalysis as a primary subject and the first to use it to solve a murder, however ham-handed it might appear today.[36] The film's opening even gives the uninitiated a sort of introduction:

Our story deals with psychoanalysis, the method by which modern science treats the emotional problems of the sane. The analyst seeks only to induce the patient to talk about his hidden problems, to open the locked doors of his mind. Once the complexes that have been disturbing the patient are uncovered and interpreted, the illness and confusion disappear ... and the evils of unreason are driven from the human soul.

The film's use of psychoanalysis in a murder case has a real-life parallel, too, and a strangely coincidental one at that. In 1928, a 22-year-old student studying at the Technische Hochschule in Dresden was hiking with his father in the Alps.[37] His father fell down a ravine, so the student, Philipp Halsmann, ran to a nearby inn for help. By the time a rescue party arrived, however, the father was dead; he had been struck on the head with a rock and robbed. Now the prime suspect, Philipp was

put to trial. Against the backdrop of intense anti-Semitism, Philipp was found guilty and sentenced to ten years in prison. When he appealed, the University of Innsbruck medical faculty came forward for the prosecution, saying that Philipp killed his father due to an Oedipus complex – Freud's psychoanalytic term for a mental complex in which the son seeks to overcome the father figure to gain the love of his mother. Freud himself was asked for a comment, to which the Jewish psychoanalyst objected to the prosecution's use of the Oedipus complex as a motive without objective proof of Halsmann's guilt. The jury found Philipp guilty of manslaughter and sentenced him to four years in prison, though Philipp would only serve two on the condition that he leave Austria. He thence travelled to France, changed his name to Philippe Halsman, and took up photography. After escaping France in 1940 (aided by Albert Einstein's intervention), Halsman established himself in America as one of the most successful commercial photographers of the twentieth century, and one of the first celebrities he met upon his arrival in New York was Salvador Dalí. Halsman forged a tremendously fruitful relationship with Dalí, resulting in the famous 1954 photography book, *Dalí's Mustache*. Over the years he would take several photographs of Hitchcock as well, and although Halsman never wrote or spoke publicly about his circumstances in Austria, his case – which had come to be known as the 'Austrian Dreyfus Affair' – had attracted such significant public attention that it's plausible it may have influenced Hitchcock and Hecht in their writing.

Given the film's base in psychoanalysis, Dalí may have seemed the obvious choice to materialise JB's oneiric revelations; though no longer officially part of Breton's Surrealist group, his art had long drawn upon the themes of psychoanalysis – he even had the opportunity to meet Freud personally in 1938 at Primrose Hill, London. But the dream sequence was not always part of the film: In Hecht's initial drafts, JB simply recounted his dream to Constance and Brulov – no flamboyant imagery at all. It was not until 14 June 1944 that a dream sequence became a component of the film, at which point Hitchcock suggested enlisting Dalí, possibly influ-

enced by James Basevi, the film's art director who had worked with the artist on *Moontide*. Selznick agreed for the publicity potential, though Hitchcock was clear that this was not his priority:

> Selznick the producer had the impression that I wanted Dalí for the publicity value. That wasn't it at all. What I was after was [...] the vividness of dreams [...] [A]ll Dalí's work is very solid and very sharp, with very long perspectives and black shadows. Actually I wanted the dream sequences to be shot on the back lot, not in the studio at all. I wanted them shot in the bright sunshine, so the cameraman would be forced to what we call stop it out and get a very hard image. This was again the avoidance of the cliché. All dreams in movies are blurred. It isn't true. Dalí was the best man for me to do the dreams because that is what dreams should be. So that was the reason I had Dalí.[38]

Dalí provided his account in his self-promotional 1945 'newspaper', *The Dalí News*:

> My movie agent and excellent friend Fe-Fe [Felix Ferry], ordered a nightmare from me by telephone. It was for the film *Spellbound*. Its director, Hitchcock, told me the story of the film with an impressive passion, after which I accepted. (Hitchcock is one of the rare personages I have met lately who has some mystery.)[39]

Selznick instructed production manager Richard Johnston to come up with an estimate of additional costs for Dalí's participation – an estimate that came to approximately $150,000. An outraged Selznick replied that the sum was such a 'ghastly shock' that no further work should be done until he had personally had the opportunity to investigate the matter, adding that 'if the dream sequence should cost anything remotely like this amount, it will have to go out of the picture.' Hitchcock scaled back the sequence to approximately $20,000 and persevered with shooting while Selznick grappled with the film's exorbitant costs; if Selznick tried

to interfere during filming, Hitchcock would pretend the camera was broken until he went off set.

After much deliberation, the first draft of Dalí's contract was delivered on 2 August 1944. This, however, raised another key issue: Who would retain his sketches and paintings upon the film's completion? Dalí's agent, Felix 'Fe-Fe' Ferry, and the studio agreed to split the artist's output 50/50, and on 18 August 1944, only 12 days before the dream sequence was scheduled to begin shooting, Dalí finally signed his contract.

This was only the first of many obstacles to be overcome. As all the elements in the dream were pivotal to Constance's solving the case, Dalí had relatively little creative freedom apart from background design and the appearance of some peripheral props. One of the scenes he was most excited about, then – the first that was scheduled for shooting, in fact – was an elaborate ballroom sequence, for this contained no hidden clues and thus had no bearing on the plot (thereby giving him space to invent). Dalí described his vision for the episode in *Dalí News*:

In one of the scenes of my 'sequence' it was necessary to create the impression of a nightmare. Heavy weight and uneasiness are hanging over the guests in a ballroom. I said to Fe-Fe: 'In order to create this impression, I will have to hang 15 of the heaviest and most lavishly sculpted pianos possible from the ceiling of the ballroom, swinging very low over the heads of the dancers. These would be in exalted dance poses but would not move at all, they would only be diminishing silhouettes in very accelerated perspective, losing themselves in infinite darkness.'[40]

This episode was to follow the scene in which the masked man drops the wheel on the roof. JB describes it in Hecht's script:

I don't know how I got there, but I was in a ballroom. The dancers were all dressed in white suits pretending to dance, but not moving.

There was an orchestra dressed in white fur hats. And Doctor Brulov was leading it. I was dancing with Constance and she had a dance card and asked me to write my name on it. I refused, then grabbed her and we started dancing – rather wildly. We danced out of the ballroom and I kissed her. The dance card kept getting bigger. It was full of names and addresses. And Constance seemed to turn into a statue. I started running.[41]

When Dalí arrived for the first day of shooting on 30 August 1944, however, he discovered that his vision had been compromised:

[...] I went to the Selznick Studios to film the scene with the pianos. And I was stupefied at seeing neither the pianos nor the cut silhouettes which must represent the dancers. But right then someone pointed out to me some tiny pianos in miniature hanging from the ceiling and about 40 lives [sic] dwarfs who according to the experts would give perfectly the effect of perspective that I desired. I thought I was dreaming. They manoeuvred even so, with the false pianos and the real dwarfs (which should be false miniatures). Result. The pianos didn't at all give the impression of real pianos suspended from ropes ready to crack and casting sinister shadows on the ground (for another expert imitated the shadows of the pianos with false shadows projected with the aid of a very complicated apparatus), and the dwarfs, one saw, simply, that they were dwarfs. Neither Hitchcock nor I liked the result, and we decided to eliminate this scene. In truth, the imagination of the Hollywood experts will be the only thing that will ever have surpassed me.[42]

As for the scene in which Bergman would become a Greek statue, this was done by creating a plaster cast around Bergman from which she broke away; when the film was played in reverse, it would seem as though she became a statue.[43] Although this, too, would ultimately fall to the cutting room floor, significant work went into this segment, which

Dalí's discarded ballroom scene for *Spellbound* with Ingrid Bergman and Gregory Peck dancing in the centre. ©United Artists/Photofest.

was shot several times using multiple casts. Despite a few photographs, no actual footage has hitherto surfaced.

The other scenes Dalí wanted were far simpler for the studio to handle. One gleans from his sketches that his vision of the gambling room, for instance, including the eyeball curtains – subcontracted to the Grosh Scenic Studio in Hollywood[44] – was followed almost exactly. Indeed, of all Dalí's ideas for the gambling room, only the cockroach with an eyeball pasted to its back that he wanted to have scurrying across the table seems to have been omitted. The tables and chairs, assembled by Selznick Studio's construction department, were fitted with feminine mannequin legs precisely according to Dalí's sketches – his unacknowledged quotation of Surrealist objects that had appeared in the 1938 International Surrealist Exhibition at the Galerie des Beaux-Arts in Paris

Dalí speaks with *Spellbound* actress Ingrid Bergman. ©United Artists/Photofest.

(e.g. André Breton's *Object Chest* [1938], in which a chest is supported by two sets of shapely female mannequin legs, and Kurt Seligmann's *Ultra Furniture* [1938], a stool by four female legs in heels). This was not the only motif Dalí 'borrowed' from his former peers: The 'man in the mask' is similar to characters in certain paintings by the Belgian artist René Magritte, and each table was to hold four metronomes with eyes pasted to their pendulums, recreating Man Ray's *Object to be Destroyed* (1932).[45] Even the curtain's eye motif can be seen in others' work – e.g. Jindrich Styrsky's 1933 collages, *Emilie Comes to Me in a Dream*, which were themselves predated by nightmarish drawings by the nineteenth-century French illustrator JJ Grandville (1803–1847) executed for 'Two dreams: Crimes and Expiations' (1847).[46] A ready comparison can also be made to the assemblage of voyeuristic eyes in Fritz Lang's

Ingrid Bergman transforming into a statue – a scene that was ultimately cut from the picture. *Spellbound,* 1945. ©United Artists/Photofest.

Metropolis (1927), in the scene where the robot Maria does a seductive dance at Yoshiwara's.

On 13 September 1944, Richard Johnston notified the studio that Hitchcock was satisfied with Dalí's efforts and that arrangements should be made to pay the artist's fee of $4,000. The very next day, however, portions of the dream sequence were deemed unsatisfactory. On 15 September, Johnston notified Selznick that the complicated statue shot would have to be redone due to the camera crew's negligence. This was only the beginning: The gambling house, the roof shot, JB's run down the slope – all needed reshooting; the ballroom scene was officially scrapped. On 13 October, a new narration was recorded to accommodate for the missing ballroom sequence: 'I don't know how I got there, but I was chasing Constance through some weird deserted place. I

The gambling hall with Dalí's curtain and the tables with women's legs. *Spellbound,* 1945. ©United Artists/Photofest.

caught up with her and kissed her. She pushed me away and then she turned into a statue.'[47] Selznick was still disappointed: 'The more I look at the dream sequence in *Spellbound*, the worse I feel it to be,' he wrote on 25 October 1944.

> It is not Dalí's fault, for his work is much finer and much better for the purpose than I ever thought it would be. It is the photography, set-ups, lighting, et cetera, all of which is about what you would expect from Monogram [a studio known for producing B movies]. I think we need a whole new shake on this sequence, and I would like to get Bill Menzies to come over and lay it out and shoot it. I'd appreciate it if you'd find out immediately if Menzies is available.[48]

In calling upon William Cameron Menzies, Selznick was hoping to

salvage his picture by bringing in one of the old guard from *Gone with the Wind*, for which both Selznick and Menzies had won Academy Awards® – Selznick for Best Picture, and Menzies an honorary award in 1940 for 'outstanding achievement in the use of colour for the enhancement of dramatic mood'.

Menzies answered Selznick's call and by November 27 had already laid out a new storyboard that, as Bigwood has shown, matches virtually shot-for-shot what would become the film's final dream sequence, right down to the camera angles. The statue scene was now gone, and though a transition using the same Dalí background was temporarily included, it, too, was soon discarded. On 5 December 1944, Menzies began his version of the dream sequence by reshooting the man cutting the eyeball curtains with an oversized pair of scissors, which he now shot close-up. On 19 December, the card game was reshot, and on 20–21 December the rooftop scene was redone using a miniature set with puppets set against Dalí's background.

In the end, then, shockingly little of Dalí or Hitchcock ended up in the dream sequence at all! Menzies' storyboard was sent to Hitchcock for approval, but the only footage remaining from the director's original shoot was the opening shot of the gambling house and Gregory Peck's stunt double, Charles Regan, running down a 35-foot slope. As the opening credits for the film make clear, the dream sequence was, indeed, only 'based on designs by Salvador Dalí' – the *designs* for the dream sequence may have been Dalí's, but all practical matters involved in its execution came from Menzies, who elected not to take any credit.

Although Menzies surely did his best to improve the film, one wonders if the dream sequence might have had a bit more gravitas if Dalí's scenes had been left in. As the film ultimately reveals, JB's amnesia stems from a guilt complex, originating in his childhood when he accidentally killed his brother by pushing him off a railing onto a fence. Dalí also had a brother who died as a child, though before the artist was born, and given his knowledge of Freudian symbolism surely could have added more convincing elements connoting JB's childhood

trauma had he been left to his own creative devices. Perhaps this was what was intended with Bergman's transformation into a statue, which may have invoked Freud's 1907 analysis of Wilhelm Jensen's novel *Gradiva* (1903), in which the main character's love for a Pompeii woman seen in a stone relief stems from the character's unresolved childhood feelings; similarly, as the film originally portrays Edwardes' murder as the result of JB's Oedipus complex, the dream's emphasis on eyes may contain some subtle Freudian baggage, recalling that in the Greek myth of Oedipus the title character blinds himself after learning he has made love to his mother Jocasta. If nothing else, the ballroom sequence might have offered a refreshing element to the dream sequence in which not everything is necessarily laden with transparent significance immediately relevant to the film's plotline. As Freud said, 'Sometimes a cigar is just a cigar'; there are no cigars in Menzies' dream sequence, nor, alas, is there a great deal of Dalí.

Destino, 1946

In *Dalí News* – the same mock-newspaper produced for his exhibition at New York's Bignou Gallery that heralded his collaboration with Hitchcock – Dalí announced that he and Walt Disney had also decided to produce a film, this time an animated one 'in a new medium never yet tried'. He could not provide details, but admirers of the 'soft watches' could be reassured, 'These will appear in the film and, thanks to the virtuosity of Disney and for the first time, one will be able to see how they move.'[49] Just before his Bignou Gallery exhibition opened, Dalí gave away another 'secret': He telegraphed the *San Francisco Chronicle* saying that the film would be called *Destino* and that it would be the perfect fusion of Technicolor photography and drawing. He would be arriving in Hollywood on 15 January to begin work.[50]

Dalí had met Disney earlier in 1945 at a party hosted by Jack Warner. The artist was a fan of the avuncular Disney, having identified him in 1937 as one of America's three great surrealists. Disney, meanwhile,

was in the midst of a precarious financial situation following the Second World War and was desperately trying to keep his studio afloat: Dalí must have seemed just the sort of publicity he needed, and further had the artistic notoriety Disney hoped would give credence to the new wave of artistic cartoons that had been spearheaded with *Fantasia* (1940).

When Dalí arrived at Disney Studios, he was teamed up with animator John Hench, whom Disney considered one of his most gifted artists. *Destino* was to be a six-minute animated short much in the style of *Fantasia* – on which Hench had worked as a sketch artist – based on a song by Armando Domínguez. According to Christopher Jones, Disney had originally intended to use the song for a short musical number featuring South American singer and dancer Dora Luz, who had appeared onscreen in *The Three Caballeros* (1944), but the word *destino* – 'destiny' in Spanish – 'sent Dalí into raptures, and he began creating wild, imaginative pictures to illustrate his emotions'.[51]

Dalí launched into *Destino* like a model employee: He arrived at Disney Studios punctually at half past nine each morning and formed genial relations with Disney, Hench and other employees.[52] Dalí's attitude was surely lifted by the tremendous liberty Disney gave him. Hench later recalled:

> Walt came in and looked at the work from time to time; he saw the storyboard in progress and decided to let Dalí go ahead and see what would happen. Walt was kind of entranced by the whole thing. They had a rapport from the beginning that was unusual. They got along remarkably, without much conversation – there was a sympathy there.[53]

Dalí's wife Gala confirmed the freedom Disney was affording Dalí, writing in a letter to Museum of Modern Art curator James Thrall Soby that Dalí 'has been working for ten days with Disney and it seems that for the first time he has enormous freedom to express his ideas. The

film will, in this respect, unquestionably be a complete success.'[54]

Inspired by Domínguez's love song, a loose narrative emerged from Dalí's drawings that he delineated for the French magazine *Arts* in April 1946:

First we see a very conventional garden scattered with statues and decorated in the middle with a fountain representing a swan. Then the garden disappears. The neck and the wings of the swan become the trunk and the ears of an elephant upside down. The elephant is transformed in turn into a pyramid on which there is engraved a head of Chronos towards which a young girl is walking. Suddenly the pyramid disappears and the long triangle it occupied on a canvas now shows the perspective of a road. The girl pauses on the road, and a moment later we see her riding on the back of a huge elephant with spider's legs among all sorts of monsters. Then the landscape changes and again we see a pyramid, accompanied this time by a church floating over a pond encircled by two human hands out of which two cypresses sprout. Around the pond circulate naked forms riding bicycles. The naked forms end up disappearing in the pond. At this moment a bell sounds a death-knell. The shadow of the bell fuses with the silhouette of the young girl and both begin to dance. The head of Chronos sculpted on the pyramid struggles free from the stone and also begins to dance, while at the same time trying to escape from a rain of monsters which falls from the sky all around. Chronos rips the monsters off his body and each time he does so a gaping hole opens in him.[55]

Another scene would feature a woman with snails for feet and a baby buggy for a head – a figure based on a 1930s 'exquisite corpse' game amongst Dalí, Gala, André Breton and Valentine Hugo[56] that had already resurfaced in January 1935 on the invitation for Caresse Crosby and Joella Levy's 'Oneiric Ball',[57] and again that February as part of Dalí's article, 'New York as Seen by Super-Realist Artist M. Dalí'.[58]

From such descriptions, it is clear Dalí had embraced animation's potential to bring his paintings to life. He had long regarded film as the most appropriate medium for realising the dissolves and double-images innate to 'paranoiac-critical' activity; now with animated drawing and the incredible facilities of Disney Studios at his disposal, literally anything was possible. Hench provides an example of Dalí's visual mechanism at work:

> We all know that DW Griffith invented everything in motion pictures, but Dalí fashioned an entirely new method that nobody had really ever thought about. Imagine a shot of two skiers in the snow. Nothing very startling about that. Just a pair of skiers. Then a panorama stops on a snowy hill. Nothing shows that the scene has changed, it's only that the skiers are out of the shot. Then the camera pulls back, and only now do we see the complete image. It's a nude, the naked hips of a woman! The substitution has been introduced very early in the sequence, but the eye continues to distinguish snow, maybe recognising feminine forms, until finally it must admit that there is a woman and nothing else.[59]

Dalí and Hench worked on various such dissolves for *Destino*, ultimately creating a 15-second sequence that Hench showed to Disney. The episode, though brief, is truly fantastic: Two grotesque heads mounted on the backs of tortoises come together; when they meet, the space between them created by their open mouths and deformed expressions forms the outline of a ballerina whose head becomes a baseball. Hench remembers Dalí's reaction at the first viewing:

> Salvador was back in Monterey, so once I finished filming the test, I drove up to show it to him. I tipped the manager of this little theatre that was showing some B Western to show it after the film was over and the audience had left. The lights went out, and Salvador saw his artwork in full motion. He loved it. Just then the projectionist came out

and practically roared, 'What was that?' Dalí and I looked at each other, and we both knew that it was a unique moment in art.[60]

Alas, the 'unique moment' was not to last. Amidst scepticism over whether the public would appreciate a wacky Dalí cartoon as well as a diminishing market for omnibus films, Disney called a halt to *Destino* in late 1946, though he indicated his hope that the film might be salvaged at a later date. This would explain Dalí's cryptic description of the film the following year in the second issue of *Dalí News*:

Ever since Dalí and Disney signed the contract to produce the first motion picture of the Never Seen Before, the most rigorous secrecy on this subject has prevailed. And in Walt Disney's studio reigns a silence like the silence of the mysterious place where the ciclotron [sic] is guarded. Only the ghostly silhouette of John Henges [sic] knows, perhaps, better than Disney and Dalí the technical secrets of the film, which will offer to the world the first vision of the 'psychological relief'. It is known for a fact that real espionage systems have been used in an effort to discover the innovations of the Disney–Dalí film. The Dial Press, which specialises in Dalínian secrets, is waiting for the date when the secrets will burst upon the public in the form of a book.[61]

Though *Destino* was not to get picked up during Dalí's lifetime, the amicability of the artist's collaboration with Disney is evidenced by the ideas 'Uncle Walt' continued to suggest for Dalí's consideration even after *Destino* had been shelved, including an animated *Inferno* sequence after Dalí's illustrations of Dante's *Divine Comedy*, an animated *Don Quixote* and a live-action film *El Cid*, starring Errol Flynn. Alas, none got off the ground.

But the story of *Destino* was not over. According to Christopher Jones, almost ten years after he stopped production on *Destino*, Disney discovered that almost all the major works Dalí had done – around 135

sketches and 32 paintings – had been stolen from the studio archives. Urgent pleas were made for their return, no questions asked, but nothing surfaced. Then after Disney's death in December 1966, when chief archivist Dave Smith asked Disney employees to donate any memorabilia they had collected, the Dalí paintings all reappeared.

Another dubious element to the *Destino* story concerns the multiplicity of animation cells: Obviously Dalí could not be expected to draw each cell, so his designs were picked up by other animators and copied to create the illusion of movement. There are thus hundreds of drawings that were copiously executed by Disney animators based on Dalí's designs – in short, hundreds of potential fake Dalís. Robert Descharnes remembers Dalí archivist Albert Field approaching the artist at the St Regis Hotel in New York with some newly-discovered artwork from *Destino*: Dalí apparently couldn't distinguish Hench's drawings from his own so he signed them all.[62]

In 1999, Walt Disney's nephew Roy decided to resuscitate *Destino*, a choice undoubtedly influenced by the discovery that Dalí's artwork, worth an estimated $10 million, was not legally Disney's property until after the film was made. Produced by Baker Bloodworth and directed by Dominique Monfrey, the finished *Destino* premiered on 2 June 2003 at the Annecy International Animated Film Festival and was met with wide acclaim, including a 2003 Academy Award nomination for Best Animated Short Film; it also featured in the 2004 *Dalí, Mass Culture* exhibition and was shown under limited engagement at the 2004 Dalí Centenary Exhibition at the Philadelphia Museum of Art. Although Hench worked closely on *Destino*'s completion before his death in 2004, one can deduce that the 2003 adaptation deviates from Dalí's original ideas, or at the very least it doesn't precisely follow the storyline he provided in 1946. It also doesn't include all the scenes for which Dalí seems to have produced drawings – e.g., the church encircled by two hands; the figure with snail feet, etc. Indeed, in my opinion, the most visually compelling sequence of the completed *Destino* remains the 15-second clip of the figures forming the ballerina, which has an unmistak-

ably more macabre tone to it than the rest of the film; it is also the only segment on which Dalí worked personally with Hench.

Father of the Bride, 1950

Whilst much – indeed, perhaps *too* much – has been made of Dalí's participation on *Spellbound* and, more recently, *Destino*, very little has come to light on the other dream sequence that materialised during his collaboration with Hollywood, that for Vincente Minnelli's 1950 motion picture comedy *Father of the Bride*, starring Spencer Tracy as the tight-fisted Stanley T Banks and Elizabeth Taylor as his ravishing young daughter Kay, engaged to be married to one Buckley Dunstan (Don Taylor).

Having encountered the explosive price of his daughter's unanticipated wedding, Tracy's 'nuptial nightmare' occurs about three quarters' way into the film. He dreams of arriving late to the ceremony. Superimposed against his own terrified eyes and the shocked grimaces of various guests, he struggles to make his way down the black-and-white chessboard aisle that disintegrates under his feet, shredding his trousers and the sleeves of his morning coat. As he works his way towards the altar, the floor begins to bounce like a balloon. Some unidentified hindrance grabs hold of his leg, impossibly stretching it like a rubber band until the trousers tear away, leaving the bewildered patriarch in his pants and the remains of his shirt and waistcoat. Mysterious forms under the floor rise up and force him off his feet, at which point Kay lets out a terrified scream and Tracy awakens in his bed with a start.

Father of the Bride's marginalisation in Dalí's history with film is surprising, as it was the last realised Hollywood picture to which he would directly contribute and, with *Spellbound*, one of only two that would materialise during his lifetime. Though the film's light-hearted tone makes Tracy's nightmare – which lasts just under a minute – more comical than terrifying, its voyeuristic eyeballs, soft floor and starkly contrasting lights and shadows are straight out of Dalí's frightful imagination. At the same

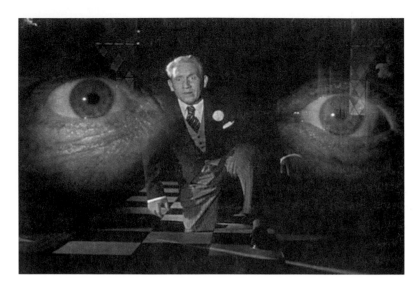

Spencer Tracy arrives late to his daughter's wedding in the 'nuptial nightmare'. *Father of the Bride*, 1950. Directed by Vincente Minnelli; Produced by Loew's international corporation, New York.

time, the sequence is welcomingly void of overt clichés of Surrealist imagery: There are no bicyclists or swarming ants. Instead, Dalí subtlely interprets Tracy's reluctance to relinquish the past and accept that his little girl has become a woman as a force that holds him back from the altar. This echoes other symbolic manifestations of burden in the artist's scripts, including the pianos from *Un Chien Andalou*, Bobo encumbered with an iron bed in *Moontide* and the head of Chronos struggling free from the stone pyramid in *Destino*; indeed, the scene of Chronos in Disney's 2003 animated short closely resembles Tracy's struggle.

In the end, the dream sequence may be amongst the most memorable and amusing scenes in the film, though in most respects it is not particularly inspired compared with some of Dalí's other cinematic visions. It is perhaps for this simplicity, though, that unlike its predecessors, it was actually filmed.

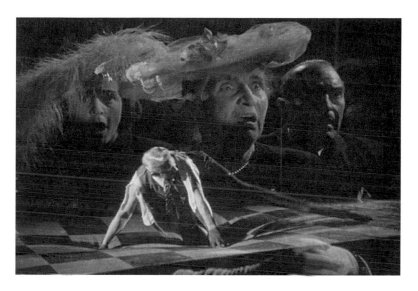

Spencer Tracy makes his way down the soft aisle. *Father of the Bride*, 1950. Directed by Vincente Minnelli; Produced by Loew's international corporation, New York.

The Temptation of Saint Anthony, 1946

Up until now we've limited our enquiry to films that Dalí conceived himself or in which his designs played a pivotal role. A relevant extension of this is his 1946 painting, *The Temptation of Saint Anthony*. Michael Taylor thoroughly discusses the circumstances surrounding this painting's execution in his thoughtful essay, 'Salvador Dalí's *Temptation of Saint Anthony* and the Exorcism of Surrealism', reminding us that this, one of Dalí's most celebrated canvases – now in the collection of the Musées Royaux des Beaux-Arts de Belgique, to which it was donated by its first owner, Anne-Marie Robiliart – was intrinsically connected to the cinema, having been executed specifically for a juried art competition publicising Albert Lewin's motion picture *The Private Affairs of Bel-Ami*.[63] Dalí was one of 12 artists that also included Max Ernst, Dorothea

Tanning and Ivan Albright who were chosen for the Bel-Ami International Competition, which asked its participants to submit a 36" x 48" unframed painting on the theme of the temptation of Saint Anthony, the story of the third-century saint who virtuously gave away his family's fortune, thereby provoking the ire of the Devil who tempted him over the course of several years with all manner of vice. The winning painting would appear in Lewin's film, and its artist would receive a cash prize of $3,000 (all others would receive $500 each).

As Taylor recounts, the director's decision to use *The Temptation of Saint Anthony* rather than Karl Marcovitch's *Christ Walking on the Water*, as in Guy de Maupassant's original 1885 novel *Bel-Ami* on which the film was based, was 'an inspired one, since the subject had traditionally provided artists with an opportunity to pursue their wildest flights of fancy'.[64] Saint Anthony's vivid hallucinations, which interrupted his sleep for 15 years, were a *carte blanche* for artists to invent fantastic visions of demons, gargoyles and lascivious concubines. Whereas for Ernst this evoked a terrorising swarm of insectoid demons besieging an anguished Saint Anthony robed in crimson and lying in position not altogether unlike the central figure in Fuseli's *Nightmare* (c. 1782), for Dalí the subject was far less chaotic: Reportedly painted during the winter of 1945–1946 in a studio that he had rented for a few days next to the Colony Restaurant in New York,[65] in Dalí's rendition a naked Saint Anthony rests on one knee in the bottom-right corner, supporting himself on a rock and brandishing a crucifix to ward off the parade of gigantic 'monsters' that stride across the desert landscape to threaten him. These horrors include elephants on spider legs porting naked women and obelisks and led by an enormous white horse that recalls not only Dalí's own *Debris of an Automobile Giving Birth to a Blind Horse Biting a Telephone* (1938), but also Picasso's *Guernica* (1937). The spindly-legged pachyderms, which Dalí described as the 'paranoiac hallucinations of his [Saint Anthony's] temptation', had appeared in his work before, in his paintings *Dream Caused by the Flight of a Bee around a Pomegranate One Second Before Awakening* (1944) and

Melancholic, Atomic, Uranic Idyll (1945), and may have been partially indebted to Sir John Tenniel's 1870 illustrations of Lewis Carroll's *Through the Looking Glass*. This second part to *Alice's Adventures in Wonderland* was much admired by the Surrealists and included an illustration of a 'rocking-horse fly', a tiny, insect-legged wooden horse that propels itself by swinging from branch to branch. The elephants with obelisks were meanwhile derived from Gian Lorenzo Bernini's 1667 sculpture in the Piazza della Minerva in Rome,[66] a sculpture Dalí very likely saw first-hand during one of his stays at the opulent Roman mansion of Lord Gerald Berners. Bernini's elephant – affectionately known to locals as *Pulcino della Minerva* ('Minerva's chick', an adaptation of *Porcino della Minerva* ['Minerva's Piggy'], jocularly referring to the sculpture's girth[67]) – was conceived in 1665, when an Egyptian obelisk was discovered in the garden of a local church built over the ruins of a temple dedicated to Minerva, the Roman goddess of knowledge. Pope Alexander VII thought it fitting that the obelisk should be erected in front of the church where it was found and commissioned a number of artists to design a base. Bernini's proposal for the elephant originated from a woodcut illustration for Francesco Colonna's 1499 *Hypnerotomachia Poliphili* (*Poliphil's Dream of the Love Battle*), one of the first books printed in Italy. The Pope judged the elephant a good choice given its connotation of strength and stability (one side of the base now reads, 'a strong mind is needed to support a solid knowledge').[68] Of course, Dalí's decision to support the heavy animals in *Temptation of Saint Anthony* on fragile legs effectively undermines the original sculpture's sense of stability, thus giving the elephants their fantastic, paradoxical quality.

The competition judges – Museum of Modern Art director Alfred Barr, Jr, art dealer Sidney Janis and Dalí's close friend, the artist Marcel Duchamp – ultimately named Ernst the winner, with Ivan Albright in second place and Paul Delvaux in third. It's likely that Lewin's plan to make the painting the only colour shot in the otherwise black and white film influenced the decision, as Ernst's painting, now at the Wilhelm-

Lehmbruck-Museum in Duisburg, Germany, was decidedly more visually jarring than Dalí's and thus perhaps more suitable for this dramatic purpose. While Dalí's painting was awarded a meagre fourth place, it was amongst the most popular pieces on the subsequent exhibition tour and has since become one of his most widely-recognised and reproduced oils.

Later Films

Although the title 'Surrealist' was more or less bestowed and revoked at André Breton's discretion, the aesthetic rupture between Dalí's 'Surrealist' and 'Ex-Surrealist' painting was largely delineated – and exaggerated – by Dalí himself. The painter was not reticent to directly oppose his 'classical' outlook – heralded in the catalogue for his 1941 exhibition at the Julien Levy Gallery, in his essay 'The Last Scandal of Salvador Dalí' – with his 1930s production, which he belittled as merely 'experimental'.[1] Over the next 40 years he declared his work was no longer 'Surrealist', yet he abandoned neither the paranoiac-critical method nor identifying himself as the only true Surrealist. Certainly his 1941 partition provides a convenient means of identifying a turn in his work: Thinly-veiled Freudian symbols give way to geometrically-organised mythological subjects. But while esteemed commentators have emphasised the severity of the 1941 'classical' shift, closer examination reveals as many continuities as differences between the artist's 'Surrealist' and 'classical' styles. While the case can – and, in my opinion, should – be made that Dalí's 40 years of pictorial output following his break with Surrealism in 1939 was neither the aesthetic chasm he pretended it to be nor the hollow commercialism critics have judged it, the evidence for continuity is all the more persuasive with regards to his film scripts – particularly those classified here as 'later films' – due largely to his habit of taking from past projects. *Impressions of Upper Mongolia – Homage to Raymond Roussel* (1975) is perhaps the cinema's most exhaustive use of the close-up that Dalí had lauded in the 1920s, launching its story

from a microscopic zoom that focuses on the scratches and stains on a ballpoint pen. Also in the legacy of 'anti-art film', both *The Wheelbarrow of Flesh* (1948–1954) and *The Prodigious Story of the Lacemaker and the Rhinoceros* (1954–1962) were described as 'exactly the opposite of an experimental *avant-garde* film, and especially of what is nowadays called "creative", which means nothing but a servile subordination to all the commonplaces of our wretched modern art'.[2] It is perhaps unsurprising, then, that certain scenes in *The Prodigious Story of the Lacemaker and the Rhinoceros* bear a striking resemblance to *Un Chien Andalou* – indeed, as the ultimate in auto-pilfering, in 1959 Dalí had his archivist Albert Field request permission from Buñuel for scenes from *Un Chien Andalou* to be recycled in *The Prodigious Story of the Lacemaker and the Rhinoceros*.[3] Though this bid was unsuccessful, *Un Chien Andalou*'s famous opening would be resurrected in 1975 for the introduction to *Impressions of Upper Mongolia – Homage to Raymond Roussel*.

Such continuities confirm that the artificial partitions that have been constructed amongst Dalí's early, Surrealist and long-censured 'late' production have been unnecessarily exaggerated. What is perhaps more true, at least in terms of cinema, is that after *L'Âge d'Or*, Dalí simply never again had access to a director as talented as Buñuel who could help bring his eccentric ideas to the screen; he was never able to single-handedly direct a picture. It is undoubtedly for this that over the years Dalí repeatedly tried to persuade Buñuel to collaborate on another film, though he wouldn't receive a response until his last pitch in 1982, '*The Little Demon*', by which time both were too aged to embark on any such venture.

In this last section I often employ the term 'film' in favour of 'cinema'. Despite Dalí's access to the top names in the industry – Alfred Hitchcock, Orson Welles, Samuel Goldwyn, Marlene Dietrich, Marilyn Monroe, Grace Kelly, Jacques Tati, Shirley Maclaine, Warren Beatty, Yul Brynner, Mia Farrow, Ali MacGraw, Brigitte Bardot, Darryl Zanuck and Otto Preminger, to name only a few – of his ideas that *did* come to

fruition after *Father of the Bride*, none was made expressly for the silver screen. *The Prodigious Story of the Lacemaker and the Rhinoceros* was, as we'll see, less a cinematic project than a visual sketchpad, *Chaos and Creation* (1960) pioneered video art rather than cinema and *Impressions of Upper Mongolia – Homage to Raymond Roussel* was made for television, raising the question of how Dalí viewed TV – as a purely vulgar medium, as Amanda Lear suggests, or as a platform potentially on a par with cinema when the right eye is behind the camera. One may remember the 1956 CBS programme Dalí directed at the height of his 'atomic period' that superimposed a cauliflower onto a rhinoceros horn, Jean-Christophe Averty's television documentary *Soft Self-Portrait of Salvador Dalí* (1967), the wonderfully amusing 'Happenings' he shot for French television in the 1970s, his Emmy Award-winning 1972 interview with Russell Harty for the UK television programme *Aquarius* and his 1978 television special, *1001 Visions de Salvador Dalí*, in which he interviewed the Romanian philosopher Stéphane Lupasco and Professor

Dalí filming the 'Happening' at the conclusion of *Impressions de la Haute Mongolie – hommage à Raymond Roussel*, 1975. Directed by José Montes-Baquer; Produced by Westdeutsches Fernsehen.

André Robinet, an expert on Nicolas Malebranche; he is also said to have worked on a stereoscopic television channel with the American company Video Head. I touch on only a few of these projects here, but if Robert Descharnes is correct in saying, 'For Dalí, a camera was a camera [...] The important thing was the film *when he intervened*', mightn't one be just in describing them all as mini-'films'? Further, how many of these actually survived? When Russell Harty asked Dalí, 'When was the last time you made a film like the one we're doing?' Dalí quickly answered, 'One everyday.' This must be an exaggeration, but certainly he had the equipment and means to make a short documentary of himself as often as he liked. Pushing the boundaries yet further, what about the TV advertisements he made for Braniff Airlines and Lanvin Chocolates – who can forget his expression when he declares himself *'fou de chocolat Lanvin'*? One of the agents who worked with Dalí on his 1974 commercial for Alka-Seltzer, in which he painted the medicine's effect (literally) on the Spanish model Natividad Abascal, remembers that the artist 'had no understanding of the 30-second time frame. He assumed that the commercial would start when he did and end when he was finished. Four minutes, five minutes, whatever';[4] it sounds like Dalí had more of a *film* in mind than a short advert, doesn't it? While I have tried to make this introductory guide to Dalí and the cinema as complete as possible, the subject is potentially far-reaching, encompassing his work with television, photography, stereoscopy and even holography. Plainly all this is beyond my scope, but to gain a true appreciation for Dalí's film work, one would be well-advised to explore these other relevant areas, too.

Wheelbarrow of Flesh, 1948–1954

I have positioned Dalí's unrealised script *Wheelbarrow of Flesh* here to launch his 'later films', though the script touches on many areas of his cinematic development and might equally have been inserted into one of the other sections: Its themes are perhaps most closely aligned with

his 'Surrealist' scripts – the symbol of the wheelbarrow was directly derived from his writings of the early 1930s; at the same time, it was conceived in California and was originally to star Paulette Goddard, one of Paramount's top actresses, and thus might have capped Dalí's 'Hollywood' period, though this wouldn't be fully accurate as it almost immediately became a chiefly European venture, perhaps due to Dalí's inability to interest the Hollywood establishment with his scenario. Justifying its presence in this section, Dalí touted *Wheelbarrow of Flesh* as the first 'Neo-mystical' film, by which he meant that it would 'integrate in realism [...] the tradition which is typical to the spirit of Spain'.[5] This suggests that the film should foster a fecund rapport with his 'later films' conceived under the rubric of 'Nuclear Mysticism' – specifically *The Prodigious Story of the Lacemaker and the Rhinoceros*, with which *Wheelbarrow of Flesh* seems to have had some cross-over.

As Dalí tended to elaborate on his projects the longer he worked on them, the first version of *Wheelbarrow of Flesh*, a script in English preserved at the Fundació Gala-Salvador Dalí, is the most straightforward. It features only four unnamed principal characters: a shepherdess and young man, a hunter and a convict. The film opens with the young man working alone on the stone wall of his vineyard far from the village. He is approached by the shepherdess, who flirts with him and uses the wheelbarrow as a table for meals between them. At one point the young man is overcome by desire and lunges at the shepherdess. A nearby hunter witness to the man's attack shoots and kills him, then escapes into the forest. The shepherdess puts the young man's body in the wheelbarrow and takes it to the village, where the hunter confesses his crime, explaining that he was only preserving the shepherdess's honour; he is sentenced to three years in prison. The shepherdess then joins a band of gypsies, during which time she becomes deliriously attached to the wheelbarrow, which she fills with all her small possessions. When the caravan makes plans to leave and the gypsies tell her that she must leave the wheelbarrow behind, she refuses, opting instead for a solitary life completely centred on the wheelbarrow. After various hallucinations

of her lover and the hunter, the shepherdess visits the hunter in prison, where he promises to marry her. She accepts, but soon after she is admitted to a mental hospital. Upon leaving the hospital, she finds her wheelbarrow again, which has now inexplicably become flesh – as Dalí notes, 'it breathes and bleeds'.[6] The hunter's friend, a convict, meanwhile seeks out the shepherdess to tell her that her fiancé is soon to be released. The hunter is released a day early, however, and when he goes to the shepherdess's house to surprise her, he finds her with his friend, who has removed his shirt to show her a tattoo on his chest. The hunter thinks he is betrayed, kills his friend, and is re-arrested. He returns to prison while the 'mad shepherdess' remains alone, clinging to the wheelbarrow, refusing to eat or move. The villagers feel the wheelbarrow is a bad omen and want it burned, but the village priest, whom Dalí describes as having the face of Freud, forbids anyone from taking the wheelbarrow, saying that the shepherdess must be the one to destroy it in order to regain her sanity. Left alone, the shepherdess takes up an axe and splinters the object of her neurotic affections. As the film closes, she picks up some of the wheelbarrow's debris – a wooden cross filled with nails – and presses it to her bosom. Dalí concludes his script by delineating the ten manifestations the wheelbarrow has taken throughout the story: a table, a nuptial bed, a coffin, a cupboard, a cradle, a bird's nest, a cat's bed, a flesh wheelbarrow, an altar and a Cross.

By the time Dalí penned his next version of the script, still in 1948, the story had become considerably more developed, not to speak of the crew that now included Alberto Puig Palau as producer, André Cauvin as photographer and assistant director and one Reverend Dr Roquer as 'theological supervisor'. In the second script, the shepherdess, persistently identified by name as the Italian actress Anna Magnani, is a much deeper character. The story now opens with her taking care of her father in a Catholic hospital; he is without arms, and his legs are cut at the knees, thus necessitating kneepads. When she is not rubbing lotion on her father's legs as he sits on a stack of cushions set up in a wheelbarrow, she cleans obsessively, particularly the wheelbarrow that serves

as her father's 'cradle'. When her father passes away from typhus, Magnani returns to the hospital to arrange the burial and discovers that the nuns plan to burn all her father's clothes and the wheelbarrow as a hygienic measure. Magnani is furious and tells the sisters that nothing she cared for could be dirty; she pulls the wheelbarrow from the fire along with the cushions and her father's kneepads. The nuns insist that the items must be burned by order of the doctor, at which Magnani takes a cross from the wall and breaks it, manifesting her contempt with a scandalous sacrilege.

Magnani manages to keep the wheelbarrow along with some of her father's rags and disappears from society by joining a travelling gypsy caravan. She begins a new life with the gypsies, though she is more obsessed with cleaning than ever. Amongst the characters that surround her life in the camp is the hunter, whom Dalí describes as a cross-eyed Andalusian known as Pacigán. Though Pacigán does not intentionally spy on Magnani, he sees her take up a relationship with a road labourer, whom she meets every week as she takes her clothes in the wheelbarrow to launder them. As in the first scenario, the labourer is eventually overcome with passion and lunges at Magnani, throwing her into the wheelbarrow to make love to her. Pacigán, out hunting with his two dogs, hears their shouts of passion and in a fit of rage shoots the labourer in the back, leaving him dead in Magnani's embrace as she lies prostrate in the wheelbarrow.

After fighting off Pacigán's dogs, Magnani puts her lover's body in the wheelbarrow and takes it into town; thus, as Dalí notes, the nuptial bed becomes a coffin. When she enters the town, the inhabitants surround the wheelbarrow. Pacigán stoically admits that he is the culprit and that he killed the man to save Magnani's honour. He makes a small package of personal belongings out of a handkerchief and follows the Civil Guard members to the prison in the Castle of Figueres – presumably the Castle of San Fernando of Figueres, just outside the city. Following these events, the wheelbarrow adopts in Magnani's imagination a delirious character. She continues living with the gypsies and manically cleaning,

though she disappears for hours at a time to hide her wheelbarrow in the wilderness. Also, every week she goes to the prison to take clean clothes to Pacigán. After many conversations, Pacigán promises he will marry her upon his release. Soon after, Magnani discovers a refuge for her wheelbarrow: the lake at Vilabertrán. As she digs holes in the mud that surrounds the lake, her subconscious vivifies the wheelbarrow, which now seems to exhibit tenderness as if it were living. As Magnani considers the love she has for this wheelbarrow, a 'Wagnerian ecstasy' overcomes her, and she spies in the centre of the lake a small bed of grass, perfect for concealing her fetish object. She attempts to take the wheelbarrow to the small island but it sinks in the mud. Ever determined, she ties the wheelbarrow around her neck and ventures into the lake. She gets about halfway before sinking into the mud herself; she begins to drown and is saved by nearby farmers who hear her cries for help. Unfortunately, the wheelbarrow is lost in the lake during the rescue, throwing Magnani into a deep madness: All she retains now are her father's kneepads and some straps from her deceased lover.

The next two years see the gypsies travelling around Spain, with Magnani still suffering from the loss of her wheelbarrow. When the group returns to Vilabertrán, the hot summer has dried up the lake, and Magnani discovers to her delight that she is able to retrieve the now horribly decrepit wheelbarrow from the lake. Sure that the wheelbarrow is alive, she conceives it to be soft and meaty, breathing like a living being. The gypsies encamp just outside Cadaqués, and Magnani finds a grotto – presumably at Cap de Creus – where she hides the wheelbarrow. She covers it with diverse objects, but its structure is too rotten and it can no longer hold all its cargo; Magnani repairs it with two crossing sections of wood affixed by large nails.

Soon the gypsies are fed up with Magnani's delusions and they expel her from the camp. Now living on her own, Magnani is visited one day by a friend of Pacigán who – as in the first script – has come to tell her that her fiancé is to be released from prison. In a Biblical reference to Thomas the Apostle, who doubted Christ's resurrection until he was

able to touch his wounds, Magnani doubts the friend and suspects him to be an apparition, prompting him to remove his shirt so that she may touch the tattoo on his shoulder. As before, though, Pacigán is let out of prison early for good behaviour and arrives just as his friend is standing before his fiancée with a naked torso. Thinking himself betrayed, Pacigán stabs his friend, killing him. The Civil Guard arrives: Pacigán collects his belongings and returns to prison.

Seeing her fiancé taken to prison for a second time and realising that now two men have died because of her sends Magnani into severe depression. She doesn't want to work or eat, nor, for the first time, does she even clean. People begin to suspect the wheelbarrow may be bewitched and want it destroyed. One day Magnani enters the church with her wheelbarrow; a tumult erupts of people wanting to burn the wheelbarrow, but the priest (Freud) warns them that destroying it would only suppress the object of her delirium; Magnani must destroy it herself. Magnani takes up an axe and attacks the wheelbarrow, leaving only the two crossed bars of wood she unconsciously nailed to the bottom in the form of the Cross. The Cross, Dalí explains, symbolises Magnani's religious faith, achieved through the transformation of her pathological fetishism. 'In all the non-civilised cultures,' Dalí told the jour nalist Manuel del Arco in 1949, speaking of *Wheelbarrow of Flesh*, 'religion exists in a state of fetishism. Herein lies the explanation of my purpose.'[7]

Following the events of the Spanish Civil War, Dalí had publicly declared himself a Catholic, albeit one who lacked faith.[8] Though many doubted him, he insisted on the sincerity of this Catholic outlook, and even received an audience with Pope Pius XII in 1949, at which the Pope apparently blessed his painting *The Madonna of Port Lligat* (1949). It is with this desire to persuade sceptics of the sincerity of his religious turn that *The Wheelbarrow of Flesh* is contextualised. The story's journey from paranoiac fetishism – exhibited by 'non-civilised' cultures, Dalí notes, suggesting in its comparison of primitive cultures to neurotic ailments the influence of Freud's *Totem and Taboo* – to salvation was not

altogether unaffected by the spiritual evolution he viewed in himself that he was indefatigably struggling to legitimise; hence his enlistment of a theological supervisor, who was presumably meant to provide expert counsel for *Wheelbarrow of Flesh*'s religious message.

By July 1949, the parade of sequences Dalí had envisioned for *Wheelbarrow of Flesh* had spiralled out of control. Speaking to Manuel del Arco, whose interviews for *Diario de Barcelona* would be published three years later in 1952 as *Dalí al desnudo* (*Dalí in the Nude*), Dalí relayed that in the most recent scenario the wheelbarrow had no fewer than *82* symbolic manifestations! The story also now featured a group of cyclists plunging down the rocks of Cap de Creus, harking back to *Babaouo* ('at the end of the scene the whole landscape is full of dead cyclists), and a bald woman dressed as a bullfighter shivering in the lake of Vilabertrán.[9]

Just as the iron bed in *Moontide* was to signify Bobo's burdened emotions and the pianos proposed for *Spellbound* were to suggest weighty tension, so Dalí wanted all the images in *Wheelbarrow of Flesh* to have a poignant meaning: 'Nothing is arbitrary', he told del Arco. 'Everything explains the emotional problem of that mad woman; but the public must understand it'.[10] If Dalí needed his audience to understand *The Wheelbarrow of Flesh*, however, this was unlikely, as the symbolism of the film was so wrapped up in his own idiosyncratic psychoanalysis. The script's fundamental image – the wheelbarrow – was a heavily burdened object in Dalínian psychology, originating from Jean-Francois Millet's painting *L'Angélus* (1857–59). At the time of writing *Wheelbarrow of Flesh*, Dalí had already written two important texts on his fascination with *The Angelus*, the serene painting of a peasant couple pausing from their work to pray at the 'hour of the Angelus' (6pm): a 1933 essay published in *Minotaure*, 'Paranoiac-Critical Interpretation of the Obsessive Image of Millet's Angelus',[11] and a book manuscript, *The Tragic Myth of Millet's Angelus*, written in the 1930s, then lost and published upon its rediscovery in 1963.[12] In these texts, Dalí dissected his fascination with Millet's painting, which

Bicyclists with bread on their heads traversing a landscape. *Babaouo*, 2000; Based on a script by Dalí. Directed by Manuel Cussó-Ferrer; Produced by Kronos Plays and Films S.A.

Destino, 2003. Directed by Dominique Monfery; Produced by Baker Bloodworth. ©Buena Vista Pictures/Photofest.

Photograph of the rock formation Eagle at Cape de Creus, the setting for *The Catalan Blood*. ©
Salvador Dalí Museum Archives, Salvador Dalí Musuem, Inc. 2007, St Petersburg, Florida, US.

Dalí banging a piano with cats in the opening to *L'autoportrait mou de Salvador Dalí*. Directed by
Jean-Christophe Averty; Produced by Coty Television and Seven Arts Ltd., 1967.

Dalí photographed during the shooting of *The Prodigious Story of the Lacemaker and the Rhinoceros*. Here he indicates the 'goose pimples' he wanted to provoke on the model by scraping bayonets across the suspended marble slab. Paris, November 1956. Photograph by Robert Descharnes ©DESCHARNES/daliphoto.com

Playing the wizard, Dalí turns a landscape with three cypress trees into the face of a sleeping woman (note the nostril!). *L'autoportrait mou de Salvador Dalí*. Directed by Jean-Christophe Averty; Produced by Coty Television and Seven Arts Ltd., 1967.

The portrait of Raymond Roussel appears in the stains on a ballpoint pen: *Impressions de la Haute Mongolie – hommage à Raymond Roussel*, 1975. Directed by José Montes-Baquer; Produced by Westdeutsches Fernsehen.

Dali interpreted this stain on the pen's copper band as an island surrounded by the blue sea. *Impressions de la Haute Mongolie – hommage à Raymond Roussel*, 1975. Directed by José Montes-Baquer; Produced by Westdeutsches Fernsehen.

The incredible *boligrafo* floating through space. *Impressions de la Haute Mongolie – hommage à Raymond Roussel*, 1975. Directed by José Montes-Baquer; Produced by Westdeutsches Fernsehen.

A double-image: This way the head of a lion, but upside-down it becomes a fly resting on a leaf. *Impressions de la Haute Mongolie – hommage à Raymond Roussel*, 1975. Directed by José Montes-Baquer; Produced by Westdeutsches Fernsehen.

he described as 'the most troubling of pictorial works, the most enigmatic, the most dense, the richest in unconscious thoughts that had ever existed'.[13] This fascination, illuminated through Dalí's expert knowledge of Freud, revealed to him a dead child concealed by the basket between the man and woman, as well as a sexual narrative based largely on the wheelbarrow. According to Dalí, *The Angelus* was chiefly the Oedipal story of a man protecting his genitals from castration, faced with the matriarchal female who is depicted in the pose of a praying mantis (the female of the species, it was believed, devoured the male during copulation) and intent on reducing him to a mere instrument of labour – a wheelbarrow. In the prologue to *The Tragic Myth of Millet's Angelus*, Dalí accounts for this concentration on the image of the wheelbarrow in the painting:

> We know that peasants, because of the severity of their labours, overwhelmed by physical fatigue, have a tendency to eroticise all the work tools that come to hand in a sort of 'atavistic cybernetic' way, the wheelbarrow being 'the supreme, blinding phantasm', because of its anthropomorphic structure and its possibilities of functioning symbolically [...] Let us look at it. The mother, who could well be a variation of the phallic mother with a vulture's head of the ancient Egyptians, uses her husband, whimsically 'depersonalised' into a wheelbarrow, to bury her son while at the same time causing her own impregnation, being herself the foster-mother-earth par excellence.[14]

The narrative for *Wheelbarrow of Flesh* is not precisely the same, but its psychoanalytic base and focus on the wheelbarrow as a symbolically-functioning object remains strong; indeed, in *The Tragic Myth of Millet's Angelus* Dalí described the *Angelus* as offering 'the most revolutionary of "secret" scenarios' for anyone 'who would dare to make the most ambitious of films'.

Dalí continued to rework and elaborate upon his ideas for the script through the mid-1950s with no directorial presence to keep him

focused only on relevant material. The June 1953 entry in his *Diary of a Genius* expounded on the latest ideas for the film, which now included: five white swans stuffed with explosive pomegranates that would detonate 'so that it will be possible to observe with all due precision the explosion of the birds' entrails and the fan-shaped burst of pomegranate seeds which will hit the cloud of feathers as one might imagine the corpuscles of light bump into each other';[15] six rhinoceroses falling one after the other into Rome's Trevi Fountain; a shot of Paris' Place de Concorde at daybreak slowly being traversed by 2,000 priests on bicycles, each carrying a placard bearing the effigy of Soviet Premier Georgy Malenkov; 100 Spanish gypsies killing and cutting up an elephant in a Madrid street; a singing scene in which Friedrich Nietzsche, Freud, Ludwig II of Bavaria and Karl Marx sing their doctrines, 'answering each other antiphonally' to some music by Bizet; and an old woman dressed as a torero standing in the frigid Lake Vilabertrán and balancing an *omelette aux fines herbes* on her shaven head – each time the omelette slides off and falls into the water, Dalí notes, a Portuguese will replace it with a fresh one.[16]

Dalí's description illustrates his desire to recuperate from his past projects to make *The Wheelbarrow of Flesh* all the more 'prodigious': His description that the film would include 2,000 priests on bicycles recalls his designs for *Babaouo*, *Destino* and the ballet *Colloque sentimental* (1944), having originated in his 1929 painting *Illuminated Pleasures*. The 'exploding swan', too, may at the time have invoked Dalí's interest in atomic disintegration as illustrated by the painting *Leda Atomica* (1947–49), though it was not so divergent from the exploding giraffes *The Secret Life of Salvador Dalí* cited in reference to *Giraffes on Horseback Salad*.[17] Even the curious meeting of Nietzsche, Freud, Ludwig II of Bavaria and Karl Marx is reminiscent of the painting *Instantaneous Presence of Louis II of Bavaria, Salvador Dalí, Lenin, and Wagner on the beach at Rosas* (1934) – now known by the no less sesquipedal title, *A Chemist Lifting with Extreme Precaution the Cuticle of a Grand Piano*, according to A Reynolds Morse – which, Dalí said,

symbolised the book he planned to write after his novel *Hidden Faces* (1944), in which are coupled 'all the real and fantastic personages of the modern tragedy'.[18] The film looked towards Dalí's future cinematic exploits, too: His desire to include rhinoceroses plunging into the Trevi Fountain and his repeated use of the term 'prodigious' in the film's description insinuates a continuity between *The Wheelbarrow of Flesh* and *The Prodigious Story of the Lacemaker and the Rhinoceros*, the latter film begun just a few months after the magazine *La Parisienne* disseminated his latest inspirations for *Wheelbarrow of Flesh* in his essay 'My Cinematographic Secrets'.

As one can see, the promise of a good script was undermined by Dalí's inability to finalise his ideas – a problem we will observe again when our attentions turn to *The Prodigious Story of the Lacemaker and the Rhinoceros*. Dalí's boundless imagination, bent on augmenting a film by introducing scenes well beyond the confines of narrative unity, made finishing *Wheelbarrow of Flesh* impossible. Had he been able to stop with the second script featuring Anna Magnani, the film might have been a powerful story of religious actualisation from paranoiac delirium; instead, Dalí failed to heed his own advice on painting from *Fifty Secrets of Magic Craftsmanship*: 'There comes a point where you run the risk of overlabouring and over-refining it instead of finishing it, and thus of ruining your work in the most disastrous fashion.'[19] In the six years of its development, Dalí overlaboured *Wheelbarrow of Flesh*, and the whole thing fell apart like a rotten wheelbarrow left to perish in the lake of Vilabertrán.

The Soul, c. 1948–1954

Very little is known of the short script *The Soul*. The scenario, probably written about the same time as *Wheelbarrow of Flesh*, was discovered in the files of Luis Marquina and published in *Contracampo* magazine in 1983 and thence by the Fundació Gala-Salvador Dalí in 2004, when it was presented as a third script for *The Wheelbarrow of Flesh*. Perhaps

this was because in both scenarios there is a period of juvenility leading to maturation in religion: *The Soul* was to visually materialise Saint Teresa of Avila's metaphor for the self that must die to become one with Christ, just as a silkworm 'dies' to become a beautiful white butterfly, whereas *Wheelbarrow of Flesh* concentrated on the transformation from paranoiac fetishism to religious faith. Also like *Wheelbarrow of Flesh*, Dalí heralded *The Soul* as the 'first neo-mystical film'. Whereas *Wheelbarrow of Flesh* was to be produced by Alberto Puig Palau, however, Dalí apparently solicited another patron, a certain George Gregori, to finance this production in which Dalí was to serve as author, producer and director, assisted by cameraman Jon Milá. Also unlike *Wheelbarrow of Flesh*, which was slated to feature Paulette Goddard or Anna Magnani – two major names in cinema – Dalí specified that *The Soul* would not include any professional actors – only the fishermen of Port Lligat and other lay people around Spain, where the entire film would take place. It seems to me, then, that *The Soul* so differs from *Wheelbarrow of Flesh* that it was probably its own distinct project.

Dalí's interest in Saint Teresa of Avila is well-established: Jeremy Stubbs has convincingly argued the relevance of Saint Teresa's ecstasy in the 1933 collage *The Phenomenon of Ecstasy*, with its Art Nouveau pin standing in for the flaming, phallic spear that the Saint recounted in her autobiography as having sent her into a religious euphoria:

In his [an angel's] hands I saw a great golden spear, and at the iron tip there appeared to be a point of fire. This he plunged into my heart several times so that it penetrated to my entrails. When he pulled it out, I felt that he took them with it, and left me utterly consumed by the great love of God. The pain was so severe that it made me utter several moans. The sweetness caused by this intense pain is so extreme that one cannot possibly wish it to cease, nor is one's soul then content with anything but God. This is not a physical, but a spiritual pain, though the body has some share in it – even a considerable share.[20]

Though Dalí was undoubtedly intrigued by the sexual undertones of Saint Teresa's account and the relationship between religious ecstasy and hysteria, it was not until the late 1940s and early 1950s that he began identifying himself as a Spanish mystic and taking such mystical revelations more personally. 'The purpose of mysticism is mystical ecstasy', he wrote in his 1951 *Mystical Manifesto*, a grandiloquent tract delineating the precepts of his budding cosmology, 'Nuclear Mysticism'.

> Ecstasy is achieved by St Teresa of Avila's path of perfection, and by the successive penetration into the penitential chapels of the spiritual castle. The mystical artist must form for himself, aesthetically, through the fierce daily self-inquisition of a 'mystical reverie' that is the most rigorous, architectonic, Pythagorean and exhausting of them all, a dermo-skeletal soul – bones on the outside, superfine flesh within – like that which Unamuno attributes to Castille, in which the flesh of the soul cannot help but rise up to the sky.[21]

Though not explicit, Dalí's description of the dermo-skeletal soul fashioned through self-inquisition is directly comparable to the chrysalis in Saint Teresa's metaphor, suggesting that although the script for *The Soul* may have been written plausibly any time between 1948 and 1954, it was likely penned subsequent to 1951, when the artist's interest in mysticism and the soul became more pronounced.

The Catalan Blood, c.1950

Another of Dalí's unrealised film scenarios to recently enter the official chronology is *Le Sang catalan* (*The Catalan Blood*), a documentary about his native land of Catalunya, the 12,328 square-mile area in Spain bordered by Aragon, France, Andorra and Valencia. Published in Spanish and Catalan in 2004 by the Fundació Gala-Salvador Dalí, the script is undated, though Agustín Sánchez Vidal writes in his notes for the translation that it is probably from the middle of the 1950s;[22] in this case, it

more or less coincides with Dalí's article, 'To Spain guided by Dalí', published in the May 1950 issue of *Vogue* magazine.[23] As this article provided Dalí's readers with a tour of his native country, one wonders whether it and *The Catalan Blood* might have been somehow connected, though no evidence for this has thus far come to light.

Much has rightly been made of Dalí's use of 'ultralocal'[24] elements in his art and of his unmitigated love for Catalunya. Though we have seen that in his youth Dalí ferociously rebelled against Catalan nationalism – calling for the abolition of the *sardana*, the traditional Catalan circle dance – there nonetheless remained a decisive fondness for the region, evidenced in the plethora of renderings he executed of the bays of Cadaqués and Port Lligat. This attraction ultimately led him to establish a permanent residence at Port Lligat, where for most of his life he spent at least a third of every year. Josep Pla observed, 'The discovery of the landscape of the Alt Empordà, which has been, is and will be the obsession of his [Dalí's] life [...] He takes it around the world with an indefatigable persistence because he bears it engraved on his memory with an almost painful – and delicious – obsessive precision';[25] indeed, throughout his world travels, as his success grew, Dalí always kept a small piece of wood from Cap de Creus as a talisman. In his later years, he was also quite moved by Catalan philosophy, gleaned through the writings of his friend and spiritual mentor Francesc Pujols, a follower of Ramón Llull and fervent Catalan nationalist whom even Dalí described as an 'unknown philosopher', the majority of whose works are 'buried in limited Catalonian editions today impossible to find'.[26] Dalí embraced Pujols' prediction that Catalunya would become the spiritual centre of Europe and was known to quote at length from the philosopher's 1918 magnum opus, *Concepte general de la ciència catalana* (*General Concept of Catalan Science*),[27] which predicted that Catalans would be one day treated like royalty for the sole reason of being Catalan.

An homage to the landscape, people and traditions that meant so much to Dalí, *The Catalan Blood* is divided into ten parts addressing Catalunya's 'convulsive, anarchic geology', its architecture and its folk-

lore, as well as nods to such notable 'locals' as Christopher Columbus – widely believed in Catalunya to have been Catalan – and Narcís Monturiol, the Figueres-born inventor of the submarine. For each section Dalí provides a narration, images and, when appropriate, music. The script begins:

> In the mineral heart of Catalunya, at the top of a strange rock in the shape of an eagle, the town runs to the inauguration of the symbolic monument to 'Catalan blood'. The fishermen from the coast arrive by sea, the farmers on foot.[28]

Dalí establishes the setting as the Eagle of Tudela, one of the famous rock formations of Cap de Creus, the most easterly point of the Iberian Peninsula and now a national park directly adjacent to Port Lligat. Since his childhood, Dalí was fond of climbing the precipitous slate rocks shaped by the sea and wind and identifying forms in their undulating surfaces; indeed, some of his most famous paintings were directly derived from the rocks he saw there. The script continues:

> We penetrate the living reality of what is above all an unknown country; one of the most phenomenal of them all; the most original, violent and philosophical of them all. Catalunya, even if its geographical placement makes it easily accessible, in order to discover it you need all the complicated instruments of the intrepid explorer, from the empty stratosphere to the diving suit, you must constantly travel up and down in the most contradictory, the deepest and the most spectacular areas of the inhabitants' lives. The life of this community bears the biological mark of blood, this mark of authentic blood. Blood!

The following section justifies this emphasis on blood and the film's title: Dalí describes a scene in which his hand, raising four fingers, transforms into a battle, invoking the legendary origins of the *senyera*, the flag of the Autonomous Community of Catalunya that consists of four hori-

zontal red stripes set against a gold background. According to legend, the red stripes were drawn on the golden shield of the Count of Barcelona, Wilfred I, by King Charles the Bald's fingers, which were drenched with blood from the former's war wounds.[29] Using camera tricks, Dalí imagined the four bars of the *senyera* flowing with a constant supply of blood, becoming a river through the Catalan landscape.

The fourth section of the script describes the region's geography, highlighting the rocks of Cap de Creus that, Dalí writes, heavily influenced the architect Antoni Gaudí (1852–1926), whose 'hyperindividualistic' work is the focus of the fifth section on architecture. Dalí's esteem for Gaudí had manifested much earlier, when he initiated the architect's rehabilitation in the pages of the Surrealist journal *Minotaure* with his essay, 'Concerning the Terrifying and Edible Beauty of Art Nouveau Architecture' (1933).[30] Dalí's identification of Gaudí's geological influences is convincing in light of the outstanding photographs of Gaudí's architecture paired with rock formations that would later be published in Clovis Prévost and Robert Descharnes' 1969 book, *La visió artística i religiosa de Gaudí*,[31] for which Dalí would write a preface.

Following an episode on folklore highlighting the *sardana* and *caramelles* – songs sung outdoors during Easter – the scene returns to the Eagle of Tudela and the 'Surrealist monument to the blood of the town'. *Sardanas* form around the Eagle's base to the music of the composer Josep María 'Pep' Ventura, while *Xiquets de Valls* create immense human pyramids, powerful nationalistic symbols to accompany the monument to Catalan blood. The narration reiterates:

> We penetrate the living reality of what is above all an unknown country, violent and philosophical above all. Catalunya, even if its geographical placement makes it normally accessible, in order to discover it you need all the complicated instruments of the intrepid explorer.
>
> We penetrate the living reality of what is above all an unknown country, above all original, violent.[32]

Given its patriotic fervour, it is striking to remember that *The Catalan Blood* was written during a political period when the public use of Catalan was banned by Generalissimo Francisco Franco, who controlled Spain from 1939 to 1975; in an effort to suppress Catalan nationalism and unite Spain under a common language and government, Franco had also banned the *sardana*, as well as the *Cant de la senyera*, a song honouring the Catalan flag that Dalí specifically includes in his script, stipulating that it should be sung with a 'Wagnerian paroxysm'.[33] Dalí has been criticised for his reactionary politics and complacency towards Franco's regime, inferred by his resolve to live part of the year in Spain after 1948 when artists like Picasso chose to remain in exile as a protest; certainly amongst the driving forces for Dalí's return was his profound connection to the Costa Brava, and while he would later make statements openly supporting Franco's dictatorship, Catalunya was never far from his heart. While Dalí's proximity to Franco clearly afforded him a certain level of prestige – and facilitated the building of the Teatre-Museu Dalí in the 1970s – *The Catalan Blood* is a reminder that the artist consistently refused political affiliation and was fundamentally indifferent to legislation when it conflicted with his artistic interests.

The Prodigious Story of the Lacemaker and the Rhinoceros, 1954–1962

The story of Dalí's next film project, *The Prodigious Story of the Lacemaker and the Rhinoceros*, began in November 1954, when Dalí returned to Paris from New York[34] determined to paint a live copy of Jan Vermeer's famous painting housed in Paris' Musée du Louvre, *The Lacemaker* (*La Dentellière*) (1669–1670). One will remember that Vermeer's celebrated depiction of a serene Dutch girl weaving multi-coloured threads had already appeared in *Un Chien Andalou*, though according to his lecture, 'Aspects phénoménologiques de la méthode paranoïaque-critique' ('Phenomenological Aspects of the Paranoiac-

Critical Method'), presented on 17 December 1955 at the Sorbonne in Paris, he had actually been attracted to *The Lacemaker* since age nine:

> At the age of nine, I was in Figueres, my birthplace, nearly nude in the dining room, and I was resting with my elbow on the table, pretending to be asleep for a young servant girl who was watching me. On the tablecloth there were some dried bread crumbs that gave me a very acute pain in my elbow corresponding to a type of lyrical ecstasy that had been preceded by the song of a nightingale that deeply moved me to tears. Also after this unforgettable song of the nightingale and this sequence of the elbow on the bread crumbs, I began to become absolutely obsessed in a truly delirious way by the painting *The Lacemaker* (a reproduction of which hung in my father's office and was visible through the open door) and the rhinoceros horn.[35]

Arrangements were made through the Louvre's conservator, Magdeleine Hours, and to chronicle the event, Dalí asked Robert Descharnes, a 28-year-old French photographer he had met in 1950 courtesy of the painter Georges Mathieu, to make a movie. Descharnes recalls:

> Wednesday, November 20[36] at 11 in the morning, Dalí was welcomed in the Louvre's Grand Galerie by Monsieur Florisonne, the curator of the museum's department of paintings. He led him to a large room in the La Trémoille pavilion, which was generally reserved for laboratory work, where they had set up two easels and a chair. On one easel was an empty white canvas and on the other, Vermeer's *Lacemaker*. Dalí promised to copy it in one hour [...] Dalí then started to methodically copy the painting surrounded by Professor [Pierre] Roumeguère, Magdeleine Hours, who created the first great laboratory in the Louvre, the painter Georges Mathieu, Nicolas Tikomirkoff and myself

– I was filming this scene because Dalí insisted that we follow his work step-by-step. Ultimately, he painted several copies of *The Lacemaker*, which were actually exercises in rhinoceros horns, because these copies had nothing more really to do with *The Lacemaker*. She represented the three rhinoceros horns or 'three converging *rhinocessalesque* bread crumbs.[37]

Per Dalí's instructions, Descharnes recorded every stage of his visit to the Louvre, from his sober entrance through the Museum's ornamented galleries to his meticulous analysis of *The Lacemaker*, during which he pointed out to the conservator a renegade hair on the work's surface. Descharnes shot many close-ups of the painter's face, reminiscent of Paul Haesaert's *Visite à Picasso* (1950) – the film in which the artist whom Dalí often regarded as his arch-rival in Spanish genius painted on a vertical pane of glass to allow the camera to record his expressions.[38] Descharnes also recorded the surprising result of Dalí's hour of work: He had not painted a copy of *The Lacemaker* at all, but instead four converging rhinoceros horns.[39] Purporting to be mystified himself,[40] Dalí suggested that he and Descharnes collaborate on a film that would explore the relationship between the rhinoceros horn and *The Lacemaker* in all its facets; It would be titled *L'histoire prodigieuse do la Dentellière et du rhinocéros* (*The Prodigious Story of the Lacemaker and the Rhinoceros*).

Having completed the first stage of his painting in the presence of *The Lacemaker*, Dalí determined the next phase should be executed before a living rhinoceros. In the spring of 1955, he sent an enthusiastic telegram to Descharnes and Georges Mathieu asking them to make the necessary arrangements, and on 30 April 1955 Descharnes packed his camera and headed to Paris's Vincennes Zoo, where Dalí painted the second stage of *Paranoiac-Critical Study of Vermeer's Lacemaker* enclosed within a rocky alcove barely separated from the Zoo's rhinoceros François and under the watchful eyes of Descharnes, André Parinaud, Georges Mathieu, art critic Michel Tapié and a number of

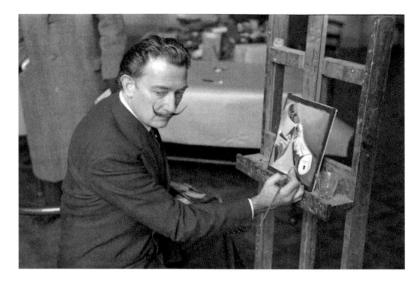

Dalí painting rhinoceros horns in lieu of *The Lacemaker* during filming of *The Prodigious Story of the Lacemaker and the Rhinoceros* (20 November 1954). Photograph by Robert Descharnes. ©DESCHARNES/daliphoto.com

press photographers. As *The Lacemaker* emerged from the assemblage of horns on Dalí's canvas, assistants lowered a large reproduction of Vermeer's masterpiece into François' pen taunting the rhinoceros to charge, though the bemused beast gave it little notice. Perhaps responding to François' apathy, the spectacle ended with Dalí rushing through the giant reproduction with a narwhal tusk – now *The Prodigious Story of the Lacemaker and the Rhinoceros*'s most well-known scene.

In his 1955 Sorbonne lecture, Dalí explained that if a battle had ensued between *The Lacemaker* and the rhinoceros that day at Vincennes, *The Lacemaker* would have triumphed because '*The Lacemaker* herself was a huge rhinoceros horn possessing a maximum of spiritual strength because, far from having the bestiality of the rhinoceros, she was further the symbol of the absolute monarchy of chastity',[41] invoking the rhinoc-

Dalí paints *The Lacemaker* at Vincennes Zoo with Vermeer's celebrated painting facing a live rhinoceros (30 April 1955). Photograph by Robert Descharnes. ©DESCHARNES/daliphoto.com

eros horn's legendary connection to the 'unicorn horn'. 'The horn of the rhinoceros, former uniceros, is in fact the horn of the legendary unicorn, symbol of chastity', Dalí wrote in 1962.[42] Many have indeed suggested that the myth of the unicorn may have originated with the rhinoceros, and some translations of the Old Testament have even translated what most now read as 'wild ox' as 'rhinoceros' or 'unicorn'. Unicorn horns, or 'alicorns' – commonly rhinoceros horns or, more frequently, narwhal

tusks – were highly valued in the Middle Ages for their alleged medicinal powers and capacity to protect against poisons. The alicorn's supposed purifying power led to the unicorn adopting within Christian allegory the connotation of chastity, and the animal became a symbol for the Virgin Mary.[43] Combining the alicorn's connotation of chastity with the unicorn's historical roots, Dalí thus further burdened the rhinoceros horn with subtext.[44] When he declared *The Lacemaker* possessed a 'maximum spiritual strength' derived from her chastity, he referred not to the painting as necessarily chaste but to the rhinoceros horns that comprise it. The painting would triumph over the living rhinoceros, he reasoned, because it is *entirely* comprised of these animated, spiritualised horns, whereas the rhinoceros wields only the single diminutive horn on the end of its nose.[45]

Dalí completed *Paranoiac-Critical Study of Vermeer's Lacemaker* later that summer in Port Lligat, surrounded by more than 15 paintings he executed on the subjects of rhinoceros horns and *The Lacemaker*, as well as drawings, engravings, machine-gunned images, sculptures and numerous models and moulds. According to Fleur Cowles writing in the mid-1950s:

> Probably no other scholar or painter in the world knows as much about Vermeer as Dalí does [...] Dalí is reputed to have asked what ten books Vermeer loved the best, and to have got and read them all. He absorbed everything he could about the Jesuit ritualism of Vermeer's period. He read every book which Vermeer had read on perspective. Then he studied, *microscopically*, the way Vermeer applied his paint [...][46]

During this rigorous study, it seems, Dalí discovered that rhinoceros horns, like sunflowers and cauliflowers, are constructed according to logarithmic spirals – forms found frequently in nature in which the distance between a spiral's turnings increases by a defined mathematical ratio $(1+ \sqrt{5})/2$, dubbed 'the Divine Proportion' by Luca Paccioli and

commonly referred to by the Greek symbol *Phi*. As with many plant species, the florets of sunflowers are arranged in opposite sets of logarithmic spirals that radiate from a common centre, spreading as they reach the edge. In sunflowers, the ratio of clockwise to counter-clockwise spirals is 21:34, corresponding to two adjacent numbers in the Fibonacci sequence – the arithmetical series in which each number is the sum of the preceding two numbers (i.e., 1, 1, 2, 3, 5, 8, 13, 21, 34...etc.);[47] as the Fibonacci sequence approaches infinity, the ratio of a given number to its preceding number more closely approximates *Phi*. As Dalí postulated, cauliflowers, sunflowers and rhinoceros horns indeed all demonstrate logarithmic growth patterns, though one presumes he might have known this already given his longstanding interest in morphology, no less his near-decade of correspondence with the Romanian mathematician Matila Ghyka, whose writings since 1931 sought the inherent harmony and proportion co-present in nature and art by analysing the mathematical construction of certain growth patterns, including those of rhinoceros horns. In approximately 1947, Dalí met Ghyka at a dinner party, soon after which Ghyka mailed Dalí a copy of his recent publication, *The Geometry of Art and Life*;[48] at their next meeting, Ghyka was struck by Dalí's advanced understanding of geometric aesthetics:

> [Dalí] talked at length about my aesthetic theories, particularly those based on the knowledge and handling of proportions and of the regular polyhedra. He had fully understood how they might be of use to him and spoke with enthusiasm of the manner in which he was going to apply them [...] I had the impression that since Leonardo's, no pencil had expressed so much dynamic beauty through its lines and arabesques.[49]

Certainly, then, Dalí was predisposed in 1954 to recognise the relationship between rhinoceros horns and logarithmic curves, though for a long time he was unable to find a sufficiently large cauliflower to test his

theory that he could truly trace *Lacemakers* within its florets; when, in 1958, Dalí finally located such a monstrous legume – efforts aided by the Flemish poet Emmanuel Lootens – he had it cast by the Susse Foundry, though Descharnes laments that it was one of the aspects of their film that was never shot.[50]

Though a missed opportunity, the absent cauliflower is a forgivable absence in light of the footage Descharnes did shoot of Dalí's visit to Vincennes Zoo and of the 1955 Sorbonne lecture, along with some scenes of the artist's numerous attempts to provoke 'goose pimples' on a female model, dubbed *Miss chair de poule* (literally 'Miss goose flesh', the French term for the familiar epidermal contraction that stands one's hairs on end), whereby the contracting epidermis would adopt the semblance of tiny rhinoceros horns. The rhinoceros was the animal that experienced the greatest fear during the creation of the world, Dalí would explain, evidenced by the multitude of horns/'goose pimples' that cover its body – exaggerated in Albrecht Dürer's famous 1515 woodcut, which Dalí began employing as an emblem; the painter invented a similar explanation for the morphology of sea urchins, which he said was due to the fear felt by a drop of water the instant it first fell to Earth:[51] Seized with dread at losing its purity, the 'drop' produced goose bumps – the urchin's well-known spines.

According to every published account including Descharnes' own testimonies – published in *Dalí de Gala* (1962), *Dalí: L'oeuvre, l'homme* (1984), *Salvador Dalí, L'Oeuvre peint* (with Gilles Néret, 1993), *Dalí: L'Héritage Infernal* (2002) and *Dalí, Le dûr et le mou: Sculptures et objets* (with Nicolas Descharnes, 2003) – these scenes exploring paranoiac ideas revolving around logarithmic spirals comprise the core of *The Prodigious Story of the Lacemaker and the Rhinoceros. Dalí de Gala* even offers a convenient formulaic chain for the film's movement, 'Nebulous = *Lacemaker* = rhinoceros horn = corpuscular and logarithmic granulations of the cauliflower = granulation of the sea urchin, this shiver of creation, etc.'[52] I have done extensive research on this little-seen film, and the first time one watches *The Prodigious Story of the Lacemaker*

and the Rhinoceros, it is clear things are not so straightforward.

Firstly, one challenges Dalí's claims to impulsivity: Why would he have asked for a film to be made at the Louvre if he had no inclination as to where it would lead? Through film, Dalí turned the process of painting into a performance, leading one to speculate how much *The Prodigious Story of the Lacemaker and the Rhinoceros*'s documentary of *Paranoiac-Critical Study of Vermeer's Lacemaker* might have been indebted to Hans Namuth's earlier films and photographs of Jackson Pollock – Descharnes complemented the filming process by shooting thousands of photographs[53] – and especially *La Bataille de Bouvines*. *Les Capétiens partout*, a film Descharnes had made earlier that year, on 25 April 1954, was of Georges Mathieu's painting-spectacle at the Paris Salon de Mai.

Dalí's stupefaction at painting rhinoceros horns in lieu of *The Lacemaker* is also highly suspect. Notwithstanding his claim that *The Lacemaker* and rhinoceroses were linked in his mind at age nine, rhinoceroses began appearing in his work only after 1950, the year his friend and patron, the Chilean millionaire Arturo López-Wilshaw, presented him with a walking stick, the handle of which was formed from a rhinoceros horn; evincing the importance López-Wilshaw's gift had in galvanising the artist's burgeoning 'rhino mania' – influencing that year the colossal *Madonna of Port Lligat* (1950) – Dalí later restaged its presentation for *The Prodigious Story of the Lacemaker and the Rhinoceros*. Though according to Descharnes, López-Wilshaw presented the cane to Dalí in 1954 just prior to the Louvre visit,[54] Michael Taylor has pointed out that the cane – or at least a similar one – was already in the artist's possession in May 1950 when he showed it during a Paris interview.[55] Two years later, on 5 July 1952 according to *Diary of a Genius*, Dalí was in the process of painting *The Christ of St. John of the Cross* (1951) as quoted in his monumental *Assumpta Corpuscularia Lapislazulina* (1952) when he noticed his Christ consisted of rhinoceros horns – indeed, that *all* his images were formed from rhinoceros horns:[56]

Like one possessed, I paint each anatomical fragment as if it were a rhinoceros horn. When my horn is perfect, then – and only then – is the anatomy of Christ also perfect and divine. [...] I marvel at my discovery, fall on my knees and thank Christ for it [...] Since the beginning, mankind has been tormented by trying to grasp form and reduce it to elementary geometric volumes. Leonardo tended to produce eggs [...] Ingres preferred spheres, and Cézanne cubes and cylinders. But only Dalí, by the convolutions of his paroxysmal hypocrisy, which had exclusively obsessed him with the rhinoceros horn, has found truth. All curved surfaces of the human body have the same geometric spot in common, the one found in this cone with the rounded tip curved toward heaven or toward the earth, and with the angelical inspiration of destruction in absolute perfection, the rhinoceros horn![57]

Given that by at least 1952 Dalí had established a precedent for using 'rhinoceros horn' shapes as building blocks for more complex imagery, one might have *expected* him to begin copying *The Lacemaker* in 1954 by laying out its essential structure with rhinoceros horns. Indeed, that he had promised to need only *one hour* to reproduce a work he revered to such an extent that he is said to have told collector Robert Lehman in 1934 that copying *The Lacemaker* 'couldn't be done'[58] is sufficient to suggest that he expected his session at the Louvre would not result in a true copy of the painting. *Diary of a Genius* strengthens the case for premeditation: 'I wanted to represent it [*The Lacemaker*] between four crusts of bread,' he wrote, 'as if it had been born from a molecular encounter according to the principle of my four-buttock continuum.'[59] Although the original four horns are now obfuscated in *Paranoiac-Critical Study of Vermeer's Lacemaker*, one envisions how they might have helped Dalí organise his canvas – clearer in another, unfinished copy of *The Lacemaker* he began that winter, now housed at the Fundació Gala-Salvador Dalí in Figueres.

Above all, however, the account of the film's logarithmic plot is challenged by the myriad of auxiliary scenes. While there is every indication

that *The Prodigious Story of the Lacemaker and the Rhinoceros* began with a certain chain of associations in mind – the first script, a single page from the Cafè Nacional Exprés in Figueres, summarises the story, 'Lacemaker and rhinoceros, Gala, sea urchin, goose pimples, cauliflower, Dalí, FINI'[60] – a number of episodes that have gone conspicuously unmentioned in past descriptions of the film don't have even the vaguest relevance to this sequence. Indeed, for those expecting *The Prodigious Story of the Lacemaker and the Rhinoceros* to be an exegesis of Dalí's passion for logarithmic forms à la 'Phenomenological Aspects of the Paranoiac-Critical Method', it may be bewildering to discover that this not only goes unexplained but is merely the springboard for a more confounding ecstasy, manifesting as a litany of auxiliary episodes with no discernible ties to rhinoceros horns or logarithmic curves – e.g. Dalí struggling to paint within the strong winds of the Catalán *tramuntana* in homage to a turn-of-the-century Figueres shoemaker who was reportedly driven mad by the winds and died trying to 'conduct' them on the city's Rambla; chairs flying across the screen to pursue Dalí and Gala across the Empordá plain; Dalí, porting a polyhydric hat inspired by Johannes Kepler, ferociously whipping nine canvases with a riding crop, aided by a local fisherman nicknamed '*Los dientes*' ('the teeth', possibly a loose connection to *La Dentellière*). In one particularly baffling sequence, Dalí, capped with a Catalán *barretina* hat, paints an abstract rendition of *The Lacemaker* while Emilio Puignau, his builder and then-mayor of Cadaqués, observes from a nearby shrub in the role of Hitler, sipping tea and offering the painter loaves of bread;[61] in the foreground, a photograph of Emperor William II juxtaposes with a portrait of Gala, elsewhere projected onto a rock to re-create the 1945 painting *Three Apparitions of the Face of Gala*.

Once again, Dalí was *too* excited by the prospect of film: As had been the case with *Wheelbarrow of Flesh*, the cinema galvanised his creativity to such an extent that he was unable to pack all his ideas into only one picture, and his film spun out of control. In 1956, Dalí had appeared on CBS's morning show directing an elaborate sequence that

included the head of a rhinoceros, 12 cauliflowers, a film clip of an atomic explosion, a reproduction of *The Lacemaker* and a photograph of a rhinoceros horn 'superimposed on the head of the lackemaker [sic] – and "a perfect fit"';[62] he was given atypical freedom with the programme, but there was only a limited amount of time to film and he was somewhat constrained by the capabilities of the television studio. As a result, however, the CBS appearance succinctly encapsulated the artist's associations amongst rhinoceros horns, sunflowers, cauliflowers and *The Lacemaker* in a way that ever eluded *The Prodigious Story of the Lacemaker and the Rhinoceros*, which, after eight years of sporadic filming in 16 mm black and white under Descharnes' direction with only the aid of cameraman Gérard Thomas D'Hoste, still represents only a fraction of the scenarios Dalí anticipated.

Viewing the film's present unedited sequences and multiple takes, it is clear that incompleteness has markedly affected the success of many planned 'paranoiac' transitions: One might gather how Raphael's *St Catherine of Alexandria* (c.1508) would have faded into Dalí's rhinocerotic painting *The Ascension of St Cecilia* (1955), but the present cut fails to convey transformation so much as to invite comparison, and the same might be said of the kernels on an ear of corn that lead to a woman's buttocks – the mythological Clytemnestra, killed by her son Orestes who is played in the film by a local fisherman grotesquely spewing milk from his mouth. Heinrich Hoffman's official portrait of Hitler, reproduced for Dalí by Philippe Halsman, transmogrifies into a sea urchin on a plate in one of the film's few accomplished dissolves, but that same image spinning horizontally to become the bucolic *Paysage au clair de lune avec accompagnement (Sérénade de Tosseli)* (1958) remains left to the imagination. Even the gut-wrenching sequence in which a glass needle is slowly advanced into actress Martine Roussel's eye lacks the drama Dalí planned: The finished montage would have had the needle mounted on an express train that charged full-speed into the eyeball, spectacularly shattering upon impact as a symbol of the 'power of the paranoiac eye' – in contrast to

Dalí at the Coral de Gala in Cadaqués filming *The Prodigious Story of the Lacemaker and the Rhinoceros*. He directs a Catalan fisherman playing the part of Orestes, while the unidentified nude woman plays his mother, Clytemnestra. 1956. Photograph by Robert Descharnes. ©DESCHARNES/daliphoto.com

the acquiescent eye that had been fiercely penetrated in 1929 by Buñuel's razor.[63]

But, according to Descharnes, these loose ends are not necessarily shortcomings: Narrative cohesion was *not* the paramount criterion for shooting *The Prodigious Story of the Lacemaker and the Rhinoceros.* Although the film began as a documentary of Dalí's work on *Paranoiac-Critical Study of Vermeer's Lacemaker*, as Descharnes explains, the project 'perpetually inflated with Dalí's desire'.[64] Priorities shifted as shooting continued, and *The Prodigious Story of the Lacemaker and the Rhinoceros* abandoned the confines of a conventional picture to become a virtual – and visual – forum for the artist's cinematic experiments. 'I was not thinking of filming for the cinema or for television', Descharnes says. 'The goal was only to express his ideas. It was continually putting elements in a sack. For him [Dalí], it was a space – just as if he decided to do a little text. But it continued, like a journal.'[65] Descharnes entertained even the artist's most laughable requests – telegrams requesting 'a giant cauliflower […] five bayonet rifles and Trotsky's reference to Bonapartism'[66] and so forth. Through this, the film became something altogether different from its genesis – no longer a documentary, it was a visual forum for Dalí to test his ideas and see what germinated. Some ideas were quite successful, too: His revelation to Descharnes that he could see the Battle of Thermopiles in the gold band of a ballpoint pen from the St Regis Hotel provided sufficient fodder for *Impressions of Upper Mongolia – Homage to Raymond Roussel*, which would also use the rotating landscape that dissolved into a photograph of Hitler. Other ideas offered a unique view of his methodology: When he struggles in the film to provoke 'goose pimples' on *Miss chair de poule*, he scrapes bayonets against a marble slab – the elaborate staging of which recalled *Dream Caused by the Flight of a Bee around a Pomegranate One Second Before Awakening* (1944) – scratches her breast with a fork and splatters it with cold milk, but only after two separate sessions and several reels of film does she finally experience the desired response; in a completed film, such failed attempts would be relegated to the

proverbial cutting-room floor, but their inclusion allows one to follow Dalí's ideas like rough sketches leading to a finished oil. And just as his drawings are fascinating and informative in their own right, so the drama of his cinematic trials is strangely gripping – I have even seen audiences *applaud* the 'goose pimples' when they finally appear. It is a testament to Dalí's 'prodigious' talent and imagination as well as to Descharnes' patience that in spite of the film's confused sequences, omissions and silence – Dalí planned to incorporate noises from nature rather than his typical Wagnerian score, but this, too, was never finished – the illustrated rhapsodies of his untethered mind still make entertaining, even compelling, viewing, perhaps even more so than if he had simply ended the film with *The Lacemaker* and rhinoceros. Descharnes' curiosity and willingness to finance the film almost entirely on his own encouraged Dalí to pursue inspirations that might never have been filmed otherwise. Ultimately, this may be *The Prodigious Story of the Lacemaker and the Rhinoceros's* most important and enduring aspect.

At a vivacious 81 years old, Descharnes still aspires to finish *The Prodigious Story of the Lacemaker and the Rhinoceros*, adamant that it be true to the ideas he and Dalí shared during their lengthy collaboration; 'The film is too special to accept less', he says.[67] He talks of shooting bread crumbs on a table cloth that pan onto an aged copy of *The Lacemaker*, invoking the nine-year-old Dalí's first reported pairing of *The Lacemaker* and rhinoceros horn, and tracing rhino horns in cauliflowers using contemporary computer animation. Recently he was invigorated to find in an art journal speculation that Vermeer may have painted two copies of *The Lacemaker*. Might Vermeer have been experimenting with stereoscopy as Dalí often suspected of the Dutch Master's contemporary, Gérard Dou?[68]

Descharnes' ambitions provoke important questions and concerns: In its present state, *The Prodigious Story of the Lacemaker and the Rhinoceros* is decidedly not what Dalí and Descharnes envisioned their film becoming when they embarked on their collaboration in 1954, and even if one can appreciate it as an innately unfinished forum for Dalí's

experiments, unrealised scenes and multiple rushes – particularly lacking the benefit of sound – can make for monotonous viewing. The addition of pivotal scenes would very likely congeal the episodes into a more comprehensible story, while other sequences that were discussed but never actually put to film – e.g. the train montage with Martine Roussel's eye, a magazine photograph of David Ben-Gurion doing a head-stand on an Israeli beach in which Dalí traced the outline of a skull[69] – would presumably be added as well, providing a richer appreciation for the ideas both Dalí and Descharnes hoped to pack into *The Prodigious Story of the Lacemaker and the Rhinoceros*. But the film's raw state should also not be undervalued. Left as an open forum for Dalí's experiments, *The Prodigious Story of the Lacemaker and the Rhinoceros* seems to mirror in film the self-recognised 'secret' of the artist's literary success, as expressed in *Dix recettes d'immortalité*:

> When the whole thing becomes too clear, dazzlingly, you go out of your way to darken the ideas, thereby paying tribute to Heraclitus the obscure, and to Tantalus when the readers tire of what is too clear or too obscure. It is then necessary to use the technique of chiaroscuro, a *fumatura* peculiar to Eugène Carrière, in order to prolong tantalising desire while at the same time allowing the reader to find particles of the truth that interest him.[70]

Simultaneously illuminating and obfuscating, offering a few tantalising gems in the midst of chaos, the inchoate assemblage of fantasies united as *The Prodigious Story of the Lacemaker and the Rhinoceros* may indeed be the *aboutissement* of Dalínian cinema, as film historian James Bigwood once dubbed it.[71] It is effectively a sketch book, and it would seem that to tie its loose ends would be to shape it into something it perchance once was but fundamentally no longer is. It is for this that one wonders whether Dalí himself would have liked to see the film any more polished, though, of course, this is a question Descharnes is presumably better positioned than anyone to assess. One thing is certain: If anyone

is to finally close this 'prodigious story' after so many decades, it must be Descharnes himself. The potential is enticing, though should he accept the challenge one hopes he will safeguard the film's present state as well so that Dalí's contributions may be easily extracted in the future, thereby staving off a criticism of the 2003 adaptation of *Destino*. And as for Dalí's view, *anyone* occupied with finishing something of that magnitude, regardless of the medium, would be wise to reflect upon his rally against completing Barcelona's *Sagrada Familia* cathedral. In a 1968 text published as the preface to Descharnes' and Clovis Prévost's monograph of Gaudí, Dalí noted with characteristic aplomb the very real perils of such an endeavour, but also the possibility that good work could be done if the project were in the right hands:

> Gaudi himself probably would have finished it in a style completely different from his original idea. Nothing should be added for which exact models do not exist [...] It would be treason against Gaudí's art to want or pretend to be able to finish the *Sagrada Familia* by bureaucratic methods lacking the touch of genius. It is far better for the building to remain like a gigantic decayed tooth, full of possibilities.[72]

INTERVIEW WITH... ROBERT DESCHARNES

Robert Descharnes (born 1926) is a French photographer, writer and film director. His unique, 40-year friendship with Dalí produced a number of books (e.g. *Dalí de Gala* [1962], *Les Metamorphoses érotiques* [1969], *La Vision artistique et religieuse de Gaudi* [1969] and *Dix recettes d'immortalité* [1973]) and collaborative works, notably the unfinished film *The Prodigious Story of the Lacemaker and the Rhinoceros* (1954–1962). He also authored *Dalí: L'oeuvre, l'homme* (1984) and *Salvador Dalí, L'Oeuvre peint* (with Gilles Néret, 1993), both of which have become standard reference books.

Perhaps we can begin by recounting the first time you met Dalí.
I met both Dalí and Gala for the first time in 1950 aboard the superb American ocean liner the SS America, owned by United States Lines. My sister and I worked with a painter, Georges Mathieu, who had a ten-year relationship with United States Lines and had become their Publicity Director. I did the display cases and the stands for the company and took photographs. I was aboard to photograph some models.

I took two portraits of Dalí at our first meeting, and then he asked me to come see him in Paris. He was staying at Neuilly with his friend, Arturo López-Wilshaw, the guano king. I went, and he was thinking about the Christ of Glasgow [*The Christ of St. John of the Cross*]; he wanted me to photograph the Madonna for him, so I found a model at Dior whom I photographed. Dalí came two times to my apartment at 29 Avenue d'observatoire to guide the photos with me and then to have a conversation about Rorschach tests with Dr [Pierre] Roumeguère. Dalí would tell him, 'I see little nuns, little sisters', etc.; he naturally knew the Rorschach tests and thus toyed a bit with our friend Roumeguère! I should say that Roumeguère was an astonishing figure: He fell in love with art one day out of the blue, when he went to an exhibition of Picasso sculptures. Apparently it created an aesthetic shock in favour of

art and painting in general. Roumeguère became a very important figure in the Dalínian universe.

Roumeguère wrote many essays in the 1960s and 1970s. It was Roumeguère who 'diagnosed' Dalí's famous 'Dioscuric' complex.
Roumeguère wrote many essays when Mathieu and I stayed all night at his home to push him and ensure that he wrote well, because otherwise it took him a very long time! Unfortunately, Roumeguère married a South African woman who had been initiated into an African tribe. She was beautiful with true Dutch features. He began going to the Kalahari Desert with her, and Dalí was furious because naturally, when Roumeguère devoted his intelligence to exploring Dalí, Dalí did not want him exploring the Kalahari Desert! His wife passed away not long ago, and his daughter is still working in the region. It was very interesting because, after Pierre died, his wife was remarried to a Masai chief. I read her obituary in *Le Monde*, and it stated that she was one of 20 other wives!

Anyway, I began to work with Dalí and take whatever photographs he wanted. There are certain drawings and paintings from the beginning of the 1950s of these young women – colourless, only tints and shadows, like an egg – that are based on my photos. But really, when Dalí based a work off a photograph, he added all his own genius to it. The photographs were a platform from which to depart. Of course Dalí always used photographs. He took many pictures when he was young, like the famous photograph of Gala that led to the painting at the Dalí Museum in St Petersburg [*Portrait of Gala*, 1932–1933]; Dalí took that photo. I took many photographs for him too, though I also did much more: I did the set-up. Also, on one of the last paintings, *The Swallow's Tail* [1983], it was me who traced the lines in the painting, because [Isador] Bea had started doing other things, then he left, so I finished it, if you like. In the end, I was a collaborator in different domains, since I also rewrote, with much modesty, some of his texts, as Éluard and Breton did in the 1930s.

When you met Dalí, were you already a film director?

I worked in various capacities. I did many things in India. I made a book about Versailles, a book about Greek sculpture and a book about Florence, and I had other activities. I was in a very cultivated family. My sister was a painter, married to an American artist, Alfred Russell; he is not well known, but he was with the painters of the New York School. He brought all the New York painters – Pollock, de Kooning, Rothko, etc. – to Mathieu for an exhibition in France. We were in a completely artistic universe. I made three films with Georges Mathieu: *La Bataille de Bouvines* (1954), in which I followed while he painted, *Les Capétiens partout*, and *Le Couronnement de Charlemagne* (1956). I have no copies; Mathieu kept everything.

In *La Bataille de Bouvines*, you filmed Mathieu in the process of executing a painting. It would seem that this same idea spurred *The Prodigious Story of the Lacemaker and the Rhinoceros*?

No, *The Prodigious Story of the Lacemaker and the Rhinoceros* was something else. I must start at the beginning: Dalí was invigorated by the conversations he had with Prince Matila Ghyka in the 1930s about the shape of the logarithmic curve. He was very passionate about morphology – he used to cut out images from the book, *Principes de morphologie générale* [1927], by [Édouard] Monod-Herzen. Immediately he wanted to apply Ghyka's theories, but not necessarily with regards to the rhinoceros horn, the cauliflower, and the sea urchin; the rhinoceros appeared in *The Madonna of Port Lligat* [1950], and the sea urchins had appeared many times before. That is why he wanted to copy Vermeer's *Lacemaker* at the Louvre. He was in contact with a tourist in Cadaqués, Magdeleine Hours, who was the conservator at the Louvre; he asked her about copying *The Lacemaker*. She recounts in her book how this was done, as well as her experience with Dalí and Jean-François Millet's *L'Angélus*.[73]

Dalí also painted *L'Angélus* at the Louvre?

Not from life, no, but he copied it many times. He told Magdeleine Hours that there was a dead child in *L'Angélus*. She took an x-ray, and you can see the outline of the coffin.

That's published in *The Tragic Myth of Millet's Angelus* (1963).

Yes, I collaborated on that book with Jean Jacques Pauvert. So, you might say that I had rather informal relations with Dalí after I met him aboard the SS America. Then, when he decided four years later, in 1954, to go copy *The Lacemaker* at the Louvre, he asked me to film.

As you had done for Mathieu?

As I had done for Mathieu. Mathieu, Dalí and I were always together. I told Dalí I would follow him and make a documentary, but at that moment the project had absolutely none of the importance it would adopt after he made the copy. He made it, and immediately afterwards he wanted to go to Vincennes Zoo to continue the documentary by painting in front of a live rhinoceros. And this is how *The Prodigious Story of the Lacemaker and the Rhinoceros* was born. It was a film that perpetually inflated with Dalí's desire. Mathieu had a friend, the poet Emmanuel Lootens, who was a member of the Association of Cauliflower Producers from the north of France; Dalí asked him to find a perfect cauliflower to make a mould. Unfortunately, in all the objects I filmed, I don't have footage of this famous cauliflower done in the Susse Foundry, which has since changed hands and closed, so we don't even know what happened to the mould. But he did make a mould, and he wanted an episode in the film with a cauliflower. It is amongst the things that may be redone for the end of the film.

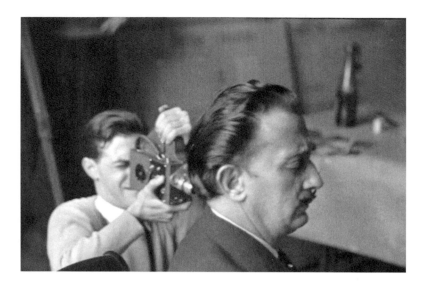

Robert Descharnes films Dalí 'copying' *The Lacemaker* in the laboratory of the Louvre for *The Prodigious Story of the Lacemaker and the Rhinoceros* (20 November 1954) © DESCHARNES/daliphoto.com

I want to speak about your plans to finish the film, but first I want to ask about *The Wheelbarrow of Flesh*: Dalí began that film in 1948, but he was still working on it in 1953, when he wrote in *Diary of a Genius* that he planned to include rhinoceroses falling into the Trevi Fountain. Was there continuity between *The Wheelbarrow of Flesh* and *The Prodigious Story of the Lacemaker and the Rhinoceros*?

The most important thing in the history of Dalí and cinema is to have the list of people Dalí asked to finance his ideas. For *The Wheelbarrow of Flesh*, the last person he asked was Alberto Puig Palau, who owned a beautiful home at Palamos. There was also George Gregori, for another project, and Philippe de Rothschild. It would be interesting to know all the people who were approached to sponsor or produce Dalí's films.

Who financed *The Prodigious Story of the Lacemaker and the Rhinoceros*?
I financed everything myself. No one ever gave me anything. Josep Forêt gave a little. [A Reynolds] Morse refused. Morse didn't understand what Dalí wanted to do. But when he said no, Dalí didn't insist; probably he told him, 'You're mistaken, you're passing up something good', probably he said that. But Morse wasn't interested in the cinema at all.

A few months before you began filming *The Prodigious Story of the Lacemaker and the Rhinoceros*, *La Parisienne* published Dalí's 'Mes secréts cinamatographiques', in which he was still writing about rhinoceroses in *The Wheelbarrow of Flesh*, even calling the film 'prodigious'.[74] Then in 1957, Dalí used the same verbiage to describe *The Prodigious Story of the Lacemaker and the Rhinoceros*.[75] That is why I suspected there might be continuity between the two projects.
I think *Wheelbarrow of Flesh* was the result of a project he proposed to George Gregori in the 1950s called *Sur l'âme* ['On the soul']. It was at the same time as *Wheelbarrow of Flesh* – maybe before.

That script was recently published by the Fundació Gala-Salvador Dalí as part of *Wheelbarrow of Flesh*.
I found it in my notes, but there are many more.

There is also a 1975 interview with Gérard Malanga in which Dalí recounts having filmed a live swan stuffed with dynamite that explodes;[76] he mentioned something similar in *Diary of a Genius*. Is it true?
He was being provocative. Dalí feared such things. I have a [Philippe] Halsman photograph that Halsman gave me. Dalí said never to use it. It shows Dalí putting his head in a bowl of milk and his head explodes – an eye over here, etc. Dalí was afraid and refused to ever use it or show it.

Was that for their book, *Dalí's Moustache* (1954)?

No, for one of their many projects. He did many projects with Halsman, as he did with me. It was also Halsman who made the photograph of Hitler for Dalí for *The Prodigious Story of the Lacemaker and the Rhinoceros*, using Heinrich Hoffman's official photograph.

Dalí also worked on a stereoscopic film...?

With an American company, Video Head, yes. The idea was a 3-D television station.

Did Dalí differentiate between film and television?

For Dalí, a camera was a camera. The important thing was the film *when he intervened*. He did many programmes for French television – a party with Pierre Desfons, etc. It was very amusing. Pierre Desfons was the first assistant to Jean-Christophe Averty, who directed *Autoportrait Mou de Salvador Dalí*; that was for television as well. There were a lot of complications on that project: Henri Coty was rich, so he did the film [...] He was the first French film producer to do a co-production with the Americans and Canadians, with CBS. But Averty and Coty didn't speak.

Henri Coty, who had financed Dalí's perfume?

No, the perfume was François Coty, his grandfather. Henri inherited from his aunt what was left of François Coty's fortune and used it to create a television company. He contacted me because he wanted to do a film about Rodin, and when he saw that I was working with Dalí, he spoke about us to an American producer who said yes, he wanted to make a film. The producer of CBS, Tom Madigan, suggested Averty. Averty had done many pseudo-surrealistic television programmes – putting a baby in a meat grinder and so forth. His visual eccentricities worked well with Dalí.

Can you please say a few words about Dalí's 1955 lecture at the Sorbonne, 'Aspects phénoménologiques de la métode para-noïaque-critique' ['Phenomenological Aspects of the Paranoiac Critical Method']?

The most important event for the continuity of *The Prodigious Story of the Lacemaker and the Rhinoceros* was the lecture at the Sorbonne in December 1955. It was organised by Michel Eristov – who claimed to be the heir of Genghis Khan – with the International Centre of Aesthetics. And as Eristov organised the conference without much splendour, Mathieu went to Les Halles, bought 500 kilos of cauliflower and loaded them all into his white Rolls Royce Phantom II. At five in the morning, the luxurious 1930s limousine filled with cauliflowers was left in front of the Hotel Ritz, where Dalí and Gala were staying. When it was time for the conference, Mathieu and Dalí drove to the Sorbonne in the Phantom II, and Gala and I followed in a taxi.

Had Dalí hoped to finish *The Prodigious Story of the Lacemaker and the Rhinoceros* before that lecture?

Dalí wanted to use the Sorbonne lecture to recount the whole adventure from the beginning: It was a platform. But the film was not finished for the Sorbonne. I have the letter to Jean Cocteau from Dalí asking to como film Vermeer's torch at his home in Milly-le-Forêt. The lecture was December 1955; before '55, I filmed in Paris, and my first trip to film in Cadaqués was in '56 – the sequence with the wind, all that was done in '56.

In some texts, Dalí said *The Prodigious Story of the Lacemaker and the Rhinoceros* was exactly opposed to experimental film, but in fact it was very artistic and experimental.

For him, it was an explanation of his creation of one image in another, one subject in another, one object in another. But it is not experimental. That is why we called it 'The prodigious story'. It is not a film based on visual, aesthetic, cinematographic experiences; it is truly a story – a

prodigious adventure! *The Prodigious Story of the Lacemaker and the Rhinoceros* is the first film in which Dalí attempted to put an image in an image in an image in an image, over and over. *Impressions of Upper Mongolia* is totally different: That film is truly an experiment where one takes an ordinary element, changes the dimensions, and it creates the illusion of a voyage. It's very different. It is truly the last Dalí film, and its theme has nothing to do with *The Prodigious Story of the Lacemaker and the Rhinoceros* except that Dalí took some images from the latter, like the image of Hitler. He always wanted to recuperate images he had done before; there is continuity. But he also wanted to introduce scenes that had nothing to do with the chain of images. For example, in one scene in *The Prodigious Story of the Lacemaker and the Rhinoceros*, Arturo Lopez gives a cane to Dalí at Neuilly, and in another Arturo Lopez and Dalí have a conversation aboard the boat, La Galeota. It has nothing to do with anything. It was to pack the film with additional elements.

Was there ever a script?

There were many scenarios, but in my opinion the first was the best: It is one page from the Cafè Nacional Exprés in Figueres: 'Distribution, Lacemaker and rhinoceros, Gala, sea urchin, goose pimples, cauliflower, Dalí, END'!

When I imagine the sea urchin dissolving into goose pimples, I think of *Un Chien Andalou*; some scenes in *The Prodigious Story of the Lacemaker and the Rhinoceros* seem very reminiscent of *Un Chien Andalou*. Was that intentional?

But with *L'Âge d'Or* and *Un Chien Andalou* you have Buñuel: That's a great personality! One can say that Dalí helped on the scenario, but in those films you also have the person behind the camera who arranged it – the eye is behind the camera.

Perhaps if I can compare you to Buñuel as two directors who both worked with Dalí: You followed Dalí's activities to see where they would lead, whereas it seems Buñuel was more actively engaged with creating the scenario for *Un Chien Andalou*. Would you agree?

It's different because Buñuel was a great director who did the montage. For Dalí's dreams, for *The Prodigious Story of the Lacemaker and the Rhinoceros*, the montage was not a language. The montage for a film director is a language. For *The Prodigious Story of the Lacemaker and the Rhinoceros*, the only rationale was that Dalí wanted continuity. He didn't take a piece and another piece and put them all in. Of course he accepted what happened, but that's not the point; the thing was to have the continuity to pass from one image to another. That's also why he dreamt of having a camera that never moved, that recorded everything that passed by – that's also important. The camera would be like a spectator in a theatre.

That idea anticipates Warhol's films, in which the camera is still for hours and records whatever happens in the frame; Dalí even wrote that he hoped his audiences would get bored, which is very Warholian... or proto-Warholian, as it were. But he also wrote that he wanted his films to consist only of spectacular episodes. José Montes-Baquer recalled that Dalí insisted that *Impressions of Upper Mongolia* 'be composed of a series of sequences, which [...] make up the best moments of most films'.[77] How did Dalí reconcile those styles?

When he had these ideas, he sometimes waited to exploit them. In my archives I have a magazine that was accidentally stained with washing powder. When it arrived at Port Lligat, Dalí guarded it preciously and said he would do something great with it. It's the same in *The Prodigious Story of the Lacemaker and the Rhinoceros*: There are elements that are researched, and others that simply passed by and he trapped them; it is what is called 'objective chance'.

I understand that you used to go to movies in Paris with your wife together with Dalí and Gala. What types of films did Dalí enjoy?

We went often to the cinema with Dalí and Gala in 1958 and 1959. We saw whatever modern films were showing.

Don't forget that when Dalí travelled through Europe, it was the middle of the epoch of Italian cinema. Naturally, the great directors were working, even under Mussolini; there was a Fascist Italian cinema. That was when he came, and how he found Anna Magnani, whom he absolutely wanted to star in *Wheelbarrow of Flesh*. Italy was a central point of reference for Dalí, from the point of view of aesthetics, painting, and cinema. And when he later discovered William Rothlein, who was surnamed Adil – that is, 'Dalí' rearranged – he immediately wanted to make a film; he did a translation for Fellini to make a film of *The Secret Life of Salvador Dalí*. Whenever he found someone who spoke about the cinema, he could come up with an idea that instant.

Did Dalí enjoy French films as well?

He was passionate about Marcel Pagnol.

In *L'Âge du cinema*, the Surrealists advised not to see Pagnol.[78]

Yes, but Dalí and Gala liked him very much, especially his first film, *Jofroi* (1933). The main character sells his land but won't let the buyer cut down the trees.

The story reminds me a bit of the man obsessed with the land in Dalí's novel *Hidden Faces*, and, indeed, Dalí's own love for the olive trees in Port Lligat.

Yes. But it's totally crazy. It's totally irrational like this peasant. That's what appealed to Dalí. The man sells his land, and he doesn't want anyone to touch a tree. So he climbs on top of the church and threatens to kill himself. He threatens the whole village.

And Dalí liked that film.

Very much. He also always liked the trilogy – *Marius*, *César* and *Fanny*.

What about Hollywood films?

Immediately when Dalí arrived in Hollywood, he was asked to make backdrops and scenery, but studios were not open enough to serve what he wanted to mount. But he was fascinated by the old American cinema, for sure – the great stars, all the comics... above all the comics.

In *The Prodigious Story of the Lacemaker and the Rhinoceros*, there are many strange scenes, like Dalí painting in the tramuntana, chairs flying across the screen, etc. It strikes me that those might have been his attempt at slapstick.

He called that 'initiation ceremony'. He would stomp his foot in a basin of milk and say it was an initiation ceremony. If you asked why, he said he didn't know. It was to add an element of strangeness. But *The Prodigious Story of the Lacemaker and the Rhinoceros* was a résumé of continuities; it was not at all comedic. It was an absolutely experimental film, placing one image in another. For example, Dalí found a photograph of [David] Ben-Gurion doing gymnastics on the beach in Israel, and in Ben-Gurion's stance he saw very clearly the shape of a skull.[79]

That's in the film?

No, but it should be! Not all the elements were done because we didn't have time. He always had more ideas. In the end, he was much more impatient than I to finish, because I wanted money. There was never an exchange of money between us.

Dalí never paid you to make the film?

No, we never exchanged money.

Who was the film's expected audience?

He dreamt of annoying everyone by being represented at Cannes. Every year, he wanted to finish the film to present at Cannes.

So he wanted a commercial film, not just a film to show in exhibitions?

Yes, a commercial film. It had nothing to do with culture.

Were any films shown in his exhibitions?

No.

Did you ever discuss *Destino* with Dalí?

Dalí considered the work with [John] Hench finished. Why it wasn't finished, I don't know. Someone who can say much more about *Destino* is Jim Bigwood. I saw John Hench two times in Burbank, but Jim had good relations with him.

Did Dalí ever project others' films privately?

Yes, for friends. And for children: Dalí showed Disney films – short films like that – for the children of Cadaqués in Port Lligat.

Do you think Dalí discussed cinema with Duchamp in Cadaqués?

Undoubtedly he did. But Duchamp wasn't around often, not all the time. Duchamp was independent. He knew Dalí very well, and if he was with Dalí, Dalí profited by developing ideas with him.

There's a famous exchange in *Entretiens avec Salvador Dalí,* in which Alain Bosquet...

I don't like that book at all. He is a liar who invented stories. Dalí was furious over what Bosquet did, and it was because of him that Dalí wrote *Letter from Salvador Dalí to Avida Dollars* [*Lettre Ouverte à Salvador Dalí*] with Albin Michel. That was against Bosquet. He was very dishonest, very, very dishonest. There are many things... I have a copy

I've marked up in red. He was intelligent, but he wanted to mock Dalí. He didn't understand anything about Dalí. Nothing.

I was just going to say that there is an exchange in the book – perhaps it is apocryphal in the end – where Dalí is talking about Godard's *Alphaville* (1965), and he tells Bosquet that Duchamp said it was the most remarkable film in years; Bosquet bemoans Duchamp, and Dalí rebuts, saying he's more interested in Duchamp's opinion than Bosquet's. It's very funny.

It's just the way of presenting things. But one must admit that Dalí really mistreated Bosquet. Dalí didn't like him.

What about Louis Pauwels? At the beginning of his book, *Les Passions selon Dalí* [*The Passions According to Dalí*], he admits that he took liberties with Dalí's quotations.

Without doubt he did, but 80% of Pauwels' book was written by his mistress, Micheline Soudois. He supervised it. But in most respects, Pauwels admired Dalí, whereas Bosquet only wanted to say negative things about him. I prefer even [Ian] Gibson[80] to Bosquet. Gibson did his research. The information is perfect, though the manner it is presented in is another matter. He did the same with Lorca. It is well done, but there are some things that are completely false; he is obsessed with homosexuality.

Was film a unique medium for Dalí? What was its relationship with the other aspects of his oeuvre?

Dalí brought elements from painting to film if it was important, but it was not the core of the operation. The important thing was the images – the true images where an object transforms into another.

So Dalí's ideas for his films were not the same as those for his paintings?

No, no, he needed to make something new. I don't remember any

important paintings executed for *The Prodigious Story of the Lacemaker and the Rhinoceros*. Naturally there is *The Madonna of Port Lligat* because there is the rhinoceros – some little notes like that, but nothing more. He did not want to make a film of his painting; painting did not dominate at all. Perhaps he would return and add elements if the project was not finished. But he never asked me for material from *The Prodigious Story of the Lacemaker and the Rhinoceros* for [José] Montes-Baquer. He never asked me for anything, because there is a unity in *Impressions of Upper Mongolia*; you have the pen and it takes off from there. Dalí did ask me in the 1970s if I wanted to sell 20 minutes of the film to [Enrique] Sabater.

For another film?

I don't know. I said no, naturally. But he tried.

The thing about Dalí is that he was not defeated if a film wasn't finished. *The Prodigious Story of the Lacemaker and the Rhinoceros* reached a point when he had given sufficiently to know that it would be a part of his enduring legacy. Nothing proves that I will not finish it – I may. But I want to finish it with complete liberty. I will follow the ideas Dalí and I had. Who could stand in my place with the knowledge of what we wanted to do? To finish the film, it is necessary to have the experience to combine the images he gave. He didn't choose his images for no reason.

But while the original scenario is very clear, as you said, many of the other scenes only make it more complicated. Will those be incorporated too?

Yes, there are more complicated sections. The point is that my adventure with *The Prodigious Story of the Lacemaker and the Rhinoceros* is an absolute continuity of what Dalí did. It is not something new that I have added. It's a true continuity. I don't believe that anyone has yet written about the indelible line in Dalínian cinema, from his youth to his death, because one is continually stifled – this is important – one is stifled by the images of his painting. I believe it is important instead to

refer to his words and writings in order to understand the cinemato-graphic images he wanted; those are completely different from what he painted – completely! It is not very easy to do an exhibition of Dalí and the cinema because you have to re-read his texts and look at all the notes in the Fundació Gala-Salvador Dalí. When he had ideas, he wrote and rewrote. Perhaps there are things about *The Prodigious Story of the Lacemaker and the Rhinoceros* that I don't know that are in the archives of the Foundation.

Speaking of the Foundation, it seems Dalí did not install any films in the Teatre-Museu Dalí. Should that suggest that he thought of his films as inferior to his paintings?
It is not a question of hierarchy at all, but one of time that occupied him. The drama of Dalí and cinema is that he was never taken seriously by the true people of cinema. They believed in him a little, but they were so annoyed with Hollywood types like Jack Warner. 'But good', they said. 'Good, Disney can do an interesting film with Dalí.' But Dalí under-stood he could not do an interesting film with Disney because there were too many imperatives. It was completely out of the question. Why not accept Dalí's ideas? Always the problem: The ideas of Dalí are very simple.

I thought Dalí 'hated simplicity in all its forms'!
I find his ideas to be simple if one does not try to complicate what he asked for. 'I cannot do it because…', whatever. No, I find the man was a genuinely practical surrealist. He is complex, but it is a form of simplicity if one looks carefully. It's always direct and simple enough, and then it changes and becomes more complex.

Like the pen from the St Regis in *Impressions of Upper Mongolia*.
Yes, it was simple when he first showed me that pen and said, 'There is the battle of Thermopiles'. It's the same thing in a book, when he saw figures in a printed image.

Begetting the warriors in *The Battle of Tetuan* (1962).
Of course.

Going back to the issue of how Dalí viewed television, *Impressions of Upper Mongolia* was also made for TV, wasn't it?
It was. *The Prodigious Story of the Lacemaker and the Rhinoceros*, no; that was a particular adventure.

That is to say that it was made expressly for the cinema?
It was not the same. It was continually putting elements in a sack. For him, it was a space – just as if he decided to do a little text. But it continued, like a journal.

Perhaps that is why it couldn't be finished: There was always more to say.
Absolutely! I never wanted to completely ossify the source. I let the adventure live.

Chaos and Creation, 1960

'The Higher Order prevails even in the disintegration. The totality is present even in the broken pieces. More clearly present, perhaps, than in a completely coherent work [...] So in a certain sense disintegration may have its advantages. But of course it's dangerous, horribly dangerous. Suppose you couldn't get back, out of the chaos...'

Aldous Huxley, *The Doors of Perception*[81]

In 1964, Carlton Lake, fresh from having published *Life with Picasso* and working towards his 1969 book *In Quest of Dalí*, made the amusing remark to Dalí that 'the art historian in him was in danger of getting the better of the painter'.[82] The comment concerned Dalí's accusation that many canonically esteemed modern artists had proliferated a cult of 'ugly painting', an argument he had advanced extensively in his 1956 publication *Les Cocus du vieil art moderne* (*The Cuckolds of Antiquated Modern Art*), which bemoaned the steady decline of art that he said had been instigated when Cézanne first evidenced his 'inability' to paint a round apple. Everyone was fair game for Dalí's venom: Matisse – 'the apotheosis of bourgeois taste' – Picasso – 'grave in the extreme, cannot possibly get worse, pure bestiality' – and Jackson Pollock, whose work, Dalí wrote, was the visual equivalent of indigestion following a fish soup[83] (ironic, then, that Dali, who perceived himself as combating Pollock's style, would go on to do a commercial for Alka-Seltzer in 1974!).

A particular artist Dalí singled out for criticism was the Dutch painter Piet Mondrian, known for his grid-based compositions consisting of rectangular blocks of red, blue, yellow, black or white, separated by thick black, or less commonly grey, lines. 'And so one was to hear the Piet, Piet, Piet of the new modern academicians', Dalí wrote:

[...] Completely idiotic critics have for several years used the name of Piet Mondrian as though he represented the *summum* of all spiritual

activity. They quote him in every connection. Piet for architecture, Piet for poetry, Piet for mysticism, Piet for philosophy, Piet's whites, Piet's yellows, Piet, Piet, Piet, Piet, Piet, Piet, Piet, Peep, Pity, Piet. Well, I Salvador, will tell you this, that Piet with one 'i' less would have been nothing but a pet, which is the French word for a fart.[84]

This argument would adopt an amusing form and a decidedly avant-garde medium in 1960, when Dalí filmed a 17-minute 'happening' at Videotape Productions Inc. in Manhattan. It seems he had been invited to give a presentation at the International Annual Conference on Visual Communications, but as he was unable to make the conference he told them he would send a *video* in his place – thus leading to one of the first – if not *the* first – example of video art, predating Nam June Paik's first works by at least five years.

Dalí's video, *Chaos and Creation*, promised to show how to create a masterpiece out of chaos with the help of photographer Philippe Halsman, the Catalan composer Leonardo Balada, a female model, several pounds of popcorn, a few pigs and a motorcycle. The idea behind this 'masterpiece' was to 'inject' a Mondrian painting with a healthy dose of critical paranoia.

Dalí set up what might only be described as a Mondrian-esque pigpen: a grid of rectangular partitions containing a model, a motorcycle and some Pennsylvanian pigs.[85] Dalí covered the enclosure with a thick layer of popcorn and then started the motorcycle, which ripped off the model's dress and sprayed paint and popcorn everywhere – all over the hapless model and the undoubtedly confused pigs. After all was suffi-ciently messy, a loose canvas was thrown over the pen to make a splatter-paint imprint. The resulting splatters could hardly be elevated to the level of a Pollock, though clearly this is what Dalí was suggesting, even in the sense that his resulting work was quite massive, echoing the enormous canvases that had become common amongst the Abstract Expressionists. Content with his new masterpiece, Dalí signed the work and proceeded to a wall telephone, where he tried to sell the painting

'hot off the press', as it were, to James Johnson Sweeney, then Director of the Solomon R Guggenheim Museum, who had also organised Mondrian's Museum of Modern Art retrospective in 1943.

Observing the 'happening' was the young composer Leonardo Balada, a recent graduate from New York's prestigious Juilliard School of Music. A fellow Catalan, Balada had befriended Dalí, and when the opportunity for *Chaos and Creation* arose, Dalí asked Balada to do something interesting: In the closing scenes of the video – shortly before its strangely abrupt end[86] – Balada is seen playing a piano, though in fact the music was added afterwards. In a telephone conversation, Balada explained to me that he was given photographs of Dalí's splatters and splotches that he interpreted as an 'automatic' musical score. The automatic score – generally coinciding with trends in contemporary music spearheaded by American composer John Cage that embraced chance and personal interpretation – was then recorded and added to the video. Balada recalls that Dalí was always very friendly and down-to-earth unless someone asked for his autograph, at which point he adopted his 'mad genius' persona; he also remembers never being paid for his work on *Chaos and Creation*, which he admits would have been useful at a time when he was a poor graduate student and flights from New York to Spain were very costly.[87]

Dalí's antics may seem a fairly clear attack on abstraction, echoing controversies that had been going on in the United States for over a decade; American President Harry S Truman had lamented the state of 'so-called modern art', setting the stage for Michigan Senator George Dondero to accuse the avant-garde of being a Communist plot. But Dalí's position was not so simple. Indeed, in the 1950s he befriended such abstract artists as William de Kooning and Georges Mathieu, whose swift brushstrokes he compared to fast-moving subatomic particles, echoing his own contemporaneous interest in 'nuclear mysticism'. In abstraction Dalí interpreted not necessarily the abandonment of figuration – this was a moot point, he felt, as Picasso had already killed modern art 'by outuglying, alone, in a single day, the ugly that all the

others combined could turn out in several years'[88] – but the penetration of reality to the quantum level. 'In the whole modern revolution one single idea has not aged and remains so living that it will be the foundation of the new classicism that is immediately awaited', Dalí wrote in *The Cuckolds of Antiquated Modern Art*: 'The most transcendent discovery of our epoch is that of nuclear physics regarding the constitution of matter. Matter is discontinuous and any valid venture in modern painting can and must proceed only from a single idea, as concrete as it is significant: *the discontinuity of matter.*'[89]

With this justification, Dalí was all too happy not only to endorse abstraction but also to incorporate it into his own work. In 1956, for instance, Mathieu presented Dalí with an antique harquebus – a predecessor to the musket – that the Catalan painter used to make his lithographs illustrating *Don Quixote*, pre-dating French artist Niki de St Phalle's famous shooting paintings by about five years. Dalí continued to refine this technique that he dubbed 'bulletism', and in 1960, the same year as *Chaos and Creation*, he detonated a nail-filled bomb against copper plates for his contribution to Joseph Foret's book, *The Apocalypse of St John*.

At the same time, Dalí's writing also professed his interest in abstraction as the legacy of Old Master painting. His 1958 'Anti-Matter Manifesto', written for his exhibition at the Carstairs Gallery, proclaimed his ambition to 'paint the beauty of the angels and of reality' using 'pi-mesons and the most gelatinous and indeterminate neutrinos'. Premiering such monumental works as *Virgin of Guadalupe, Patron Saint of Mexico* (1958) and *The Cut End of Van Gogh's Ear Dematerialising Itself From Its Frightful Existentialism and Pi-Mesonically Exploding in the Dazzlement of Raphael's Sistine Madonna* (1958) – a formerly unattributed work that I have discovered was the original title for the painting now known as *Cosmic Madonna*[90]– Dalí's exhibition evinced his interest in abstraction giving movement to classical imagery, perhaps best revealed in the original, sesquipedal title for *The Sistine Madonna* (1958), *Quasi-grey picture which, closely seen, is an abstract one; seen from*

two metres is the Sistine Madonna of Raphael; and from fifteen metres is the ear of an angel measuring one metre and a half; which is painted with anti-matter; therefore with pure energy. 'My ambition, still and always, is to integrate the experiments of modern art with the great classical tradition', Dalí wrote in the catalogue. 'The latest microphysical structures of Klein, Mathieu and Tapié must be used anew *to paint*, because they are only what, in Velasquez's day, was the 'brush stroke', about which the sublime poet Quevedo, already at that time, said that he painted with 'stains and distant spots'.[91] Though the catalogue uses the spelling 'Tapié', possibly referring to the French art critic and friend of Dalí, Michel Tapié, who coined the term *l'art informel*,[92] it is more convincing that it is a misspelling of Antoni Tápies, who in 1958 represented Spain at the Venice Biennale;[93] similarly, it is unclear whether Dalí's 'Klein' refers to French artist Yves Klein or the Abstract Expressionist Franz Klein; I would vote for the latter,[94] though *Chaos and Creation* is not a far cry from Yves Klein's 'anthropometries' (1959–1960) – spectacles, emceed by Klein dressed in a tuxedo with white gloves, in which women were covered in paint and pressed against canvases, all to the music of an orchestra.

Dalí followed his 'Anti-Matter Manifesto' two years later with another exhibition at the Carstairs Gallery, 'The Secret Number of Velasquez Revealed', which beget two articles in *Art News*, both published in early 1961: 'The Secret Number of Velasquez Revealed', which dissected Dalí's 1960 painting *The Maids-in-Waiting* (*Las Meninas*), and 'Ecumenical "chafarrinada" of Velasquez', which likened the brushstrokes of Spanish Baroque painter Diego Velasquez (also Velázquez) to contemporary Action Painting and identified Mathieu's 'calligraphy' as the visual equivalent of Max Planck's 'quantum of action': 'At the tricentennial of his death Picasso, Dalí, the *pompiers*, the abstractionists, the followers of Action Painting, all consider Velasquez the most alive and most modern of painters', he wrote.[95] There is the spectre of these ideas in *Chaos and Creation*, as Dalí suggests that to generate truly contemporary art, it must be built upon the chaotic swarm of protons

and antiprotons anticipated by Velasquez and rendered contemporane-ously by the Abstract Expressionists. This would become a recurring trope as the decade progressed: Dalí purportedly showed de Kooning some enlargements of details from a Velasquez to which Dalí claimed de Kooning declared, 'That's Action Painting raised to the sublime!',[96] and in 1967 Dalí enlarged details of Meisonnier's *Friedland 1807*, claiming that the movement of the tall grass 'might almost be a Pollock'.[97] Finally Dalí closed the 1960s with his 1969 essay, 'De Kooning's 300,000,000th Birthday', in which he declared the Dutch artist to be 'the most gifted painter and the most authentic final point of modern painting' and 'the initial point of the *pompier* art of the future', whose 'spasmodic impastos' were readily derived from Velasquez's 'brutal brushstrokes'.[98]

What *Chaos and Creation* arguably reveals, then, is not so much Dalí's attack on abstract painting but his *reinterpretation* of it. In the same spirit as *The Cut End of Van Gogh's Ear Dematerialising Itself From Its Frightful Existentialism and Pi-Mesonically Exploding in the Dazzlement of Raphael's Sistine Madonna* that 'atomised' Raphael's beloved *Sistine Madonna* (1513–1514), so in *Chaos and Creation* Dalí stages a spectacle that imbues Mondrian's harmonious composition with his unique brand of nuclear, Expressionistic frenzy. And just as Dalí does not mean to demote Raphael's composition through his 1958 rein-vention, so one might be too hasty in concluding that he was altogether cold to Mondrian: 'I [...] have a soft spot for Mondrian', he wrote in 1956, 'for as I adore Vermeer I find in Mondrian's order the chamber-maid's cleanliness of Vermeer and even his retinian instantaneity of blues and yellows. I nevertheless have to say that Vermeer is almost everything and Mondrian almost nothing.'[99] A comparison to Vermeer was a weighty compliment for Dalí to make indeed,[100] and from it one might conclude that *Chaos and Creation* is strongly linked to Dalí's 1961 essay, 'The Secret Number of Velasquez Revealed', in which he declared that he would 'do nothing less than *save painting from chaos*, demonstrating to the younger painters that from the actual "0 Figure" one must reach the 76,758,469,321 of Velasquez.'[101] For Dalí, Vermeer

was on a par with Velasquez as 'almost everything': By elevating Mondrian's grid-line composition, with the aid of some 'ecumenical "chafarrinadas"' and some Pennsylvania pigs, Dalí sought to turn it, too, into something spectacular.

Soft Self-Portrait of Salvador Dalí, 1967

Originally produced for French television by Henri Coty – heir to the perfume fortune of his grandfather François Coty, 'the Napoleon of Perfume' who had at one time financed a Dalí line of fragrances – *Autoportrait Mou de Salvador Dalí (Soft Self-Portrait of Salvador Dalí)* was amongst the first collaborations between French and North American television. The film was directed by Jean-Christophe Averty, who had been recommended for the project by CBS producer Tom Madigan based on his pseudo-Surrealistic style and established credentials.

Soft Self-Portrait of Salvador Dalí – a title taken from the 1941 painting *Soft Self-Portrait with Grilled Bacon*, in which the artist's visage is loosely draped over crutches with a side of streaky bacon – opens with a bewigged Dalí ecstatically playing a piano filled with cats whose heads protrude from the instrument's top; they let out bewildered 'meows' as the artist improvises a dissonant score. Pianos were a recurring subject in Dalí's work, beginning with *Un Chien Andalou* through to numerous pictorial references – *Diurnal Illusion: The Shadow of a Grand Piano Approaching* (1931),[102] *Necrophiliac Fountain Flowing from a Grand Piano* (1933), *Atmospheric Skull Sodomising a Grand Piano* (1934), *Portrait of Emilio Terry* (1934), *A Chemist Lifting with Extreme Precaution the Cuticle of a Grand Piano* (1934), *Piano Descending by Parachute* (c.1941) – on to *Babaouo*, *Giraffes on Horseback Salad*, the ultimately discarded ballroom scene in *Spellbound* and *Chaos and Creation*. The image in *Soft Self-Portrait* is mildly reminiscent of Dalí's 1931 painting, *Partial Hallucination: Six Apparitions of Lenin on a Grand Piano*, with the cats' heads substituted for those of Vladimir Lenin.

Given that Dalí associated pianos with sexual organs – a link formed in his childhood by a book of venereal diseases that his father left open on the family piano to teach his son the perils of sexual promiscuity[103] – the cats may also suggest the idiomatic 'pussy', connoting both a cat and, more vulgarly, a woman's vulva and vagina, an expression that also translates in French.

Despite its apparent animal cruelty, the image of Dalí banging the piano is a dramatic opening for what proves to be an extremely entertaining and enlightening autobiographical film. Over the next 60 minutes, the artist explains the inspirations behind many of his most famous canvases; he points out the corner of his fishing hut at Port Lligat where he painted *The Weaning of Furniture Nutrition* (1934) and describes his intrauterine 'memories' inspired by Otto Rank's 'birth trauma'. He also provides the viewer with tremendous entertainment: Interspersed with a comprehensive biography narrated in the film's English version by Orson Welles, one finds Dalí – described as a 'reactionary anarchist monarchist', a 'prince of paradox' and a 'frenzied advocate of every kind of censorship' – marching across the landscape throwing fistfuls of feathers into the air with a plaster rhinoceros head in a wheelbarrow and two children dressed as cherubs in tow. Elsewhere he parades with a six-metre-long white dress shirt that he demanded be made especially for the film, and orders a Catalan hog – his 'truest symbol', he says – painted bright green before draping it with a reproduction of Vermeer's *Lacemaker*. One of the more poetic spectacles is the 'divine birth', staged to illustrate Dalí's identification with Castor and Pollux, the *Dioscuric* twins. According to Greek mythology, Leda was seduced by Zeus in the form of a swan and, on the same night, made love to her husband, Tyndareus. She subsequently bore two sets of twins, each set born in a separate egg. One egg contained Helen – who became Helen of Troy – and Clytemnestra, and the other contained the *Dioscuri*, Castor and Pollux. Being the children of Zeus, Helen and Pollux were immortal, while the children of Tyndareus, Castor and Clytemnestra, were mortal.[104] Based largely on a thesis put forward by the French psycho-

Dalí's symbol, the Catalan pig, investigating Vermeer's *Lacemaker*. *L'autoportrait mou de Salvador Dalí*. Directed by Jean-Christophe Averty; Produced by Coty Television and Seven Arts Ltd., 1967.

analyst Pierre Roumeguère, Dalí advanced that he and Gala were the divine twin souls of Helen and Pollux – an especially appropriate analogy given Gala's Christian name, Helena Dimitrievna Diakonova. In *Soft Self-Portrait*, Dalí re-enacts his divine birth with Gala by bursting forth from a giant egg, spraying milk, 'symbolic blood', and 'symbolic [Mediterranean] fish' across the beach. The film also shines when Dalí introduces his double-images, traced to the geological landscape of Cap de Creus; amongst the most effective examples is a landscape with three Cypress trees that one only realises are actually painted on the face of a sleeping woman when she awakens with a yawn. The effect substantiates Welles' narration: 'Dalí sets himself up to be a magician […] not only a wizard in command of real mysteries but a charlatan […] a sublime harlequin.' He is not bothered to be taken for a clown; as he points out in the film, the mythological prototype for the clown was the god Hermes.

One of the ideas Dalí especially pushes in *Soft Self-Portrait* is his antecedence to Pop Art, then the contemporary art movement promoted by such artists as Andy Warhol, Roy Lichtenstein and James

Rosenquist. Dalí's claim is just: Decades before Pop Art challenged critical distinctions between museum-quality art and mass culture, Dalí was meticulously copying from magazine advertisements, newspaper clippings and photographs. The artist described his endorsement of Pop Art as based upon the movement's emphasis on realism, which he considered the heir to his 'hand-painted dream photographs' – the phrase he used describe his miniaturist painting of the 1930s. 'Lichtenstein says, "I don't want anyone to feel the intervention of the artist in any way,"' he told art critic Carlton Lake, 'and so he gets down on his knees before some anonymous machine-made object [...] That is the attitude of the absolute realist [...] The pure act of opening up his heart before reality, to fall in love with it – even if it is a Coca-Cola poster – is something.'[105] Defining abstraction as the '*negation* of reality', Dalí recognised Pop Art – conversely the '*affirmation* of reality'[106] – as part of the revolt towards realism that he had predicted would mount after Picasso 'killed modern art':[107] 'The finest art is always the most photographic,' he said in 1964. 'Pop art is part of the healthy trend away from abstract expressionism [...] back to the maximum of visual reality'.[108]

Anticipating his 1975 film *Impressions of Upper Mongolia – Homage to Raymond Roussel*, *Soft Self-Portrait* concludes with an elaborate 'happening'. As the six-metre shirt is flown in by helicopter, Dalí encloses himself in a clear plastic dome to 'paint the sky' with an angel and flaming Crucifix. Completely covered in thick oil paint by the end, the artist dances for his adoring entourage, called 'The Court of Miracles', signing his 'sky' with a flourish.

Although the film may be less informative for those new to Dalí's ideas and especially for those unaccustomed to his peculiar manner of speech – described in the film as 'Dalínian English' – *Soft Self-Portrait of Salvador Dalí* remains one of the most engaging and visually exciting documentaries produced on the artist. And if one cannot decipher his 'Dalínian English', Dalí reassures us that it's not necessary to understand everything he says: He is a master of mysticism, and even if one comprehends only a 'particle', that will be 'absolutely sufficient'.

Filming *L'Autoportrait mou de Salvador Dalí*, 1967. ©DESCHARNES/daliphoto.com

The Explosion of the Swan, c. 1967

In an interview with Andy Warhol's former assistant Gerard Malanga published in 1975, Dalí alluded to a disturbing bit of cinematic history:

Malanga: I saw the film you were in where you put a piano in a tree. It was shown at the Caresse Crosby memorial at Gotham Book Mart.

Dalí: Bravo! Bravo! Bravo! Many crazy scenes are now lost. We had three living turtles and the turtles moved inside the piano with cats. And the tails of the cats were attached so when you made a certain sound the cats me-e-eeowed, and suffered very much. And after, we killed every cat with guns. After, we caught a swan and killed it. One beautiful white swan and put one bomb inside and the swan explodes in a thousand pieces... intestines in slow motion... going everywhere, and the feathers! The most beautiful explosion of the swan.

Malanga: And this is on film?

Dalí: Movies disappear and you can never recollect them... And now you have discovered one.

Malanga: The swan explosion sounds very romantic...

Dalí: Absolutely divine...[109]

Many question whether Dalí's grotesque vision was ever put to film or if he was merely being provocative. Although those closest to him generally feel it is a case of the latter,[110] one cannot remove it from the realm of possibility: As noted, there was indeed a disturbing scene in *Soft Self-Portrait of Salvador Dalí* in which he pounded a piano with cats meowing from inside – hence my speculative dating of the alleged swan film to the same year, 1967. Five years later, in a May 1972 interview with Russell Harty for *Aquarius* – broadcast in 1973 with the title 'Hello Dalí!' – the artist conveyed much to Harty's astonishment the pleasure he experienced from animal cruelty. After throwing one of his pet ocelots into the swimming pool, Dalí declared that the only animals he liked were rhinoceroses – because they were cosmic – and fillets of sole; otherwise, he added with a mischievous smile, he liked it best when animals suffered.

The idea for an 'exploding swan', one might recall, had actually been put forward for *Wheelbarrow of Flesh*: In 1953 Dalí described a scene in which 'five white swans explode one after the other in a series of minutely slow images that develop according to the most rigorous archangelic eurhythmics',[111] at which time it may have invoked his interest in atomic disintegration and the ephemeral swan that appears alongside Gala in his *Leda Atomica* (1947–1949). Conversing with Malanga, might Dalí have been referring to some lost footage of *Wheelbarrow of Flesh*? No further information is available, though '*The Explosion of the Swan*' anyway serves as another reminder that Dalí's cinematic experiments extend beyond those for which we have solid evidence; as he said himself, 'Movies disappear and you can never recol-

lect them'. Only time will tell if 'The Explosion of the Swan' is a lost film or only a fictitious rumour.

Dune, 1974

Another of Dalí's ill-fated forays into the cinema – though this time, at least, not his own film – was his proposed role in Alejandro Jodorowsky's mammoth 1974 adaptation of Frank Herbert's 1965 science-fiction novel Dune. Born in Chile to Russian immigrants, Jodorowsky had travelled to Paris in 1953 to study mime with the renowned Marcel Marceau, where, he said, the first thing he did was telephone André Breton to announce himself. When Breton asked who he was, Jodorowsky purportedly replied, 'A young man of 24, and I've come to revive Surrealism, here I am. I want to see you.' It was 3 o'clock in the morning when this 'Surreal' conversation took place, so Breton said that they should plan to meet the next day; that Breton was not willing to meet straight away signified to Jodorowsky that he was insufficiently 'Surrealist', and the director consequently vowed to distance himself from the Movement. As Michael Richardson has written, Jodorowsky's tale is unlikely for several reasons:

> That a young man from Chile who, according to other testimony by Jodorowsky, was still unsure of himself would have had the confidence to telephone Breton in the middle of the night, demanding to meet him immediately when they did not even share a common language, is difficult to accept. If it really did happen, the surprising thing about it seems to be Breton's patience. Yet the telling of the story is revealing about Jodorowsky's own personality, in which arrogance and insensitivity go hand in hand with charm and naivety.[112]

Dune was not meant to be especially 'Surrealistic', though as this and other anecdotes evince, Jodorowsky was acquainted with Surrealism and may have even been a member of the group in the late 1950s, until the splinter group Panique – a collaboration amongst Jodorowsky,

Fernando Arrabal and Roland Topor – emerged in the early 1960s.[113] Certainly by this time the Surrealists had completely rejected Dalí, so Jodorowsky's decision to include him in the star-studded *Dune* cast – which already included Orson Welles, Gloria Swanson, HR Giger and Pink Floyd – had little to do with any authentic vestiges of Surrealism. Regardless, if, as Richardson has noted, arrogance and insensitivity were amongst Jodorowsky's outstanding traits, a collaboration with Dalí was fated to be explosive; and certainly it was.

In 1974, Jodorowsky, Michel Seydoux and Jean-Paul Gibon travelled to New York in search of the moustachioed painter, whom the director considered the perfect choice to play Shaddam IV, *Dune*'s 200-year-old Padishah Emperor of the galaxy.[114] The day after checking in to the St Regis Hotel, Jodorowsky phoned him to explain his proposal. Dalí had never seen any of Jodorowsky's films – not even the celebrated 1971 film *El Topo* that secured the director's cult status after being heralded by John Lennon and Yoko Ono – though he was interested and invited Jodorowsky to a private exhibition that evening. The invitation for 7 o'clock 'sharp' arrived under Jodorowsky's room door at 6 o'clock, and by the time he and Michel Seydoux arrived, five minutes late, Dalí had left. Dejected, Jodorowsky returned to the St Regis, where he stumbled into Dalí once again; they made an appointment at the Hotel's King Cole Bar for the following day.

Dalí was enthusiastic about playing the Emperor of the galaxy, though he refused to read Jodorowsky's script, telling him bluntly, 'My ideas are better than yours'. The Emperor should sit on a throne that is also a toilet, Dalí told him; this scatological throne would be comprised of two intersecting dolphins – one for urinating, and the other for defecating, as it would be poor taste to mix the two. Dalí's other conditions for accepting the role were no less extravagant: Filming would take place over one week in Cadaqués, for which he wanted giraffes, elephants and a helicopter; he also reserved the right to select his 'imperial court' from amongst his friends and admirers rather than use professional actors. Jodorowsky was remarkably unfazed, bringing Dalí to his final

demand: His fee was $100,000 per hour – a sum apparently arrived at to ensure he was a better-paid thespian than Greta Garbo. Only complicating the issue, Dalí would not guarantee how many hours he would act; he would provisionally agree to one hour per day, though he might film longer if the mood struck him... at the same hourly fee, of course. Dalí's participation would cost *at least* $700,000.

That night Jodorowsky recounts that he returned to his hotel room and tore a page out of a book on the tarot. On a reproduction of the Hanged Man, he wrote Dalí a note: He couldn't pay $700,000, though he would try to convince his producer to use him for three days at $300,000. Dalí said he would consider the offer and suggested they arrange a meeting in Paris at the luxurious Hôtel Meurice along the Rue de Rivoli.

At that meeting, amongst the chaos that commonly enshrouded Dalí, Jodorowsky managed to deliver a questionnaire: 'How does an Emperor die?', it asked. 'What is his palace like? How does he dress?' Dalí appreciated Jodorowsky's preparations and replied that he, too, had 'come prepared': He produced a drawing of the scatological throne. 'It is completely necessary to see the Emperor making wee and excrement', he said. When asked whether he would be performing these scenes himself, Dalí answered no. He would require a double, at an additional expense...

Dalí and Jodorowsky arranged to meet again in Barcelona, though a few days later Dalí called the director to speak about the film and deliver another stipulation: He did not want to be directed. He would only be in the film if he could do whatever he wanted. Jodorowsky thoughtfully replied, 'If I were rich and asked you to paint me however you wanted but in the shape of an octagon, would you do it?' When Dalí responded in the affirmative, Jodorowsky continued, 'Then it is possible to work together. I will direct you by asking you questions (the form), and you will answer me as you like with actions.' Jodorowsky was keenly aware that entering into such an arrangement was a recipe for disaster; he would have to pose just the right questions that could have but one answer:

> [I]f I ask how will the Emperor be dressed, it is quite possible that he [Dalí] will answer me: 'In the year 20,000, Dalí will be considered a God [...] The Padishah Emperor will be dressed like Dalí'. If I ask him to describe his palace, he may answer: 'Like a reproduction of the old station of Perpignan'. If he gives me these two answers, it could kill *Dune*, and it should be said to him that there is a limit: Dalí cannot interpret Dalí.

There also still remained the issue of his fee – $300,000 was still considerably over the film's budget. Jodorowsky gave an ultimatum: He could only pay $150,000, for which he wanted three days of filming and not an hour and a half, and he needed it to be in Paris rather than Cadaqués; for those scenes that were too peripheral to justify Dalí's expense, his character would be played by a polyethylene puppet – a suggestion that worked well for Jodorowsky, as the puppet had already been incorporated into the script as a robot whose 'resemblance [to the Emperor] is so perfect that the citizens never know if they are faced with a human or a machine'. Dalí was enraged: 'I will have you like rats!', he screamed. 'I will film in Paris, but the set will cost you more than the landscapes of Cadaqués and the framework of my museum. Dalí costs $100,000 per hour!'

Jodorowsky knew that haggling with Dalí was a lost cause and drafted a final proposal: The polyethylene puppet would be donated to the Teatre-Museu Dalí upon the film's completion, while Dalí's role would be reduced to a page and a half of script to be read for one hour at the rate of $100,000 per hour. Dalí agreed and enthusiastically set to work on the Napoleonic bed that would serve as the scatological throne.

But other circumstances would soon come into play: In September 1975, Dalí incited an international firestorm by expressing his support for General Franco's execution of five alleged Basque terrorists, an act that had been carried out despite worldwide criticism. When the press disseminated Dalí's comments against democracy and calls for three times more executions, the artist began receiving death threats.

Jodorowsky announced that as a result of his statements, Dalí would not be appearing in *Dune*: 'I would be ashamed to use now in my work a man who in his masochistic exhibitionism demands the ignoble death of human beings', Jodorowsky was quoted.[115]

Dalí's comments may have cost him his role in *Dune*, though the film was anyway advancing precariously. Not long after the announcement that Dalí had been sacked, the film met its end, due largely to Jodorowsky's ambitious 14-hour script and a reluctant Hollywood establishment that purportedly considered the film 'too French'.[116] Dalí was not likely too disappointed: During negotiations, Amanda Lear, whom Dalí had arranged to play his daughter in the film, had warned Jodorowsky that the painter was a great saboteur who always preferred the things that failed – a position she still holds today, describing all Dalí's conditions for playing Shaddam IV as carefully orchestrated to ensure the film's collapse: 'I realised that all those conditions were just to make sure that they wouldn't be accepted', she says.[117]

In this, Jodorowsky can be said to have one-upped Dalí by doing the unthinkable: He actually *accepted* Dalí's outlandish conditions. It is with this in mind that it is especially lamentable that *Dune* did not materialise. Not only might Jodorowsky's adaptation have been a visual masterpiece, but the freedom he was willing to give Dalí, allowing him to act and interpret the role as he desired, might have made it an authentically Dalínian picture as well. Unfortunately, such was not to be the case. Dalí never received his $100,000, and the fate of the puppet remains to this day an enticing mystery.

Impressions of Upper Mongolia – Homage to Raymond Roussel, 1975

On 21 March 1939, Dalí's exhibition at the Julien Levy Gallery opened to enormous public attention, with lengthy queues reportedly second only to the 1934 viewing of *Whistler's Mother*.[118] His catalogue essay, 'Dalí! Dalí!', expounded on the history of his paranoiac-critical method, which

he had now honed to such precision that his latest exploration, *The Endless Enigma* (1938), contained not a mere double-image but six different, combined subjects – each illustrated in the catalogue by an onion-skin transparency. The aim of 'Dalí! Dalí!' was to legitimise the paranoiac-critical method by chronicling its lengthy history, from prehistoric cave drawings to Aristophanes' play *The Clouds*, about philosophers who saw shapes in clouds. The greatest credit went to Leonardo da Vinci, who, Dalí wrote:

> [...] proved an authentic innovator of paranoiac painting by recommending to his pupils that, for inspiration, in a certain frame of mind they regard the indefinite shapes of the spots of dampness and the cracks on the wall, that they might see immediately rise into view, out of the confused and the amorphous, the precise contours of the visceral tumult of an imaginary equestrian battle.

The 1939 Levy exhibition, Dalí's last before his formal expulsion from Bretonian Surrealism, is not irrelevant to his activity with the cinema some 35 years later, when in January 1974 he approached director José Montes-Baquer about making a film based on the uric acid stains he had cultivated on the three-centimetre brass band of a ballpoint pen from the St Regis Hotel in New York – what would become *Impressions de la Haute Mongolie – Hommage à Raymond Roussel* (*Impressions of Upper Mongolia – Homage to Raymond Roussel*) (1975). The film's copious attention to seeing images emerge from 'stains and spots' bears the unmistakable mark of Leonardo, whose *Trattato della pittura* explicitly encouraged locating images within stains on walls.[119] Robert Descharnes recalls Dalí showing him the famous pen during filming for *The Prodigious Story of the Lacemaker and the Rhinoceros* and telling him that in its markings one could easily see the Greek battle of Thermopiles – not a far cry from Leonardo's ability to see an 'equestrian battle'. Descharnes also recounts an effect Dalí designed for *The Prodigious Story of the Lacemaker and the Rhinoceros* in which an

image of a boat floating on a moonlit lake would rotate 90-degrees counter-clockwise, revealing itself to be the nose and moustache of Adolf Hitler. Again, one might reflect on the 1939 Levy exhibition, which saw the premiere of Dalí's first portrait of the Führer in *The Enigma of Hitler* (c. 1938), the fruit of a contentious fascination sparked in 1933 that never fully subsided. Descharnes never shot the transformation of the boat becoming the Hitler portrait, though 15 years later Dalí resurrected it for the memorable opening sequence of *Impressions of Upper Mongolia – Homage to Raymond Roussel*.

According to Amanda Lear, Dalí kept at least 20 pens from the St Regis Hotel on which he regularly urinated to expedite oxidation and then kept in a drawer 'where he gloated over them'.[120] The opportunity for him to turn his peculiar collection into a motion picture came when director José Montes-Baquer arrived at the St Regis to discuss a docu-

The pen from the St Regis Hotel in which Dalí 'saw' the Battle of Thermopiles. ©DESCHARNES/daliphoto.com

mentary he was shooting for the German television company *Westdeutsche Rundfunk* about audiovisual art in the United States. Dalí showed him one of the pens, saying:

> In this clean and aseptic country, I have been observing how the urinals in the luxury restrooms of this hotel have acquired an astounding range of rust colours through the interaction of the uric acid on the precious metals. For this reason, I have been regularly urinating on the brass band of this pen over the past weeks to obtain the magnificent structures that you will find with your cameras and lenses. By simply looking at the band with my own eyes, I can see Dalí on the moon, or Dalí sipping coffee on the Champs Elysées. Take then this magical object, work with it, and when you have an interesting result, come see me. If the result is good, we will make a film together.[121]

Intrigued by the challenge, the German team spent a week filming the forms that had developed on the pen's brass band. When they presented their condensed 30-minute video to Dalí, he proclaimed it 'infinitely better' than anything he had expected and agreed that they should make a film.

The completed *Impressions of Upper Mongolia – Homage to Raymond Roussel* vacillates between images of the newly-inaugurated Teatre-Museu Dalí in Figueres and a fable Dalí invented upon seeing Montes-Baquer's footage about an expedition to western Upper Mongolia in search of giant hallucinogenic mushrooms many times more powerful than LSD. In Dalí's tale, these white mushrooms – which take six years to develop and grow up to eighteen metres high – had been administered by a princess to her subjects in the midst of a famine; the whole region had thence become 'cretinised' when her subjects were no longer able to distinguish reality from their visions. It's only at the end of the film that one discovers that all the strange scenes are actually extrapolated from the microscopic stains and scratches on the pen, at which point the movie concludes with an outdoor 'happening':

Explorers on camelback seeking hallucinogenic mushrooms – amongst the many visions in *Impressions de la Haute Mongolie – hommage à Raymond Roussel*, 1975. Directed by José Montes-Baquer; Produced by Westdeutsches Fernsehen.

Dalí personally films enthusiastic townspeople spraying paint on an enormous canvas through high-pressure fire hoses, whilst others brandish placards adulating the film's extraordinary *boligrafo* (ballpoint pen).

It's possible that Dalí's inspiration to make a movie based on the oxidation of copper was encouraged by Pier Pasolini's 1968 film *Teorema*, in which one of the characters, inspired by Francis Bacon to become an artist, urinates on a canvas; it was reportedly one of the few modern films Dalí enjoyed.[122] Although Dalí's interest in the potential of uric acid on copper seems to have predated *Teorema*, it is noteworthy that when Warhol described to Dalí the 'oxidation paintings' he began making in December 1977 by hiring friends to urinate on canvases

primed with copper-based paint, Dalí criticised them as 'old-fashioned' and likened them to *Teorema*,[123] despite that Warhol's method was essentially identical to what he himself had conceived years earlier using the pens from the St Regis.

Dalí's idea meanwhile seems to have been indebted primarily to Raymond Roussel. Roussel's name has come up frequently in this book, particularly in terms of the artist's idiosyncratic take on humour. An eccentric French poet, novelist and playwright who was largely unpopular during his lifetime but much admired by the Surrealists, Roussel is best-known for his impenetrable writing style, exemplified by *Impressions of Africa* (1910), *Locus Solus* (1914)[124] and *New Impressions of Africa* (1932). Each of these has its own bewildering characteristics: *New Impressions of Africa* is a 1,274-line poem composed of four enormous cantos, each of which consists of only one drawn-out sentence that is interrupted by a parenthetical 'aside'. That parenthesis is then interrupted by another parenthesis and so forth until a maximum of five parentheses is reached and the phrases begin to return to the original subject; a rather unpoetic example of my own devise: 'The cat (I have owned it ((it was given to me (((I remember it was a Christmas present ((((she had wrapped it (((((put it in a bag, really))))) with a lovely red bow)))) in 1992))) by a friend)) for five years) is eating a mouse'. Of course, Roussel's meanderings are much more extensive: In the second canto, 608 lines separate the subject of the first sentence from its main verb.[125]

Dalí was extremely enthusiastic about *New Impressions of Africa* and, having sent Roussel a copy of *Babaouo* in 1932,[126] published a review of the book in *Le surréalisme au service de la révolution* in 1933.[127] Dalí championed *New Impressions of Africa* as 'the dream journey of the new paranoiac phenomena': 'Roussel's analogies are the product of the most direct, unmediated associations, quite anecdotal and random', he wrote.

They allow us to witness the darkest and deepest conflicts anyone has ever lived through. Indeed we must look on the sequence of

'compound elements' as *relations*, since they unfold in a coherent, consecutive way, and remorselessly present a number of very clear, obsessive invariables; for example, fried eggs, multiple allusions to the smell of urine after the ingestion of asparagus, etc. The irrational nature of Roussel's book is established beyond doubt by its universe of relationships between elements.[128]

Thus in 1933 Dalí already recognised the parallel between his burgeoning paranoiac process of uncovering hidden relationships and the irrational associations Roussel forged in his writing. This can also be inferred from Dalí's quotation of Roussel's title in his 1938 painting, *Impressions of Africa* – a work that premiered in the artist's 1939 exhibition at the Julien Levy Gallery, possibly under the title *Melancholic Eccentricity*.[129] Amongst Dalí's most memorable self-portraits, this impressive oil painting executed in Italy boasts some of the artist's most intricate double-images, suggesting the relationship between Roussel's 'irrational' sequences and the 'concrete irrationality' Dalí was striving to capture in his work.

Dalí was moved by other passages in Roussel's writing, too. Roussel's description of the euphoria he experienced upon finishing *La Doublure* (1897) seems to have acutely influenced *Impressions of Upper Mongolia – Homage to Raymond Roussel*:

What I was writing was wreathed by light, I closed the curtains for I was afraid that the slightest chink might let escape the luminous rays which emanated from my pen, I wanted to pull back the screen suddenly and flood the world with light. If I had left these sheets of paper lying about, shafts of light would have been created and would have travelled as far as China, and the demented crowd would have burst into the house.

Roussel's description of the 'luminous rays' that emanated from his pen – quoted in several essays including Pierre Janet's 'The Psychological

Characteristics of Ecstasy' (1926)[130], which Dalí would have known given his interest in 'the phenomenon of ecstasy', and André Breton's 1933 essay published in *Minotaure* in 1937[131] – influenced Dalí's 1975 movie based on a pen that, indeed, transports the viewer 'as far as China'.

Ian Monk, who masterfully tackled the challenge of translating *New Impressions of Africa* from French into English, writes, 'Perhaps one of the points of the structure of *New Impressions* is to show how a truly imaginative writer can use a fleeting (and intrinsically not very interesting) experience to take his readers anywhere he wants and then take them back again';[132] Dalí's *Impressions of Upper Mongolia – Homage to Raymond Roussel* endeavours to do the same, and although Monk singles out Roussel for exploring 'the rich potentiality of this technique', one must not forget the work of another author Dalí revered, Marcel Proust (1871–1922), who launched into *Remembrance of Things Past* with something as seemingly trivial as a madeleine dipped in tea. The

A boat on a moonlit lake transforms into this, Heinrich Hoffman's photograph of Hitler. *Impressions de la Haute Mongolie – hommage à Raymond Roussel*, 1975. Directed by José Montes-Baquer; Produced by Westdeutsches Fernsehen.

influence of Proust and Roussel on *Impressions of Upper Mongolia – Homage to Raymond Roussel* cannot be underestimated. Attesting to the relationship Dalí saw between these two writers, he staged a fascinating group portrait at his swimming pool in Port Lligat for the 1971 Christmas issue of Paris *Vogue* that included members of his colourful entourage hoisting three large photographs: Proust, Roussel and Chairman Mao Zedong.[133] Proust was highlighted in the issue for his image of a mummy wrapped in gold in *In the Shadow of Young Girls in Flower*, which, Dalí noted, was written despite that Proust probably never saw a mummy himself – Dalí concluded that he most likely gained his inspiration from a box of sardines.[134] This ability to envision something without having experienced it first-hand recurs again in the *Vogue* issue, in Dalí's adaptation of Albrecht Dürer's 1515 woodcut of a rhinoceros – possibly art history's most famous depiction of the animal, though Dürer is known to have made it based on written descriptions without ever having seen a rhinoceros himself. Dalí may have likened all this to

The photograph of Hitler becomes the head of a pig. *Impressions de la Haute Mongolie – hommage à Raymond Roussel*, 1975. Directed by José Montes-Baquer; Produced by Westdeutsches Fernsehen.

Henri Zo's original 59 illustrations for *New Impressions of Africa*: Zo was approached to illustrate Roussel's text through a detective agency, and he executed the drawings without knowing the author's identity or having the opportunity to even read the story. 'The choice of illustrations confirms once again the genius of Raymond Roussel', Dalí wrote in 1933.

Also pertinent is Michel Leiris' account that when Roussel visited Beijing, he 'shut himself away after the most cursory visit of the city',[135] thereby illustrating the writer's preference for the realm of the imagination over reality. Similarly, *Impressions of Upper Mongolia – Homage to Raymond Roussel* invokes a geographic location Dalí never saw; filming took place in New York, Paris and Spain, but not in Mongolia – though he allegedly toyed with travelling to Beijing.[136] But the film is not completely isolated from reality. This is clear in Dalí's earlier cinematic exploitation of the division between imagination and reality, *Giraffes on Horseback Salad*, which opposed a 'Surrealist Woman' personifying 'the world of fantasy, dreams and the imagination' with the unimaginative character, Linda.[137] 'The entire film takes place amidst the struggle between these two women,' Dalí wrote in 1937, 'who personify the world of convention and the world of imagination. Their struggle culminates in a process in which it becomes impossible to judge which of the two worlds is more absurd than the other.'[138] Dalí's agenda was more militant than Roussel's: Where Roussel took refuge in the chimerical, Dalí actively strove to 'discredit reality', the aim of paranoiac-critical activity according to his essay, 'The Rotting Donkey'.[139] *Impressions of Upper Mongolia – Homage to Raymond Roussel* is not separate from reality like Roussel's visions of China, but rather it launches its fantasy voyage from something one might easily see on a daily basis without giving it a second thought, a ballpoint pen. Dalí reveals that even the quotidian items one takes for granted are overflowing with the potential for reverie.

INTERVIEW WITH... AMANDA LEAR

International singer, actress, painter and television personality, Amanda Lear was impassioned by art at an early age. At 16 she went to Paris to study painting before attending St Martins College of Art and Design in London in 1964. In 1965, she returned to Paris as a model for Paco Rabanne and Yves St Laurent, during which time she met Salvador Dalí. She became his muse and one of his closest friends, staying at the painter's side for over 15 years. Amanda published her memories of Dalí in *Lo Dalí d'Amanda* (1984), with a revised edition, *Mon Dalí*, published by Michel Lafon in 2004.

I'm happy to have the opportunity to speak with you as someone very close to Salvador Dalí in the 1960s and 1970s. I know he was experimenting with various film projects at that time, though we don't know a lot about those he began and never finished.

He never finished anything. The only one he finished was *Un Chien Andalou* and that was it. He was planning to do this and planning to do that, but nothing ever happened. He was terrified, I think, to be standing behind the camera and doing a movie. He realised he was not up to it. It's a proper job – I mean, you have to be a film director, which he wasn't. He would sometimes say he wanted to collaborate with Pasolini or Fellini, but it never happened. In the end I really think he thought he was incapable of directing a movie. It's a big job.

I hadn't thought about it, but all his films are collaborations, aren't they? He did not successfully direct any films himself.

Absolutely. He realised he couldn't do it. It's very difficult to direct a movie. I remember, I wrote in my book when we met Pasolini. Pasolini came to order a poster for *Salò* and they couldn't agree on the price. At the same time there was Alejandro Jodorowsky there. Jodorowsky wanted to make a film of *Dune* – this was long before *Dune* was made with Sting – and he wanted Dalí to play the Emperor of the galaxy in

Dune, and I was going to play his daughter. And Dalí did everything – it was really striking to watch what sabotage he was doing. It was a complete work of sabotage. He was doing everything to make sure the thing wouldn't happen. First he was making an absolute fortune, I don't know how many millions of dollars, and then he said 'And I want to have elephants, and I want to have giraffes, and I want to have a helicopter', and they were saying, 'Mr Dalí, cool down. I mean, this costs a lot of money, and I'm not sure we can do all this.' At the time they didn't have such special effects that we have nowadays.

I think they were already paying him $100,000 an hour, in fact.
Absolutely. And I realised that all those conditions were just to make sure that they wouldn't be accepted. The poor people would go back home saying, 'Well at least we got to meet Dalí, it was nice', and nothing happened. It's really very sad, and he looks a bit pathetic because when he was confronted with real filmmakers, big filmmakers like Stanley Kubrick, Fellini, he realised what an incredible job they were doing. It's very difficult to direct people. Dalí couldn't direct anybody; I mean, he couldn't even direct himself! He was too confused; he couldn't do it. I think a movie was completely out of the question with him. Earlier on he had collaborated with Buñuel, and he had approached all the great directors of Hollywood, so people continued to come to him thinking he was also able direct or to contribute to a movie, but it was out of the question. It was unthinkable. The man was not practical at all. To give you an example, he couldn't make a telephone call. If he had to call somebody, he couldn't pick up the phone and actually dial the number – he didn't want to do it. It was something technical, and he couldn't do it. Driving a car, he didn't know how to do that at all. And his wife Gala was saying to me all the time, 'Watch him. He doesn't know you have to wait for the red light to cross the street.' He was completely in his world, and to make a movie you have to be a little down to earth, to look at some practical details – lighting, etc. So to manipulate a film camera would be absolutely horrible, because of those practical things – Dalí really couldn't do that.

He did well with coming up with ideas, of course. And designing...
Yes, the thing for Hitchcock was brilliant, but that was different: It was just designing sets. So many things are really fascinating, what he said about Hitchcock, when he had this idea about a sewing machine piercing the eye of Ingrid Bergman. I mean, can you imagine? People in Hollywood freaked and said, 'Are you crazy?' Ingrid Bergman would be laying there and there should be a sewing machine going boom, boom, boom. It would be getting nearer and nearer and pierce her eye, so they all said, 'Okay, thank you very much, here's your cheque. He's crazy.'

In *The Prodigious Story of the Lacemaker and the Rhinoceros*, there's a scene where they put a needle in an actress's eye. Dalí had suggested something similar for *Moontide*, though I didn't realise he had done so for *Spellbound* too. There are so many continuities: Dalí got an idea and then tried to recuperate it for a later project.
He was a great source of information for all those film directors, all those artists. He was very much ahead of his time, I must say. People would come to Dalí and say he was way before us, and they wanted to meet him. They were sure he was on drugs, but Dalí would say, 'No, I only drink mineral water'. People thought he must be out of his mind all the time to have such visions and such incredible ideas.

He was also very friendly with Jack Warner. I remember we met in New York, and he said, 'I'm going to send you to Jack Warner', that I would be a movie star. I said 'I don't think so', but he wrote me a letter – I still have this ridiculous letter – that says, 'Dear Jack, I'm sending you Amanda. Make her a star!' And can you imagine *Jack Warner*? And again, it was done in a way that was really stinking of sabotage: 'I'm helping you, but I'm not really helping you at all.' He sent me to Fellini – who was casting for *Satyricon* [1969] – knowing very well that he would never take me. He wasn't looking for someone like me at all. He wasn't looking for a good-looking girl. He was looking for a monster – he had just collaborated with Donyale Luna who was an incredible American, six-feet-high. He wanted a fat woman, a dwarf, a giant. When I went to

Fellini, I said Dalí sent me, and he said, 'Well, you're a very nice girl, very good-looking, very pretty, but I have absolutely no use for you. You're not at all what I'm looking for. Dalí should know that I'm looking for monsters, no, no way.' And I was very sorry. It was always the same. The same when we had dinner with Darryl Zanuck in New York and Dalí said to Zanuck, 'Look, Amanda, you can help her', and Zanuck said, 'Yeah, sure, why not? Look, she's pretty, so send her to me and we'll make a test.' So I went to Twentieth Century Fox, I made a test, and a couple days later Zanuck called me and said, 'I got your test, we should talk about it, come to my suite at the Plaza', and so I said to Dalí that Zanuck called me to come to his suite at the Plaza, what shall I do? And Dalí said, 'Sure, of course, that's wonderful, go! I know Darryl Zanuck very well', and so I went to the Plaza and Darryl Zanuck obviously jumped on me. It was 3 o'clock in the afternoon, he opened the door and was in his pyjamas. Zanuck was chasing me all around the room. I went back to Dalí and told him everything, and Dalí was incredibly angry and picked up his phone and said to Zanuck, 'You are a pig! I shall never work with you again, ever! You insulted Amanda, who is my friend!' And Zanuck was begging Dalí to do the poster for the movie with Raquel Welch, *The Fantastic Voyage*, that he had just produced, and Dalí said he wouldn't do the poster. So that was the end of the poster for the film, and the end of my career with Zanuck. But it was always the same. The way he behaved with film people always struck me as a man who just knows he's not up to it and so he just makes a fool of himself, anything, in order not to actually be confronted to having to do it.

You also met Otto Preminger through Dalí, didn't you?
We had dinner in New York with Otto Preminger. Otto Preminger had done a movie with Mia Farrow, and Dalí was very friendly with Mia Farrow, so we were going out with her often. But he knew them all – not just Otto Preminger and Hitchcock. He met Marilyn Monroe – said she was nothing, just a little fat girl. [laughs]

Why do you think Dalí was always so captivated by the cinema?

He was captivated by the idea of what you can do. He very much admired Stanley Kubrick, but that's about it; he didn't admire many people. He pretended he liked Fellini, but not very much. Buñuel he kept criticising, but he was running to see every new movie Buñuel put out. Dalí would say, 'Oh my God, the man's lost his touch. It's a disaster.' He was always criticising, but at the same time he was always running to watch those movies. He liked the cinema very much.

In Cadaqués, he had a very old movie projector – must have been from the 40s or the 50s, one of those old things you have to do by hand. It was black and white – really a disaster. He liked it very much, so he would say 'Let's watch a movie', and he would show some old Buster Keaton. He liked to laugh, you know. He was laughing so much at all those old Hollywood funnies.

And then one day in '68 or '69, suddenly a whole film crew arrived in Cadaqués to film Jules Verne's *The Light at the Edge of the World* [1971]. There was Kirk Douglas, Yul Brynner and Samantha Eggar. They were there for weeks filming in Cadaqués, so we would see them every day. We were going on the set because Dalí was very interested in watching them all do the film. He invited them to dinner, so we had dinner many times with Kirk and with Yul Brynner. It was a great film atmosphere, and a great occasion for Dalí to mention that he worked with Hitchcock. Yul Brynner was very charming. He wanted to be a photographer, and he took many pictures of me in the nude posing for Dalí; his daughter, Victoria Brynner, published a beautiful coffee table book a couple of years ago of Yul Brynner's photographs, and there are at least five or six of me and Dalí. Kirk was a different story: Kirk Douglas asked me where he could find something to smoke because he wanted to smoke a bit of dope, and I said, 'I'll find it for you', and Dalí got incredibly angry because he didn't want me to do drugs anymore. I had just finished my hippie girl days, and he got me out of that ridiculous period where I was a bit out of my head. Dalí said to me, 'I told you never to touch it again! And now you want to do it with Kirk Douglas!' I mean, it

Amanda Lear with Dali and Yul Brynner at a dinner Dalí hosted at the Gare de Lyon, Paris, 1970. Photo by J. Cuinieres/Roger Viollet/Getty Images.

was only a joint! He was so angry: 'I'll never see you again! I'll never see Kirk Douglas again!' So that was another movie episode with Kirk Douglas and Brynner. We saw Brynner many times in Paris after that. Dalí gave a dinner for him in the beautiful setting of the restaurant at the *Gare de Lyon*.

Do you have any memories of Dalí's 1975 film, *Impressions of Upper Mongolia – Homage to Raymond Roussel*?

Dalí said he wanted to make a special movie called *Trip to Higher Mongolia*. He had a pen from the St Regis Sheraton in New York, and he noticed this pen had oxidation stains. In the stains, with his big specta-

cles, he could see things, like you can see things in clouds or in stains on the walls. Well, on the stains on that pen, he could see trees and mountains and little camels, and he said, 'This is it. All my movie is on that pen. Just take the pen, film it in close up and it's a movie.' Of course, he was just sowing an idea, just to provoke people, but there was a team of German filmmakers who believed this and said they would do the movie. They took the pen to Germany, spent hours in the laboratory, and actually brought back to Dalí all the images on the pen. And he said, 'Ah you see, here is the caravan entering Higher Mongolia, and entering the desert'; he was commenting on all the images that were supposed to be on that pen.

Impressions of Upper Mongolia – Homage to Raymond Roussel **was financed by German television, though you've said before that Dalí actually hated TV...**

Yes, he did, he did. He liked movies, but for him television was a very vulgar medium. It was something terrible. What we saw on French TV – people singing, dancing – he thought that was disgusting, really poor and pathetic. And when I became a television personality and a singer, he was very upset. We had a TV set in the Hôtel Meurice, and he asked that the TV set was turned upside-down! And so I said, 'But I'm on TV next', and he said, 'That's why I'm putting it upside-down. I'm sure it will be much better that way.' So I had to watch myself completely upside-down and without any sound as well, because he preferred to imagine the dialogue and the sound rather than listen to all the rubbish we were talking on TV. He had something really against television.

Some of his happenings were for television.

He used television, of course, as a medium. He realised it was instant fame. In those days, it was very fashionable to do a 'happening', so what Dalí called a 'happening' was to just create havoc in the studio. He would have the journalists there and say, 'I want this. I want the naked girl. Let's make a giant omelette and now throw it on that lady's face'. I

couldn't stop laughing. But that was a 'happening'. It was supposed to make people aware, you know, make them think of what could be done. And he did them often. The French people have a lot of footage of Dalí on television.

You said Dalí liked the old comics, Buster Keaton, etc.
Yes, he liked that very much.

Do you think he was trying to be comedic in his own films?
I don't know if it was voluntary or not, but he really was very funny. He was completely comical to me – the way he dressed, the way he walked, the way he behaved, the way he spoke English. People were in hysterics all the time. He liked being the centre of attention, so he enjoyed acting like this and overdoing the accent, the mistakes – 'Booooterfly!', and so on and so on. I really think he was the funniest man I ever met. Really, to me, he was show business completely.

I found an article in a March 1971 magazine saying that Dalí was planning to film a 'happening' and that you were going to play the role of Queen Elizabeth I and Marilyn Monroe. Did that, er... 'happen'?
No, what did happen was that I said to Dalí that I was reading a book by an English writer named Ronald Firbank, and Ronald Firbank described a beautiful woman crucified on a cross. And that's when Dalí got the idea for French *Vogue* to have David Bailey photograph me as a queen crucified on a cross. At the same time we used Verushka to do the picture with Mao Zedong. All those pictures ended up in French *Vogue* magazine.

But very often Dalí said, 'Amanda should be an actress'. He thought it would be nice, that it would be glamorous. He didn't like the idea of me being a singer. He introduced me to a lot of film directors, but nothing ever happened. The way he introduced me, those people were terrified of making a mistake, saying, 'Yeah, but if we use her, she's

Dalí's girlfriend'. Being Dalí's girlfriend, instead of opening doors, it closed doors. Now it's different. I'm making films, I'm acting. But then it was really very different.

You've been in some recent films?

Last winter I made a film with Vincent Gallo and Ernest Borgnine called *Oliviero Rising*, and last summer, in July and August, I was in Portugal filming a French comedy that should be out this winter. There are plans for more. Acting is interesting for me at the moment. At the same time, I've been asked to go on stage and do a tour with a French play, so that's also something that interests me very much.

And you're painting more as well?

Painting has taken on a greater importance. In New York, I sold two paintings, so that was great. I hope it's not *just* because my name is associated with Salvador Dalí, because I do not paint like him. My style has nothing to do with his art. For many years I was painting olive trees in the south of France because it's the land of Cézanne, the land of Van Gogh – all the artists Dalí hated! – but that's over. Now I paint things that are much more violent and much more personal. It's completely different from what I was doing before. Things will happen, though. I'm pretty confident about all that.

The Little Demon, 1982

Dalí's final attempt at the cinema came in 1982, when on 6 November the 79-year-old artist sent a telegram to Luis Buñuel in Mexico proposing one last time that they do another film together:

> DEAR BUÑUEL. EVERY TEN YEARS I SEND YOU A LETTER WITH WHICH YOU DISAGREE BUT I DO NOT GIVE UP. LAST NIGHT I HAD AN IDEA FOR A FILM WHICH WE COULD MAKE IN TEN DAYS, NOT ABOUT THE PHILOSOPHICAL DEMON BUT ABOUT OUR BELOVED LITTLE DEVIL. IF YOU FANCY IT, COME AND SEE ME AT THE PÚBOL CASTLE. I EMBRACE YOU. DALÍ.[140]

Immediately afterwards, Dalí sent a second telegram providing directions to the castle at Púbol where he had taken up residence, suggesting that he was optimistic Buñuel might accept this invitation to rekindle the magic they had created together for *Un Chien Andalou* and *L'Âge d'Or* so many years earlier. Dalí's confidence was certainly idealistic: Buñuel had not spoken to him now for over 40 years, vexed that Dalí had refused to give him a loan in 1939 when he was at his most desperate. Ian Gibson provides the details of Dalí and Buñuel's decisive break-up: The Spanish Republican authorities had sent Buñuel to Hollywood in 1938 to serve as an advisor on films being made about the Spanish Civil War. As Franco's victory became imminent, Buñuel was sacked and desperately turned to Dalí for help. Buñuel wrote Dalí two letters, the latter of which asked for a loan, to which Dalí replied:

> Dear Luis: I can't send you anything at all, and it's a decision taken after great hesitation and much reflection, which I'm now going to explain to you. This is the reason for my delay in answering you, since normally I hate making people wait for replies having to do with money –
>
> Here is the outline of my attitude (tremendously abbreviated, but I know that you will appreciate my sincerity in such matters). For three

years now I've been occupying myself passionately with all matters relating to 'objective chance'. Destiny – prophetic dreams – interpretation of the smallest events in daily life in order to act in consequence – chiromancy – astrology (very important – morphology applied to the immediate moment), etc. etc. All of this was inevitable given my almost inhuman sentiments of 'FRENETIC egoism', that is to say the need to control, as long as I live, and with the maximum intensity, every situation (Freud's pleasure principle).

All the predictions and experiences I've had recently counsel me not to lend you money – Before I got your letter its arrival had been foretold to me in various different ways, particularly by a female Swiss medium, one of the most important in New York at the moment, who guides me a lot (although it's I who decide whether I'm convinced or not). My present situation is as follows: the overcoming of my William Tell complex, that is to say, the end of hostilities with my father, the reconstruction of the idea of The Family, sublimated in racial and biological factors, etc. etc etc. As a result of this, I send everything I can to Cadaqués (everything I am able to do in this sense will contribute to my own triumphant self-construction). At the same time it's been predicted that I'll be assailed by all the myths of family inconformity, represented by my old friends. [...] To recapitulate – my life must now be orientated towards Spain and The Family. Systematic destruction of the infantile past represented by my Madrid friends, images which have no real consequence.[141]

Dalí suggested that Buñuel instead ask the Vicomte de Noailles, adding, 'In the past our collaboration was bad for me. Remember that I had to make great efforts to have my name on Un Chien Andalou'. Clearly he had not yet forgiven Buñuel for screening Un Chien Andalou in May 1934 without acknowledging Dalí's contributions; this was a bit of sweet revenge. Buñuel was livid and, according to his son Juan Luis, carried the vital letter in his wallet for many years afterwards as a reminder of Dalí's selfishness.[142]

Buñuel's anger never stopped Dalí from sending him telegrams with

suggestions for film scenarios, however. He sent numerous ideas to Mexico, and in 40 years Buñuel never once replied: There was little hope that '*The Little Demon*' would be any different. But then Buñuel *did* reply. His response was alas not in the affirmative, but the gesture of reconciliation in Dalí's twilight years must have made the artist very happy. 'I RECEIVED YOUR TWO CABLES,' Buñuel wrote. 'GREAT IDEA FOR FILM LITTLE DEMON BUT I WITHDREW FROM THE CINEMA FIVE YEARS AGO AND NEVER GO OUT NOW. A PITY. EMBRACES.'[143]

Dalí was not defeated, and in January 1983 he asked the Spanish film director Luis Revenga to come to Púbol and film a sample of the movie, which he planned to send to Buñuel to persuade him out of retirement. 'Dalí wanted to record a sequence destined to be the end of a film that he wanted to shoot with Buñuel', recalled Revenga. 'A film that he more or less sang to me, inspired by *Babaouo* [in that much of the latter's absurd action also takes place in the Métro], and that recalled a scene that seemed exciting to me: a snowfall inside the métro station.'[144] Revenga arrived with two photographers, Gerardo Moschioni and Antonio Marcos. The team filmed Dalí wildly singing 'The Merchant's Daughter', a Catalan folksong that he wanted his 'beloved little demon' – a combination between a devil and a dwarf – to sing throughout the movie:

The merchant's daughter
they say she's the prettiest,
but she's not the prettiest, no,
there are others without her [...]

The artist got through the better part of the song's 134 verses before exhaustion overcame him and his friend, the painter Antonio Pitxot, intervened; Dalí collapsed into his chair from fatigue. Buñuel died only a few months later, on 29 July 1983, and nothing more was done with '*The Little Demon*'. The short bit of footage that remains with Revenga is the final testament to Dalí's unending desire to make moving pictures out of his fantastic visions.

NOTES

SALVADOR DALÍ, THE YOUNGEST, MOST SACRED MONSTER OF THE CINEMA IN HIS TIME

1 Salvador Dalí with Louis Pauwels, *Les Passions selon Dalí*, Éditions DeNoël, Paris, 1968, p. 122.

2 Amanda Lear, *My Life with Dalí*, Virgin Books, London, 1985, p. 170. Originally published in French as *Le Dalí d'Amanda*, Favre, Paris, 1984.

3 Interview with Amanda Lear, in this volume.

4 Conversation with Denise Sandell, 24 September 2006, London, England.

5 Haim Finkelstein, *The Collected Writings of Salvador Dalí*, Cambridge, Cambridge University Press, 1998, p. 124–125.

6 Paul Hammond in Dawn Ades (ed.), *Dalí*, Bompiani Arte, Milan, 2004, p. 430.

7 Dawn Ades, *Dalí* (London: Thames and Hudson, 1995), 206. Originally published in 1982.

8 Amanda Lear, *My Life with Dalí*, Virgin Books, London, 1985, p. 60. Originally published in French as *Le Dalí d'Amanda*, Favre, Paris, 1984.

ART AND ANTI-ART

1 Once described as 'Oxford and Cambridge in Madrid' (JB Trend, *A Picture of Modern Spain* [1921], 36. Quoted in Ian Gibson, *The Shameful Life of Salvador Dalí*, Faber and Faber, London, 1997, p. 90.

2 Rafael Santos Torroella (ed.), *Salvador Dalí escribe a Federico Garcia Lorca [1925–1936]*, Poesia, *Revista ilustrada de información poética* (Madrid), no. 27–38, April 1987.

3 Dawn Ades, 'Morphologies of Desire', in Michael Raeburn (ed.), *Dali: The Early Years*, South Bank Centre, London, 1994, p. 139.

4 C.f., Luis Buñuel in *Gaceta Literaria*, no. 56, 15 April 1929, translated in *An*

Unspeakable Betrayal: Selected Writing of Luis Buñuel (University of California Press, 1995), p. 123–124.

5 Sebastià Gasch, *L'expansió de l'art català al món* (Barcelona: privately printed, 1953), 142. Quoted in Gibson, p. 146.

6 Salvador Dalí, 'Els meus quadros del Saló de Tardor', *L'Amic de les Arts* (Sitges), 2 (19) 31 October 1927. Supplement. Translated and published in Haim Finkelstein (ed.), *The Collected Writings of Salvador Dalí*, Cambridge University Press, Cambridge, 1998, p. 51.

7 Salvador Dali, 'La fotografía, pura creació de l'esperit', *L'Amic de les Arts* (Sitges) 2 (18) (30 September 1927), p. 90–91. Translated and published in Finkelstein, p. 46.

8 Ades, 'Morphologies of Desire', p. 142.

9 Louis Aragon, 'Du Décor', *La Film*, September 1918. Quoted in Robert Short, *The Age of Gold: Surrealist Cinema*, Creation Books, New York, 2003, p. 13–14.

'C'EST UN FILM SURRÉALISTE!'

1 *La Révolution surréaliste*, no. 12 (15 December 1929), p. 34.

2 Sebastià Gasch, 'L'exposició colectiva de la Sala Parés', *AA*, no. 19 (31 October 1927), p. 95. Quoted in Ian Gibson, *The Shameful Life of Salvador Dalí*, Faber and Faber, London, 1997, p. 171.

3 Salvador Dalí, *Journal d'un genie*, Éditions Table Ronde, Paris 1964, p. 17.

4 Dalí, *The Secret Life of Salvador Dalí*, Dial Press, New York, 1942, p. 206.

5 *Ibid.*, p. 205.

6 *Ibid.*, p. 206.

7 Wendy Everett, 'Screen as threshold: The disorienting topographies of surrealist film', *Screen*, vol. 39, 1998, p. 141.

8 Robert Short, *The Age of Gold: Surrealist Cinema*, Creation Books, New York, 2003, p. 8.

9 Philippe Soupault in Jean-Marie Mabire, 'Entretien avec Philippe Soupault', *Etudes Cinématographiques*, no. 38–39, special number 'Surréalisme au cinéma' (1965), p. 29. Translated and cited in English in *ibid.*, p. 12.

10 Josep Puig Pujades, 'Un film a Figueres. Una idea de Salvador Dalí i Lluís Buñuel', *La Veu de l'Empordà*, Figueres, 2 February 1929. Cited in Gibson, p. 192.

11 Agustín Sánchez Vidal, *Buñuel, Lorca, Dalí: El enigma sin fin*, Editorial Planeta, Barcelona, 1988, p. 158.

12 Roger Ebert, 'Un Chien Andalou', 16 April 2000. <http://rogerebert.suntimes.com/apps/pbcs.dll/article?AID=/20000416/REVIEWS08/401010369/1023>. Accessed 5 January 2007.

13 Agustín Sánchez Vidal, 'The Andalusian Beasts', in Michael Raeburn (ed.), *Dali: The*

Early Years, South Bank Centre, London, 1994, p. 194.

14 Luis Buñuel, 'Notes on the Making of *Un Chien Andalou*', in Joan Mellen (ed.), *The World of Luis Buñuel: Essays in Criticism*, Oxford University Press, New York, 1978, p. 153. Cited in Short, p. 90.

15 Ebert, *op.cit.*

16 Gibson, p. 193–8.

17 *Ibid.*, p. 196.

18 Luis Buñuel, *My Last Breath* (Jonathan Cape, 1985), p. 116.

19 C.f., Dalí, *The Secret Life of Salvador Dalí*, p. 282.

20 C.f., Francisco Aranda, *Luis Buñuel: A Critical Biography* (Secker and Warburg, 1975), p. 60.

21 Quoted in Gibson, p. 240.

22 Agustín Sánchez Vidal, 'The Andalusian Beasts', in *Dalí: The Early Years*, *op.cit.*, p. 200.

23 Salvador Dali, '*L'Âge d'Or*. Studio 28 revue-programme' (Paris) 1931. Translated and published in Gibson, p. 270–271.

24 Dawn Ades, *Dali*, London, Thames and Hudson, 1982, p. 194.

25 Salvador Dalí and André Parinaud, *Comment on devient Dali*, Robert Laffont, Paris, 1973, p. 131 Buñuel had actually embarked for Hollywood on 28 October.

26 Short, p. 104.

27 Salvador Dalí, 'Documental-Paris-1929', *La Publicitat* (Barcelona), 28 June 1929. Translated and published in Haim Finkelstein (ed., trans.), *The Collected Writings of Salvador Dalí*, Cambridge University Press, Cambridge, 1998, p. 117.

28 Dawn Ades, 'Unpublished scenario for a documentary on Surrealism (1930?)', *Studio International Journal of the Creative Arts and Design* (London), vol. 195, no. 993–4, 1982, p. 62–77. The script is also published as a facsimile in Salvador Dali, 'Cinco minutes de surrealismo', *Salvador Dali, Obra completa vol. III: Poesía, prosa, teatro y cine*, Ediciones Destino, Barcelona, 2004, p. 1050–1075.

29 Gibson, p. 243.

30 Salvador Dalí, 'L'Ane pourri, à Gala Eluard'. *Le Surréalisme au Service de la Révolution* (Paris) no. 1, July 1930, p. 9-12. Translated and published in Finkelstein, p. 223–226. Published in English as 'The Stinking Ass' in *This Quarter* (Paris) vol. V, no. 1, September 1932, p. 49–54.

31 *Ibid.* (Finkelstein, p. 226).

32 Otto Rank, *The trauma of birth*, Robert Brunner, New York, 1924, p. 17. Quoted in Stephen Khamsi, *Healing of Pre- & Perinatal Trauma*, <http://www.birthpsychology.com/healing/review2.html>, accessed 8 December 2006.

33 Dalí, *The Secret Life of Salvador Dalí*, p. 26.

34 *Ibid.*, p. 253.

35 An excerpt from the letter is published in Gibson, p. 239.
36 Salvador Dalí, 'Le Mythe de Guillaume Tell: Toute la Vérité sur Mon Expulsion du Groupe Surréaliste', lecture published by the University of Texas, 9 June 1952. Cited in Dawn Ades, 'Dalí and the Myth of William Tell', in Dawn Ades and Fiona Bradley (eds.), *Salvador Dalí, A Mythology*, Tate Gallery Publishing, London, 1998, p. 40.
37 Salvador Dalí, 'Contra la Familia', *Salvador Dalí, Obra completa vol. III: Poesía, prosa, teatro y cine, op.cit.*, 1081
38 André Breton, *Oeuvres complètes*, II, p.23, quoted in Gibson, p. 352.
39 Dalí, 'Le Mythe de Guillaume Tell', *op.cit.*
40 Salvador Dalí, 'La chèvre sanitaire', *La Femme Visible*, Éditions surréalistes, Paris, 1930, p. 23–34. Translated and published in Finkelstein, p. 229.
41 David Lomas identifies a number of connections between Leonardo and Dalí, including this one, in 'Painting is dead – long live Painting! Notes on Dalí and Leonardo' (*Papers of Surrealism*, issue 4, spring 2006. Accessed online 19 October 2006 at <http://www.surrealismcentre.ac.uk/publications/papers/journal4/>). Other references to this passage from Breton and Ernst are cited in Finkelstein, p. 431.
42 Salvador Dalí, '*Babaouo*: scénario inédit précedé d'un abrégé d'une histoire critique du cinéma et suivi de Guillaume Tell, ballet portugais', Las Ediciones liberales, Barcelona, 1978. Originally published in French by Éditions des Cahiers libres (Paris), 1932.
43 Gibson, p. 301.
44 Pilar Parcerisas, 'Dalí and Irrationality in Cinema: "*Babaouo*, c'est un film surréaliste"', in Hank Hine, William, Jeffett and Kelly Reynolds (eds.), *Persistence and Memory: Critical Perspectives on Dalí at the Centennial*, Bompiani Arte, Milan, 2004, p. 138.
45 Finkelstein, p. 124.
46 Salvador Dalí, 'Luis Buñuel', *L'Amic de les Arts* (Sitges), 4 (31), (31 March 1929), p 16. Translated and published in Finkelstein, p. 125. Emphasis added.
47 Dalí, '*Babaouo*', *op.cit.* Translated and published in Finkelstein, p. 140.
48 Pilar Parcerisas, 'Salvador Dalí and Marcel Duchamp: A game of chess (with Raymond Roussel, Georges Hugnet, André Breton and Man Ray as *voyeurs*)', *Dalí, Elective Affinities*, Department de Cultura de la Generalitat de Catalunya, Barcelona, 2004, p. 123.
49 'Roundtable discussion with Amanda Lear, Ultra Violet and Dawn Ades', in Michael Taylor, *The Dalí Renaissance* (forthcoming 2007).
50 Salvador Dalí, 'Sketch for a scenario', unpublished manuscript, Bibliothèque Kandinsky, Centre Georges Pompidou, Musée National d'Art Moderne, Paris.

51 Salvador Dalí, *Dalí News, monarch of the dailies* (New York) vol. I, no. 2, 1947.

52 Reproduced in Montse Aguer in Dawn Ades (ed.), *Dalí*, Bompiani Arte, Milan, 2004, p. 489.

53 Salvador Dalí, 'New York Salutes Me' (November 1934).

54 Dalí, *The Secret Life of Salvador Dalí*, p. 331.

55 Michael Taylor in Ades, *Dalí*, 2004, p. 240.

56 Augustín Sáchez Vidal, *Salvador Dalí, Obra completa vol. III: Poesía, prosa, teatro y cine*, op.cit., p. 1282.

57 Translated and published in Fèlix Fanés, *Dalí, Mass Culture*, Fundació 'la caixa', Barcelona, 2004, p. 92.

58 A disreputable cabaret venue made famous by Picasso's blue period painting, *Lady at Eden Concert* (1903).

59 Salvador Dalí, 'Los Misterios Surrealistas de Nueva York', *Salvador Dalí, Obra completa vol. III: Poesía, prosa, teatro y cine*, op.cit., p. 1164.

60 *Ibid.*, p. 1160.

Hollywood

1 Salvador Dalí, 'Surrealism in Hollywood', *Harper's Bazaar* (New York) June 1937, p. 68. I would like to thank Michael Taylor for providing me with a photocopy of this essay.

2 Salvador Dalí, 'Total Camouflage for Total War', *Esquire*, no. 2 (New York), August 1942, p. 64–66, 129–30.

3 Robert Descharnes and Gilles Néret, *Salvador Dalí, 1904 1989. L'Oeuvre peint*, Benedikt Taschen, Cologne, 1997, p. 472–473.

4 I am grateful to Michael Taylor for providing me with a manuscript of his essay, 'Hallucinatory Celluloid. Salvador Dalí, Harpo Marx, and the *Giraffes on Horseback Salad* Film Project' (*Dalí and Film*, Tate Publishing, London, 2007), which very much informed the writing of the present text. I would also like to thank Dr Taylor for providing me with a copy of Dalí's unpublished manuscript for *La Femme Surréaliste*, obtained with the permission of the Bibliothèque Kandinsky, Paris.

5 Salvador Dalí, 'Abrégé d'une histoire critique du cinema,' in *Babaouo: Scenario inédit précédé d'un Abrégé d'une histoire critique du cinema et suivi de Guillaume Tell ballet portugais*, Éditions des Cahiers Libres, Paris, 1932, p. 11–21, translated and published in Haim Finkelstein (ed., trans.), *The Collected Writings of Salvador Dalí*, Cambridge University Press, Cambridge, 1998, p. 140–141.

6 *Ibid.*, p. 141.

7 The photograph is reproduced in Robert Descharnes, *Dalí, l'oeuvre et l'homme*, Edita, Lausanne, 1984, p. 158. According to Descharnes, in 1964 Dalí reconstructed the harp for his retrospective exhibition in Tokyo (Robert and Nicolas Descharnes,

Dalí, The Hard and the Soft, Sculptures and Objects [Christopher Jones, trans.], Eccart, Azay-le-Rideau, 2004, p. 48).

8 Reproduced in Descharnes, *Dalí, l'oeuvre et l'homme*, p. 158.

9 James Bigwood, 'Cinquante ans de cinema dalinien', in Daniel Abadie (ed.), *Salvador Dalí. Rétrospective, 1920–1980*, Centre Georges Pompidou, Musée National d'Art Moderne, Paris, 1979, p. 345.

10 Dalí, 'Surrealism in Hollywood'.

11 Wes D. Gehring, *The Marx Brothers: A Bio-Bibliography*, Greenwood Press, New York, 1987, p. 173. Cited in Taylor, "Hallucinatory Celluloid', *op.cit.*

12 Fleur Cowles described a painting of Harpo that Dalí executed in the style of Frans Hals' painting *The Laughing Cavalier* (1624) (*The Case of Salvador Dalí*, Heinemann, London, 1959, p. 249, cited in Taylor, 'Hallucinatory Celluloid', *op.cit.*). It should be said that Cowles' book includes several historical inaccuracies, so one should not be overly confident in her description. Cowles may be confusing Dalí's drawings of Harpo with his essay, 'Surrealism in Hollywood', which refers to Watteau's *L'Embarquement pour Cythère*.

13 Salvador Dalí, 'Sketch for a scenario', unpublished manuscript, Bibliothèque Kandinsky, Centre Georges Pompidou, Musée National d'Art Moderne, Paris. It seems the artist had already begun this scenario by the time he met Harpo, as some of its pages are on letterhead from the Château Frontenac, a hotel in Quebec where Dalí and Gala stayed at the end of December 1936.

14 *Ibid.*

15 Fèlix Fanés, *Dalí, Mass Culture* (Sue Brownbridge, trans.), Fundació 'la Caixa', Barcelona, 2004, p. 95.

16 Translated excerpts from this scenario have appeared in Descharnes, *Dalí, l'oeuvre et l'homme*, p. 158; 'A (Very Strange) Day at the Races', *Harper's Magazine*, vol. 292, no. 1752, May 1996 (<http://www.miskatonic.org/dali-marx.html>, accessed 1 December 2006); Fèlix Fanés, 'Dalí y Harpo Marx. Un guión inédito', *Cuadernos de la Academia*, no. 2, January 1998: 175–186; and most recently in the Fundació Gala-Salvador Dalí's collection of the artist's completed works (Salvador Dalí, 'La mujer surrealista', *Salvador Dalí, Obra completa vol. III: Poesía, prosa, teatro y cine*, Ediciones Destino, Barcelona, 2004, p. 1169–1188), which publishes the complete script.

17 Descharnes, *Dalí, l'oeuvre et l'homme*, p. 158.

18 Dalí, 'La mujer surrealista', p. 1182.

19 *Ibid.*, p. 1186.

20 Groucho Marx, *The Groucho Phile: An Illustrated Life*, Bobbs-Merrill, New York, 1976, p. 147. Quoted in Taylor, 'Hallucinatory Celluloid', *op.cit.*

21 Meredith Etherington-Smith, *The Persistence of Memory: A Biography of Dalí*, Da Capo, New York, 1993, p. 220.

22 Joe Adamson, *Groucho, Harpo, Chico, and Sometimes Zeppo: A History of the Marx Brothers and a Satire on the Rest of the World*, Simon and Schuster, New York, 1973, p. 161. Quoted in Taylor, 'Hallucinatory Celluloid', *op.cit.*

23 Dalí's two scenarios for *Moontide*, kept in the archives of the Centre d'Estudis Dalinians at the Fundació Gala-Salvador Dalí, are published in Spanish in *Salvador Dalí, Obra completa vol. III: Poesía, prosa, teatro y cine*, op.cit., p. 1191–1199.

24 Salvador Dalí, 'Declaration of the Independence of the Imagination and the Rights of a Man to His Own Madness', *Art Digest* (New York) vol. 13, no. 19, 1 August 1939, p. 9.

25 L. Genonceaux, *Comte de Lautréamont, Isidore Ducasse, Oeuvres Complètes*, Librarie José Corti, Paris, 1961, p. 9. Quoted by Hank Hine in Dawn Ades (ed.), *Dalí*, Bompiani Arte, Milan, 2004, p. 212.

26 Comte de Lautréamont, *Lautréamont's Maldoror* (Alexis Lykiard, trans), Thomas Y. Crowell, New York, 1972, p. 177.

27 Salvador Dalí, 'Explanation of an Illustration from the Chants de Maldoror' (1934). Translated and published in English as an appendix to Salvador Dalí, *The Tragic Myth of Millet's Angelus* (Eleanor Morse, trans.) Salvador Dalí Museum, St Petersburg (FL), 1986, p. 151.

28 *Ibid.*, 156.

29 Lautréamont, *Lautréamont's Maldoror*, p. 77–78.

30 'Dalí's Heterosexual Monster Invades Chicago', *The Art Digest*, col. 18, no. 2, 15 October 1943, p. 13.

31 Lautréamont, *Lautréamont's Maldoror*, 123.

32 Fanés, *Dalí, Mass Culture*, p. 101–102.

33 Enrique Sabater, *Las arquitecturas de Dalí*, Fundación de Cultura. Ayuntamiento de Oviedo, n.p.

34 Fanés, *Dalí, Mass Culture*, p. 84.

35 'Ingrid Bergman told Hitchcock biographer Donald Spoto in 1976, "It was a wonderful twenty-minute sequence that really belongs to a museum. It was marvellous. But someone said, 'What's all that drivel?' So they cut it. It was such a pity."' (James Bigwood, 'A Nightmare Ordered by Telephone', in *Spellbound* (1945), Dir. Alfred Hitchcock. Perfs. Ingrid Bergman, Gregory Peck. Criterion Collection, DVD, 2002). Much of the information in this section is owed to Bigwood's fascinating essay.

36 See Marc Vernet, 'Freud: effects espéciaux-Mise en scène: USA', *Communications* (Paris), no. 23 (1975), p. 223–234, cf. Fanés, p. 84.

37 Deborah H. Weinstein, 'The Austrian Dreyfus Affair', *Reform Judaism*. Winter 2000. *http://reformjudaismmag.net/1100dw.html*. Accessed 17 November 2006.

38 *Film Profiles: Alfred Hitchcock*, interview with Philip Jenkinson for BBC TV, n.d.

Quoted in Nathalie Bondil-Poupard, 'Such Stuff As Dreams Are Made On: Hitchcock and Dalí, Surrealism and Oneiricism', in Dominique Païni and Guy Cogeval (eds.), *Hitchcock and Art: Fatal Coincidences*, Montreal Museum of Fine Arts, Montreal, 2000, p. 156.

39 Salvador Dalí, 'Spellbound', *Dalí News*, 20 November 1945 (New York: Bignou Gallery).

40 *Ibid.*

41 Quoted in Bigwood, *op.cit.*

42 Dalí, 'Spellbound', *op.cit.*

43 Dalí also wanted the cracks in the statue to be crawling with ants, but Hitchcock made it clear that covering Ingrid Bergman with ants was out of the question.

44 According to their contract, Grosh scenic studio was allowed to keep the backdrop following the film's completion for inclusion in its rental stock. Though originally painted in black, white and grey, the curtain was repainted in the 1960s in rather garish colours to accommodate those wanting to rent it for colour television programmes. The curtain is presently exhibited at the Dalí Universe at London's County Hall.

45 After Man Ray, this famous piece is often dated 1923, though the eye and metronome seem to have first appeared in an ink drawing in 1932, while the actual object debuted at Paris' Galerie Pierre Colle as *Ceil-metronome* [*Eye-Metronome*] in 1933. Man Ray made editions of the piece repeatedly throughout his life with subsequent incarnations going by the titles *Lost Object* (1945), *Indestructible Object* (1958), *Last Object* (1966) and *Perpetual Motif* (1972) (Merry Foresta, ed., *Perpetual Motif: The Art of Man Ray* [Washington, D.C.: National Museum of American Art with Abbeville Press, 1988], 9). Although Man Ray's original instructions indeed called for the object to be destroyed with a hammer, this was famously put into practice in 1957, when a group of students destroyed the object at an exhibition; hence Man Ray's decision to change the title to *Indestructible Object*.

46 C.f., Annie Renonciat, *La vie et l'oeuvre de JJ Grandville*, ACR Édition Internationale, Courbevoie, 1985.

47 Quoted in Bigwood, *op.cit.*

48 *Ibid.*

49 Salvador Dalí, 'Walt Disney and Dalí Close to Signing', *Dalí News*, 20 November 1945 (New York: Bignou Gallery). Printed in *La Vie publique de Salvador Dalí*, Centre Georges Pompidou, Musée National d'Art Moderne, Paris, 1980, p. 118.

50 Alfred Frankenstein, 'Dalí "Stops Experimenting" – But He's Still Enigmatic', *San Francisco Chronicle*, 19 November 1945. Quoted in Ian Gibson, *The Shameful Life of Salvador Dalí*, Faber and Faber, London, 1997, p. 436.

51 Christopher Jones, 'When Disney met Dalí.' *The Boston Globe* (Boston), 30 January 2000.

52 *Ibid.*

53 Jordan R. Young, 'Dalí and Disney', *Los Angeles Times*, May 1989. Quoted in Etherington-Smith, p. 304.

54 Letter from Gala to James Thrall Soby, dated 29 January 1946. The Museum of Modern Art Archives, NY: James Thrall Soby papers. Quoted in Fanés, *Dalí, Mass Culture*, p. 85.

55 A. Frankenstein, *Arts* (Paris), 14 April 1946, Translated and quoted in Gibson, p. 437.

56 The drawing is reproduced in Descharnes, *Dalí, l'oeuvre et l'homme*, p. 140.

57 C.f., *La Vie publique de Salvador Dalí*, p. 43.

58 Salvador Dalí, 'New York as seen by the Super-Realist Artist M. Dalí', *American Weekly* (New York), 24 February 1935. Printed in *Ibid.*, p. 48.

59 Jones, *op.cit.*

60 *Ibid.*

61 Salvador Dalí, 'Disney-Dalí-Destiny to be published by Dial?', *Dalí News*, 25 November 1947 (New York: Bignou Gallery). Printed in *La Vie publique do Salvador Dalí*, p. 125.

62 Jones, *op.cit.* Evincing Hench's artistic prowess in copying Dalí's work, the two reportedly collaborated on a 'stereoscopic' image in which a face comprised of architecture in a snowy landscape is divided in half; Dalí apparently executed one half of the face and Hench the other. The result was published on the cover of the 1 December 1946 issue of *Vogue* magazine (Gibson, p. 437).

63 Most of the information relayed here, including the circumstances of Dalí's participation in the *Bel Ami* International Competition, is indebted to Michael Taylor, 'Salvador Dalí's *Temptation of Saint Anthony* and the Exorcism of Surrealism', in Hine, Jeffett and Reynolds (eds.), *op.cit.*, p. 177–185.

64 *Ibid.*

65 Robert Descharnes, *Salvador Dalí*, Nouvelles Éditions Françaises, Paris, 1973, p. 144.

66 C.f., Michael Taylor in Ades, *Dalí*, 2004, p. 342.

67 'Minerva's Chick' <http://mp_pollett.tripod.com/roma-c1.htm>, accessed 30 November 2006.

68 *Ibid.*

Later Films

1 Salvador Dalí, 'The Last Scandal of Salvador Dalí', Julien Levy Gallery, New York, 1941. Written under the pseudonym Felipe Jacinto.

2 Salvador Dalí, *Journal d'un génie*, La Table Ronde, Paris, 1964, p. 104–106. Portions of this text were published in Salvador Dalí, 'Mes Secrets cinématographiques', *La Parisienne* (Paris) February 1954, p. 165–168.

3 Letter from Albert Field to Luis Buñuel with commentary by Dalí, 18 February 1959, reproduced in *Salvador Dalí, La Gare de Perpignan, Pop, Op, Yes-yes, Pompier*, Museum Ludwig, Cologne, 2006, p. 171.

4 'On Set with Dalí', *Adweek*, 7 February 2007. Accessed online at <http://www.adweek.com/aw/magazine/article_display.jsp?vnu_content_id=1003541510>

5 Manuel Del Arco, *Dalí in the Nude* (Antonio Cruz and Jon Berle, trans.), The Salvador Dalí Museum, St Petersburg (FL),1984, p. 25. Originally published in Spanish as *Dalí al desnudo*, José Janès, Barcelona, 1952.

6 Salvador Dalí, 'La carretilla de carne', *Salvador Dalí, Obra completa vol. III: Poesía, prosa, teatro y cine*, Ediciones Destino, Barcelona, 2004, p. 1203–1217.

7 Del Arco, *Dalí in the Nude*, p. 25.

8 Salvador Dalí, *The Secret Life of Salvador Dalí*, Dial Press, New York, 1942, p. 400.

9 Del Arco, *Dalí in the Nude*, p. 25.

10 *Ibid.*

11 Salvador Dalí, 'Interprétation paranoïaque-critique de l'image obsédante 'L'Angélus' de Millet', *Minotaure* (Paris) no. 1, 1 June 1933, p. 65–67.

12 Salvador Dalí, *The Tragic Myth of Millet's Angelus* (Eleanor Morse, trans.), Salvador Dalí Museum, St Petersburg (FL), 1986. Originally published in French as *Le Mythe tragique de l'Angélus de Millet, Interprétation 'paranoiaïque-critique'* (c. 1932) Jean-Jacques Pauvert, Paris, 1963.

13 *Ibid.*, p. 3.

14 *Ibid.*, iii–iv.

15 Dalí, *Journal d'un génie*, p. 104–106.

16 *Ibid.*

17 Dalí, *The Secret Life of Salvador Dalí*, p. 332.

18 A. Reynolds Morse, *Dalí, a study of his life and work*, New York Graphic Society, Greenwich, 1958, p. 42.

19 Salvador Dalí, *Fifty Secrets of Magic Craftsmanship*, Dover Publications, Inc., Mineola, 1992, p. 73-74. Originally published by Dial Press, New York, 1948.

20 *The Life of Saint Teresa of Ávila by Herself*, Penguin, Harmondsworth, 1957, p. 210. Quoted in Jeremy Stubbs, 'The Dalí-Breton Honeymoon: Hallucination, Interpretation, High and Low Ecstasies', in Hank Hine, William Jeffett and Kelly Reynolds (eds.), *Persistence and Memory: New Critical Perspectives on Dalí at the Centennial*, Bompiani Arte, Milan, 2004, p. 22.

21 Salvador Dalí, 'Manifeste mystique', Robert J Godet, Paris, 1951. Translated and published in Haim Finkelstein (ed., trans.), *The Collected Writings of Salvador Dalí*,

Cambridge University Press, Cambridge, 1998, p. 364.

22 Agustín Sánchez Vidal in *Salvador Dalí, Obra completa vol. III: Poesía, prosa, teatro y cine*, op.cit., p. 1288.

23 Salvador Dalí, 'To Spain guided by Dalí', *Vogue* (New York), 15 May 1950, p. 54–57, 91.

24 C.f., Patrick Gifreu, *Dalí, un manifeste ultralocal*, Mare nostrum, Narbonne, 1997; Cristina Masanés, 'Ultralocal Dalí', *Dalí Elective Affinities* (Pilar Parerisas, ed.) Departament de Cultura de la Generalitat de Catalunya, Barcelona, 2004, p. 193–235.

25 Josep Pla, *Homenots. Quarta série*. Obra completa 29, Destino, Barcelona, 1975, p. 173, 175. Quoted in Masanés, p. 194.

26 Salvador Dalí with Louis Pauwels, *Les Passions Selon Dalí*, Éditions DeNoël, Paris, 1968, p. 81

27 Elliott H. King, 'Winged Fantasy with Lead Feet: The influence of Llullism and Hiparxiologi on Dalí's Mysticism', in Hine, Jeffett and Reynolds, *op.cit.*, p 189–193.

28 Salvador Dalí, 'La Sangre Catalana', *Salvador Dalí, Obra completa vol. III: Poesía, prosa, teatro y cine*, op.cit. p. 1221. This is a slightly modified version of the English translation published by Montse Aguer in Dawn Ades (ed.), *Dalí*, Bompiani Arte, Milan, p. 509.

29 Sánchez Vidal, p. 1289.

30 Salvador Dalí, 'De la beauté terrifiante et comestible de l'architecture modern style', *Minotaure* (Paris) no. 3-4, December 1933, p. 69–76.

31 Robert Descharnes and Clovis Prévost, *La visió artística i religiosa de Gaudí*, Ayma S.A., Barcelona, 1969.

32 Dalí, 'La Sangre Catalana', 1231.

33 *Ibid.*, 1224.

34 'I had just finished doing *Dalí's Moustache* [Simon and Schuster, New York, 1954] with Philippe Halsman. I was in New York for the retrospective exhibit of my 200 *Divine Comedy* watercolours, when, going through Paris, I had happened on Vermeer of Delft's *Lacemaker*, and discovered the importance of the rhinoceros horn' (Salvador Dalí with André Parinaud, *Comment on devient Dalí*, Éditions Robert Laffont, Paris, 1973, p. 283). Dalí strangely refers to his exhibition at New York's Carstairs Gallery, which exhibited 7 December 1954–31 January 1955 – thus after his November 1954 visit to the Louvre.

35 Salvador Dalí, 'Aspects phénoménologiques de la métode paranoïaque-critique' (1955), published in *La Vie publique de Salvador Dalí*, Centre Georges Pompidou, Paris, 1980, p. 144.

36 Dalí's visit to the Louvre has alternatively been dated December 1954 (c.f., Robert Descharnes, *L'Héritage infernal*, Ramsay/La Marge, Paris, 2002, p. 85, and VE Barnett, *Handbook: The Guggenheim Museum Collection 1900–1980*, Solomon R

Guggenheim Museum, New York, 1980, p. 313), and Dalí himself insinuates that the visit occurred in May 1955 (Dalí with Parinaud, p. 284). The 20 November 1954 date comes directly from the photographs of the visit in Robert Descharnes' archive.

37 Robert and Nicolas Descharnes, *Dalí, The Hard and the Soft, Sculptures and Objects*, Eccart, Azay-le-Rideau, 2004, p. 60.

38 I am grateful to Matthew Gale for pointing out this comparison.

39 Fleur Cowles recounts these events as leading to a precise copy of *The Lacemaker* (*The Case of Salvador Dalí*, Heinemann, London, 1959, p. 253), referring to the painting Dalí executed c.1955 and subsequently sold to collector Robert Lehman, now in the collection of the Metropolitan Museum of Art, New York. Although A Reynolds Morse corroborates this history (*Dalí, A study of his life and work*, p. 77), Dalí began the *Paranoiac-Critical Study of Vermeer's Lacemaker* – not the Lehman painting – at the Louvre in 1954. Dalí painted three versions of *The Lacemaker*, all of equal size to the original (24 x 21cm): *The Paranoiac-Critical Study*, the Lehman painting, and an unfinished version Dalí bequeathed to the Spanish State. According to Descharnes, he copied *The Lacemaker* from life only the single time.

40 C.f., Dalí, 'Aspects phénoménologiques de la métode paranoïaque-critique', p. 144.

41 *Ibid*.

42 Robert Descharnes, *Dalí de Gala*, Edita, Lausanne, 1962, p. 186. Also c.f. Morse, *Dalí, A study of his life and work*, p. 78.

43 According to myth, the unicorn could only be caught through deception; a virgin would lure it, and, unable to resist her purity, the unicorn would tamely lay its head in her lap, making itself vulnerable to nearby hunters.

44 Dalí recognised this association, too (c.f., Dalí with Pauwels, p. 246–247).

45 Dalí also analyses the rhinoceros anus, suggesting that it too exhibits logarithmic spirals specifically akin to sunflowers.

46 Cowles, 253.

47 HE Huntley, *The Divine Proportion: A study in mathematical beauty*, Dover Publications, Inc., New York, 1970, p. 164.

48 Matila Ghyka, *The World Mine Oyster*, William Heinemann Ltd., London, 1961, p. 302. Originally published in French by Éditions du Vieux Colombier (La Colombe), 1956.

49 *Ibid.*, 303.

50 Conversation with Robert Descharnes, 25 November 2005.

51 Dalí's description seems to be extrapolated from D'Arcy Thompson's *On Growth and Form* (1917). In a passage Dalí quotes at length as an appendix to *Fifty Secrets of Magic Craftsmanship* (1948), Thompson considers the sea urchin as a spherical shell, comparable to a drop of falling water.

52 Descharnes and Descharnes, *Dalí, The Hard and the Soft, Sculptures and Objects*, p. 60. The cited passage is an adaptation of the story as recounted in *Dalí de Gala* (*op.cit.*, p. 52), though the histories differ slightly: Whereas *Dalí, The Hard and the Soft* implies that the artist's links surrounding rhinoceros horns and *The Lacemaker* were conceived *en masse* during the summer of 1954, *Dalí de Gala* insinuates more correctly that their development was gradual. This quotation, as well as others related to *The Prodigious Story of the Lacemaker and the Rhinoceros*, was curiously omitted in *Dalí de Gala*'s English translation, *The World of Salvador Dalí* (Harper and Row, New York, 1962).

53 On Dalí, Mathieu and Pollock's use of film and photography to disseminate a persona, see Frederick Gross, 'Mathieu Paints a Picture', *PART: Journal of the CUNY PhD Program in Art History*, 2002, City University of New York, 12 September 2006 <http://dsc.gc.cuny.edu/part/part8/articles/gross.html>.

54 Descharnes and Descharnes, *Dalí, The Hard and the Soft, Sculptures and Objects*, p. 60.

55 M. Horton and J. Appleton, 'Mostly About People', *International Herald Tribune* (Paris), 15 May 1950, n.p., cited by Michael Taylor in Ades, *Dalí*, 2004, p. 376.

56 Dalí, *Journal d'un génie*, p. 51.

57 *Ibid*

58 Cowles, p. 253.

59 Dalí, *Journal d'un génie*, p. 157.

60 Archives Descharnes, Azay-le-Rideau, France.

61 C.f., Emilio Puignau, *Vivències amb Salvador Dalí*, Editorial Juventud, Barcelona, 1995, p. 91–92.

62 Cowles, p. 155–156.

63 After several attempts, the needle finally broke – the careful work of Professor Gaétan Jayle, an opthamological surgeon who oversaw the manufacturing of a special contact lens capable of withstanding the tinted-glass needle – but the special effects for which Dalí hoped have never been added.

64 Interview with Robert Descharnes, 4 October 2006, Azay-le-Rideau, included in this volume.

65 *Ibid*.

66 Telegram from Dalí to Robert Descharnes and Georges Mathieu, 20 April 1956 (Archives Descharnes, Azay-le-Rideau, France).

67 Conversation with Robert Descharnes, 25 November 2005.

68 *Ibid*. Although it is likely that neither Dou nor Vermeer was experimenting with stereoscopy, Dalí described Dou to Luis Romero as the 'first stereoscopic painter', contending that his 'pioneering stereoscopy' in the seventeenth century developed out of a Dutch preoccupation with optics (Luis Romero, *Todo Dalí en un rostro*, Editorial Blume, Barcelona, 1975, p. 160).

69 'El Presidente hace equilibrios', *Ondas*, no. 137, 15 August 1958, p. 6–7.

70 Salvador Dalí, 'Prologue', *Dix recettes d'immortalité* (English supplement, Haakon Chevalier, trans.), Audouin-Descharnes, Paris, 1973, n.p.

71 James Bigwood, 'Cinquante ans de cinema dalinien', in Daniel Abadie (ed.), *Salvador Dalí rétrospective 1920–1980*, Centre Georges Pompidou, Musée National d'Art Moderne, Paris, 1979, p. 352.

72 Salvador Dalí, 'Preface', in Robert Descharnes and Clovis Prévost, *La visió artística i religiosa de Gaudí*, Ayma S.A., Barcelona, 1969, p. 11.

73 Magdeleine Hours, *Une vie au Louvre*, Robert Laffont, Paris, 1987.

74 Salvador Dalí, 'Mes Secrets cinématographiques', *La Parisienne* (Paris) February 1954, 165–168.

75 Claude Brulé, 'Tous les secrets du film-bombe de Salvador Dalí', *Ciné Revue*, no. 20, 17 May 1957, p. 6–7.

76 Salvador Dalí and Gerard Malanga, 'Explosion of the swan', *Sparrow 35*, Black Sparrow Press, August 1975.

77 Christopher Jones in conversation with José Montes-Baquer. I am grateful to Christopher Jones for providing me with extracts from his hours of interviews.

78 *L'Âge du cinema* (Paris) 4–5 (August–November 1951), p. 2. Published in Paul Hammond (ed., trans.), *The Shadow & Its Shadow: Surrealist Writings on the Cinema*, City Lights Books, San Francisco, 2000, p. 47.

79 'El Presidente hace equilibrios', *op.cit.*, p. 6–7

80 Ian Gibson, *The Shameful Life of Salvador Dalí*, Faber and Faber, London, 1997.

81 Aldous Huxley, *The Doors of Perception*, Granada, London, 1977, p. 42–43. Originally published by Chatto & Windus, Ltd., 1954.

82 Carlton Lake, *In Quest of Dalí*, GP Putnam's Sons, New York, 1969, p. 58.

83 Salvador Dalí, *Dalí on Modern Art: The Cuckolds of Antiquated Modern Art* (Haakon Chevalier, trans.), Dover Publications, Inc., New York, 1996, p. 64. Originally published in French as *Les Cocus du vieil art moderne*, Fasquelle, Paris, 1956.

84 *Ibid.*, p. 61. Slightly earlier in the text Dalí invents the amusing witticism, 'Piet. "Niet"', referring to the painter's extreme minimalism (p. 57).

85 See Charles Stuckey, 'The Persistence of Dalí', *Art in America*, March 2005, p. 119.

86 According to Balada, the film owned by the Fundació Gala-Salvador Dalí is incomplete, accounting for the abrupt ending. It is presently unknown whether a full copy exists (Telephone conversation with Leonardo Balada, 13 December 2006).

87 *Ibid.*

88 Dalí, *Dalí on Modern Art: The Cuckolds of Antiquated Modern Art*, p. 21.

89 *Ibid.*, p. 73.

90 The painting and its original title is reproduced in GB, 'On the Cover', *Art Voices*, vol. IV, no. 1, winter 1967. The text notes: 'Many viewers have been disconcerted

by the title which, at first glance, seems to have nothing to do with the religious subject. A careful examination of the picture shows that the general sweep of the draperies resembles an ear, which the details of the folds repeat, on a small scale, again and again – for example, on the right side of the Madonna's elbow. The clouds on the lower left also converge into the general configuration of the folds of the ear. The bloody red slashes that severed Van Gogh's ear are indicated on the lower left edge of the Madonna's dress and on her arm and breasts.'

91 Salvador Dalí, 'Anti-matter manifesto', Carstairs Gallery, New York, 6 December 1958–January 1959.

92 Haim Finkelstein (ed., trans.), *The Collected Writings of Salvador Dalí*, Cambridge University Press, Cambridge, 1998, p. 436.

93 Jordi Falgàs, 'The *Chafarrinadas* of Modern Abstract Art': Dalí and Abstract Expressionism', in Hine, Jeffett and Reynolds, *op.cit.*, p. 36.

94 Finkelstein makes a case for the alternative, noting that in 1956 Yves Klein created an environmental piece composed of blue globes floating in the gallery space (Finkelstein, p. 436).

95 'Ecumenical "chafarrinada" of Velásquez', *Art News*, vol. 59, no. 10, Feb 1961, p. 30.

96 Lake, p. 60. Dalí asserted that these same aggressive brushstrokes were characteristic of Ernest Meissonier.

97 *Ibid.*, p. 169.

98 Salvador Dalí, 'De Kooning's 300,000,000th Birthday', *Art News* (New York) 68 (April 1969), p. 57, 62–3.

99 Dalí, *Dalí on Modern Art: The Cuckolds of Antiquated Modern Art*, p. 61.

100 Dalí followed this in 1966 with a comparative chart for several artists that gave Mondrian exemplary marks in the areas of 'authenticity', 'legitimacy' and 'aesthetic sense' (Salvador Dalí, *Open Letter to Salvador Dalí*, JH Heineman, New York, 1967, p. 156, 158. Originally published in French as *Lettre ouverte à Salvador Dalí*, Albin Michel, Paris, 1966.)

101 'The Secret Number of Velasquez Revealed'. *Art News* (New York) vol. 59, no. 9, January 1961, p. 45. Emphasis mine. Dalí alludes to his 'magic operation' in *The Maids-in-Waiting (Las Meninas)*, a copy of Velázquez's *Las Meninas* in which Dalí has substituted the painting's personages for numbers corresponding to their general shapes (e.g., the edge of the large canvas becomes a number seven); the resulting number, Dalí reveals, is 76,758,469,321, though the painting actually presents 77,758,469,321.

102 This work is now commonly known by this title, though it exhibited only as *Diurnal Illusions* prior to the 1964 exhibition of Dalí's works in Tokyo, when its title was augmented to include the piano.

103 Lluis Permanyer, 'El pincel erótico de Dalí', *Playboy* (Barcelona), no. 3, January

1979, p. 161. Cited in Michael Taylor, 'Salvador Dalí's *Temptation of Saint Anthony* and the Exorcism of Surrealism', in Hine, Jeffett and Reynolds, *op.cit.*, p. 180.

104 Elliott H. King in Ades, *Dalí*, 2004, p. 344.

105 Lake, p. 50.

106 Salvador Dalí, 'Eureka', (Paris: Hôtel Meurice, October 1976). Published in Robert Descharnes (ed). *Oui 2: l'Archangelisme scientifique*, Éditions Denoël, Paris, 1979, p. 198–199.

107 Dalí, *Dalí on Modern Art: The Cuckolds of Antiquated Modern Art*, p. 21.

108 'Playboy interview: Salvador Dalí, a candid conversation with the flamboyantly eccentric grand vizier of surrealism.' *Playboy* (New York), July 1964, p. 64.

109 'Explosion of the swan', *op.cit.*

110 Interview with Robert Descharnes, 4 October 2006, in this volume.

111 Dalí, *Journal d'un génie*, p. 104–106.

112 Michael Richardson, *Surrealism and Cinema*, Berg, Oxford and New York, 2006, p. 136.

113 *Ibid.*

114 Jodorowsky's account of his adventures with Dalí and *Dune* was published in 1985 as part of a special section of the French comic book *Metal Hurlant* (Alejandro Jodorowsky, 'Dune: Le film que vous ne verrez jamais', *Metal Hurlant*, no. 107, supplement, 1985: XIII). Most of the information on Jodorowsky's meetings with Dalí, including quotations, is taken from this article unless stated otherwise.

115 'Dalí Speaks his Mind and Loses his Job', *San Francisco* Examiner, 10 October 1975. Quoted in Gibson, p. 619.

116 *Dune* would finally make it to the cinema in 1984 courtesy of director David Lynch, with José Ferrer cast as Shaddam IV.

117 Interview with Amanda Lear, 17 October 2006. In this volume.

118 *Life* (New York), 18 April 1939.

119 See 'C'est un film surréaliste!', note 41.

120 Amanda Lear, *My Life with Dalí*, Virgin Books Ltd., London, 1985, p. 269. Originally published in French as *Le Dalí d'Amanda*, Favre, Paris, 1984. She adds that Dalí asked her to urinate on the pens, too, so that she would contribute to the rusting process.

121 Christopher Jones in conversation with José Montes-Baquer, *op.cit.*

122 Lear, p. 254.

123 Pat Hackett (ed.), *The Andy Warhol Diaries*, Warner Books, New York, 1989, p. 119.

124 In 1966, Dalí told Alain Bosquet that of all the books in the world, he would rescue *Locus Solus*, which he revered even more than Cervantes (Alain Bosquet, *Entretiens avec Salvador Dalí*, Éditions du Rocer, Monaco, 2000, p. 96.) Originally published by Pierre Belfond (Paris), 1966.

125 Ian Monk, introduction to Raymond Roussel, *New Impressions of Africa*, Atlas Press, London, 2004, p. 5.

126 On the influence of Roussel on *Babaouo*, see Pilar Parcerisas, 'Dalí and Irrationality in Cinema: "Babaouo, c'est un film surréaliste"', in Hine, Jeffett and Reynolds, *op.cit.*, p. 142.

127 Salvador Dalí, 'Raymond Roussel. – "Nouvelles impressions d'Afrique"', *Le Surréalisme au service de la révolution* (Paris) no. 5, 15 May 1933, p. 40–41. Translated by Martin Sorrell and published in *Raymond Roussel: Life, Death and Works,* Atlas Press, London, 1987, p. 55.

128 *Ibid.*

129 Although *Impressions of Africa* is absent in the 1939 Levy catalogue – it is not recorded in any exhibitions prior to the 1941 Dalí retrospective at the Museum of Modern Art, New York, in fact – Eric Schaal's photographs of the 1939 Levy Gallery installation reveal that *Impressions of Africa* was exhibited, presumably as a loan from Edward James (Montse Aguer and Marc Aufraise, *Dalí versus Schaal*, Fundació Gala-Salvador Dalí, Figueres, 2006, p. 44–57). Meanwhile, I have discovered that on 8 April 1941, the Virginia newspaper *The Richmond Times Dispatch* reproduced *Impressions of Africa* with the title *Melancholic Eccentricity*, a title that appeared as number thirteen in the 1939 catalogue. *The Richmond Times Dispatch* may well have published the incorrect title and/or image, though no painting titled *Melancholic Eccentricity* is listed in the catalogue for the 1941 Levy Gallery show on which the article was reporting, and no reference to it appears in any of Dalí's subsequent exhibitions. *Melancholic Eccentricity* was thus either purchased and disappeared, or, like many of his other canvases from the 1930s, is now known by another title. In its online catalogue raisonné, the Fundació Gala-Salvador Dalí hypothesises that *Melancholic Eccentricity* might alternatively have been the title for the painting now known as *Mountain Lake*.

130 Pierre Janet, 'The Psychological Characteristics of Ecstasy', *De l'angoise à l'extase* (1926). Translated by John Harman and published in *Raymond Roussel: Life, Death and Works, op.cit.*, p. 39.

131 André Breton, 'Raymond Roussel' (1933), *Minotaure* (Paris), p. 10, 1937. Translated by Martin Sorrell and published in *Raymond Roussel: Life, Death and Works* (*op.cit.*), 59. The quotation from Roussel is taken from this translation.

132 Monk, 12.

133 Salvador Dalí, 'Le 'Vogué' de Salvador Dalí', *Vogue* (Paris), Éditions condé nast. s.a., December 1971–January 1972: 180. On Dalí's paradoxical esteem for Chairman Mao, see Elliott H. King, 'Little Black Dress, Little Red Book: Dalí, Mao and monarchy (with special attention to Trajan's glorious testicles)', in Michael R. Taylor (ed.), *The Dalí Renaissance* (forthcoming 2007).

134 Dalí, 'Le 'Vogué' de Salvador Dalí', p. 161.

135 Breton, p. 59.

136 '[A]lready he could see the two of us standing on the Great Wall, brandishing his photo-montage of Mao-Marilyn' (Lear, p. 248). Lear refers to the photograph of Marilyn Monroe Dalí had asked Philippe Halsman to graft onto the head of Chairman Mao in c.1967 that later graced the cover of the 1971 *Vogue*.

137 Fèlix Fanés, *Dalí, Mass Culture*, Fundación 'la Caixa', Barcelona, 2004, p. 95.

138 *Ibid.*

139 Salvador Dalí, 'L'Âne pourri', *La Femme visible*, Éditions surréalistes, Paris, 1930.

140 Published in Ades, *Dalí*, 2004, p. 539.

141 Luis Buñuel Archive, Ministry of Culture, Madrid. Translated and published in Gibson, p. 394–395.

142 Gibson, p. 395.

143 Ibid., p. 597.

144 Màrius Carol, Juan José Navarro Arisa and Jordi Busquets, *El último Dalí*, El País, Madrid, 1985, p. 14.

BIBLIOGRAPHY

Many of the unrealised scripts presented in this book are manuscripts preserved in the archives of the Centre d'Estudis Dalinians at the Fundació Gala-Salvador Dalí (Figueres, Spain). Most are unavailable in English at the time of this printing but are published in Spanish and Catalan in:

Salvador Dalí, Obra completa vol. III: Poesía, prosa, teatro y cine, Ediciones Destino, Barcelona, 2004.

The bibliography for Salvador Dalí is growing every day, and an equally hefty body of scholarship exists on Surrealism and the cinema. I have found the following resources helpful in providing a useful introduction to Dalí and film (*=available in English):

Ades, Dawn (ed.). *Dalí*, Bompiani Arte, Milan, 2004.*
This catalogue for the 2004 centenary exhibition contains useful entries on a number of Dalí's paintings as well as a short text by Paul Hammond on Dalí and cinema.
Ades, Dawn. *Dalí*, Thames and Hudson, London, 1995 (1982).*
Ades concludes this monograph with a survey of Dalí and the cinema.
Bigwood, James. 'A Nightmare Ordered by Telephone', in *Spellbound* (1945), Dir. Alfred Hitchcock., Perfs. Ingrid Bergman, Gregory Peck. Criterion Collection, DVD, 2002*
This essay, included on the Criterion Collection DVD, presents groundbreaking research on Dalí's role in Spellbound *and comes highly recommended.*
Bigwood, James. 'Cinquante ans de cinema dalinien', in Daniel Abadie (ed.), *Salvador Dalí. Rétrospective, 1920–1980*, Centre Georges Pompidou, Musée National d'Art Moderne, Paris, 1979.
Amongst the first investigations of Dalí's work with cinema.
Dalí, Salvador. 'Aspects phénoménologiques de la métode paranoïaque-critique' (1955), published in *La Vie publique de Salvador Dalí*, Centre Georges Pompidou, Paris, 1980.

Despite my best efforts, this lecture remains only in French. It is essential for under-standing Dalí's art and thought of the 1950s and its relation to The Prodigious Story of the Lacemaker and the Rhinoceros.

Dalí, Salvador. *Journal d'un genie*, Éditions Table Ronde, Paris 1964. Translated in English as *Diary of a Genius*, Double-day, New York, 1965.*

The highly-entertaining 'diary' of the mustachioed Surrealist, spanning 1952 to 1963.

Dalí, Salvador. *The Secret Life of Salvador Dalí*, Dial Press, New York, 1942.*

Dalí's famous autobiography. Some elements are fictitious, but it's essential and fasci-nating reading. An acquired taste for some, this is the book that first turned me on to Dalí!

Descharnes, Robert, and Gilles Néret. *Salvador Dalí, 1904–1989. L'Oeuvre peint*, Benedikt Taschen, Cologne, 1997.*

The standard reference book – inexpensive and indispensable.

Finkelstein, Haim (ed., trans.). *The Collected Writings of Salvador Dalí*, Cambridge University Press, Cambridge, 1998.*

The most useful resource for English translations of Dalí's writings up to 1968. Finkelstein's commentaries are also informative. Tragically the book is out of print, but it's sometimes available through used bookshops.

Gibson, Ian. *The Shameful Life of Salvador Dalí*, Faber and Faber, London, 1997.*
The most thorough biography of the artist to date.

Short, Robert. *The Age of Gold: Surrealist Cinema*, Creation Books, New York, 2003.*
An excellent and approachable examination of Surrealism and the cinema, especially focusing on Un Chien Andalou *and* L'Âge d'Or.

The following have also been cited in the preparation of this text:

DALÍ WRITINGS (CHRONOLOGICAL)

'La fotografía, pura creació de l'esperit', *L'Amic de les Arts* (Sitges) 2 (18) (30 September 1927), p. 90–91.*

'Luis Buñuel', *L'Amic de les Arts* (Sitges) 4 (31) (31 March 1929), p. 16.*

'Documental-Paris-1929', *La Publicitat* (Barcelona) 28 June 1929.*

'L'Ane pourri, à Gala Eluard'. *Le Surréalisme au Service de la Révolution* (Paris) no. 1, July 1930, p. 9–12; *La Femme visible*, Éditions surréalistes, Paris, 1930; Published in English as 'The Stinking Ass' in *This Quarter* (Paris) vol. V, no. 1, September 1932, p. 49–54.*

'La chêvre sanitaire', *La Femme Visible*, Éditions surréalistes, Paris, 1930, p. 23–34.*

'L'Âge d'Or: Studio 28 revue-programme' (Paris) 1931.*

'Babaouo: scénario inédit précedé d'un abrégé d'une histoire critique du cinéma et

suivi de Guillaume Tell, ballet portugais', Las Ediciones liberales, Barcelona, 1978.
Originally published in French by Éditions des Cahiers libres (Paris), 1932.* (excerpt
in English in Finkelstein, op.cit.)

'Raymond Roussel. 'Nouvelles impressions d'Afrique', Le Surréalisme au service de la
révolution (Paris) no. 5, 15 May 1933, p. 40–41.*

'Interprétation paranoïaque-critique de l'image obsédante 'L'Angélus' de Millet',
Minotaure (Paris) no. 1, 1 June 1933, p. 65–67.*

'De la beauté terrifiante det comestible de l'architecture modern style', Minotaure
(Paris) no. 3-4, December 1933, p. 69–76.*

'New York Salutes Me' (November 1934).*

'New York as seen by the Super-Realist Artist M. Dalí', American Weekly (New York)
24 February 1935.*

'Surrealism in Hollywood', Harper's Bazaar (New York) June 1937.*

'Declaration of the Independence of the Imagination and the Rights of a Man to his
Own Madness', Art Digest (New York) vol. 13, no. 19, 1 August 1939, p. 9.*

'Total Camouflage for Total War', Esquire, no. 2 (New York), August 1942, p. 64–66,
129–30.*

'The Last Scandal of Salvador Dalí', Julien Levy Gallery, New York, 1941. Written under
the pseudonym Felipe Jacinto.*

Dalí News, monarch of the dailies (New York: Bignou Gallery), 20 November 1945.*

Dalí News, monarch of the dailies (New York: Bignou Gallery) vol. I, no. 2, 1947.*

Fifty Secrets of Magic Craftsmanship, Dover Publications, Inc., Mineola, 1992.
Originally published by Dial Press, New York, 1948.*

'To Spain guided by Dalí', Vogue (New York) 15 May 1950, p. 54–57, 91.*

'Manifeste mystique', Robert J Godet, Paris, 1951.*

'Mes Secrets cinématographiques', La Parisienne (Paris) February 1954, p 165–168.

Les Cocus du vieil art moderne, Fasquelle, Paris, 1956. Translated and published in
English as Dalí on Modern Art: The Cuckolds of Antiquated Modern Art (Haakon
Chevalier, trans.), Dover Publications, Inc., New York, 1996.*

'Anti-matter manifesto', Carstairs Gallery, New York, 6 December 1958–January 1959.*

'The Secret Number of Velasquez Revealed'. Art News (New York) vol. 59, no. 9,
January 1961: 45.*

'Ecumenical "chafarrinada" of Velásquez', Art News, vol. 59, no. 10, Feb 1961, p. 30.*

Le Mythe tragique de l'Angélus de Millet, Interprétation 'paranoïaïque-critique'
(c. 1932) Jean-Jacques Pauvert, Paris, 1963. Translated and published in English as
The Tragic Myth of Millet's Angelus (Eleanor Morse, trans.), Salvador Dalí Museum,
St Petersburg (FL), 1986.*

Lettre ouverte à Salvador Dalí, Albin Michel, Paris, 1966. Translated and published in
English as Open Letter to Salvador Dalí, JH Heineman, New York, 1967.*

(with Louis Pauwels), *Les Passions selon Dalí*, Éditions DeNoël, Paris, 1968. Translated and published in English as *The Passions According to Dalí* (St Petersburg: Salvador Dalí Museum, 1985).*

'De Kooning's 300,000,000[th] Birthday', *Art News* (New York) 68 (April 1969), p. 57, 62–3.*

'Preface', in Robert Descharnes and Clovis Prévost, *La visió artística i religiosa de Gaudí*, Ayma SA, Barcelona, 1969.*

'Le 'Vogué' de Salvador Dalí', *Vogue* (Paris), Éditions condé nast. s.a., December 1971–January 1972.

(with André Parinaud), *Comment on devient Dalí*, Robert Laffont, Paris, 1973. Translated and published in English as *The Unspeakable Confessions of Salvador Dalí*, Marrow, New York, 1976.*

Dix recettes d'immortalité (English supplement, Haakon Chevalier, trans.), Audouin-Descharnes, Paris, 1973.*

(with Gerard Malanga), 'Explosion of the swan', *Sparrow 35,* Black Sparrow Press, August 1975.*

ADDITIONAL REFERENCES

Ades, Dawn. 'Unpublished scenario for a documentary on Surrealism (1930?)', *Studio International Journal of the Creative Arts and Design* (London), vol. 195, no. 993–4, 1982, p. 62–77.*

Ades, Dawn and Fiona Bradley (eds.), *Salvador Dalí, A Mythology*, Tate Gallery Publishing, London, 1998.*

Barnett, VE. *Handbook: The Guggenheim Museum Collection 1900–1980*, Solomon R Guggenheim Museum, New York, 1980.*

Bondil-Poupard, Nathalie. 'Such Stuff As Dreams Are Made On: Hitchcock and Dalí, Surrealism and Oneiricism', in Dominique Païni and Guy Cogeval (eds.), *Hitchcock and Art: Fatal Coincidences*, Montreal Museum of Fine Arts, Montreal, 2000.*

Bosquet, Alain. *Entretiens avec Salvador Dalí*, Éditions du Rocer, Monaco, 2000. Originally published by Pierre Belfond (Paris), 1966.

Brulé, Claude. 'Tous les secrets du film-bombe de Salvador Dalí', *Ciné Revue*, no. 20, 17 May 1957, p. 6–7.

Carol, Màrius, Juan José Navarro Arisa and Jordi Busquets, *El último Dalí*, El País, Madrid, 1985.

Cowles, Fleur. *The Case of Salvador Dalí*, Heinemann, London, 1959.*

'Dalí's Heterosexual Monster Invades Chicago', *The Art Digest*, col. 18, no. 2, 15 October 1943, 13.*

Del Arco, Manuel. *Dalí al desnudo*, José Janès, Barcelona, 1952. Translated and published in English as *Dalí in the Nude* (Antonio Cruz and Jon Berle, trans.), The

Salvador Dalí Museum, St Petersburg (FL), 1984.*

Descharnes, Robert. *Dalí de Gala*, Edita, Lausanne, 1962.*

Descharnes, Robert. *Dalí, l'oeuvre et l'homme*, Edita, Lausanne, 1984.*

Descharnes, Robert (ed). *Oui 2: l'Archangelisme scientifique*, Éditions Denoël, Paris, 1979.

Descharnes, Robert, and Nicolas Descharnes, *Dalí, The Hard and the Soft, Sculptures and Objects* (Christopher Jones, trans.), Eccart, Azay-le-Rideau, 2004.*

Descharnes, Robert, and Clovis Prevost, *La visió artística i religiosa de Gaudí*, Ayma SA, Barcelona, 1969. Translated and published in English as *Gaudí the Visionary*, Patrick Stephen, London, 1971.*

Descharnes, Robert. *L'Héritage infernal*, Ramsay/La Marge, Paris, 2002.

Descharnes, Robert. *Salvador Dalí*, Nouvelles Éditions Françaises, Paris, 1973, p. 144.*

'El Presidente hace equilibrios', *Ondas*, no. 137, 15 August 1958, p. 6–7.

Etherington-Smith, Meredith. *The Persistence of Memory: A Biography of Dalí*, Da Capo Press, New York, 1993.*

Falgàs, Jordi. 'The *Chafarrinadas* of Modern Abstract Art': Dalí and Abstract Expressionism', in Hank Hine, William Jeffett and Kelly Reynolds, *Persistence and Memory: New Critical Perspectives on Dalí and the Centennial*, Bompiani Arte, Milan, 2004.*

Fanés, Fèlix (ed.), *Dalí, Mass Culture*, Fundació 'la caixa', Barcelona, 2004.*

Ghyka, Matila. *The World Mine Oyster*, William Heinemann Ltd., London, 1961. Originally published in French by Éditions du Vieux Colombier (La Colombe), 1956.*

Gifreu, Patrick. *Dalí, un manifeste ultralocal*, Mare nostrum, Narbonne, 1997.

Hackett, Pat (ed.). *The Andy Warhol Diaries*, Warner Books, New York, 1989.*

Hammond, Paul (ed., trans.). *The Shadow & Its Shadow: Surrealist Writings on the Cinema*, City Lights Books, San Francisco, 2000.*

Hours, Magdeleine. *Une vie au Louvre*, Robert Laffont, Paris, 1987.

Huntley, HE. *The Divine Proportion: A study in mathematical beauty*, Dover Publications, Inc., New York, 1970.*

Huxley, Aldous. *The Doors of Perception*, Granada, London, 1977. Originally published by Chatto & Windus, Ltd., 1954.*

Jodorowsky, Alejandro. 'Dune: Le film que vous ne verrez jamais', *Metal Hurlant*, no. 107, supplement, 1985.* (some English translations of varying quality are available on the Internet.)

Jones, Christopher. 'When Disney met Dalí.' *The Boston Globe* (Boston), 30 January 2000.*

King, Elliott. 'Little Black Dress, Little Red Book: Dalí, Mao and monarchy (with special attention to Trajan's glorious testicles)', in Michael R Taylor (ed.), *The Dalí Renaissance*, forthcoming 2007.*

King, Elliott. 'Winged Fantasy with Lead Feet: The influence of Llullism and Hiparxiologi on Dalí's Mysticism', in Hank Hine, William Jeffett and Kelly Reynolds, *Persistence and Memory: New Critical Perspectives on Dalí at the Centennial*, Bompiani Arte, Milan, 2004.*

Lake, Carlton. *In Quest of Dalí*, GP Putnam's Sons, New York, 1969.*

Lautréamont, *Lautréamont's Maldoror* (Alexis Lykiard, trans.), Thomas Y. Crowell, New York, 1972.*

La Vie publique de Salvador Dalí, Centre Georges Pompidou, Musée National d'Art Moderne, Paris, 1980.

Lear, Amanda. *Le Dalí d'Amanda*, Favre, Paris, 1984. Translated and published in English as *My Life with Dalí*, Virgin Books, London, 1985.*

Masanés, Cristina. 'Ultralocal Dalí', in Pilar Parerisas (ed.), *Dalí Elective Affinities*, Departament de Cultura de la Generalitat de Catalunya, Barcelona, 2004.*

Minguet Batllori, Joan. *El Cinema de Dalí: Dalí i el cinema (films, projectes i textos)*, Fimoteca de la Generalitat de Catalunya, Barcelona, 1991.

Morse, A. Reynolds. *A Dalí Primer*, Reynolds Morse Foundation, Cleveland, 1970.*

Morse, A. Reynolds. *Dalí, a study of his life and work*, New York Graphic Society, Greenwich, 1958.*

Parcerisas, Pilar. 'Dalí and Irrationality in Cinema: "Babaouo, c'est un film surréaliste"', in Hank Hine, William Jeffett and Kelly Reynolds (eds.), *Persistence and Memory: Critical Perspectives on Dalí at the Centennial*, Bompiani Arte, Milan, 2004.*

Parcerisas, Pilar. 'Salvador Dalí and Marcel Duchamp: A game of chess (with Raymond Roussel, Georges Hugnet, André Breton and Man Ray as *voyeurs*)', *Dalí, Elective Affinitites*, Department de Cultura de la Generalitat de Catalunya, Barcelona, 2004.*

'Playboy interview: Salvador Dalí, a candid conversation with the flamboyantly eccentric grand vizier of surrealism.' *Playboy* (New York), July 1964, p. 41–42, 44–46, 48.*

Puignau, Emilio. *Vivències amb Salvador Dalí*, Editorial Juventud, Barcelona, 1995.

Raeburn, Michael (ed.). *Dali: The Early Years,* South Bank Centre, London, 1994.*

Renonciat, Annie. *La vie et l'oeuvre de JJ Grandville*, ACR Édition internationale, Courbevoie, 1985.

Richardson, Michael. *Surrealism and Cinema*, Berg, Oxford and New York, 2006.*

Roussel, Raymond. *New Impressions of Africa* (Ian Monk, trans.), Atlas Press, London, 2004.*

Raymond Roussel: Life, Death and Works, Atlas Press, London, 1987.*

Sabater, Enrique. *Las arquitecturas de Dalí*, Fundaciôn de Cultura, Ayuntamiento de Oviedo.

Sánchez Vidal, Agustín. *Buñuel, Lorca, Dalí: El enigma sin fin*, Editorial Planeta, Barcelona, 1988.

Santos Torroella, Rafael. *Dalí, residente*, Publicaciones de la Residencia de Estudiantes,

Consejo de Investigaciones Cientificas, Madrid, 1992.

Santos Torroella, Rafael (ed.). *Salvador Dali escribe a Federico García Lorca (1925–1936), Poesia, Revista ilustrada de información poética* (Madrid), no. 27–38, April 1987.

Stubbs, Jeremy. 'The Dalí-Breton Honeymoon: Hallucination, Interpretation, High and Low Ecstasies', in Hank Hine, William Jeffett and Kelly Reynolds (eds.), *Persistence and Memory: New Critical Perspectives on Dalí at the Centennial*, Bompiani Arte, Milan, 2004.*

Stuckey, Charles. 'The Persistence of Dalí', *Art in America,* March 2005.*

Taylor, Michael. 'Hallucinatory Celluloid: Salvador Dalí, Harpo Marx and the *Giraffes on Horseback Salad* Film Project', *Dalí and Film*, Tate Publishing, London, forthcoming 2007.*

Taylor, Michael. 'Salvador Dalí's *Temptation of Saint Anthony* and the Exorcism of Surrealism', in Hank Hine, William Jeffett and Kelly Reynolds (eds.), *Persistence and Memory: New Critical Perspectives on Dalí at the Centennial*, Bompiani Arte, Milan, 2004.*